AMERICAN PIETÀS

CRITICAL AMERICAN STUDIES SERIES

George Lipsitz, University of California–Santa Barbara, Series Editor

American Pietàs

. . . .

Visions of Race, Death, and the Maternal

Ruby C. Tapia

CRITICAL AMERICAN STUDIES SERIES

University of Minnesota Press
Minneapolis
London

A version of chapter 1 was previously published as "Suturing the Mother: Race, Death, and the Maternal in Barthes' *Camera Lucida*," *English Language Notes* 44, no. 2 (Fall/ Winter 2006): 203–8; copyright 2006 Regents of the University of Colorado; all rights reserved; reproduced by permission. A version of chapter 2 was previously published as "Un(di)ing Legacies: White Matters of Memory in Portraits of 'Our Progress,'" *Journal for Cultural Research* 5, no. 2 (2000): 261–87; reprinted by permission of Taylor and Francis Ltd., http://www.tandf.co.uk/journals. A version of chapter 4 was previously published as "Impregnating Images," *Feminist Media Studies* 5, no. 1 (2000): 7–22; reprinted by permission of Taylor and Francis Ltd., http://www.tandf.co.uk/journals.

ר

Published by the University of Minnesota Press
111 Third Avenue South, Suite 290
Minneapolis, MN 55401-2520
http://www.upress.umn.edu

Library of Congress Cataloging-in-Publication Data

American pietàs : visions of race, death, and the maternal / Ruby C. Tapia.
 p. cm. — (Critical American Studies series)
Includes bibliographical references and index.
 ISBN 978-0-8166-5310-2 (hc : alk. paper) — ISBN 978-0-8166-5311-9 (pb : alk. paper)
 1. Motherhood in popular culture—United States. 2. Death in popular culture—United States. 3. Ethnicity—United States. 4. Pietà. 5. Mothers in art. 6. Death in art. 7. Race in art. I. Tapia, Ruby C.
 HQ759.A447 2011
 306.874'30973—dc22

 2011001281

Printed in the United States of America on acid-free paper

The University of Minnesota is an equal-opportunity educator and employer.

18 17 16 15 14 13 12 11 10 9 8 7 6 5 4 3 2 1

Contents

Introduction: Race, Death, and the Maternal in
American Visual Culture 1

1. Maternal Visions, Racial Seeing: Theories of the Photographic
 in Barthes's *Camera Lucida* 29

2. Commemorating Whiteness: The Ghost of Diana in the
 U.S. Popular Press 43

3. *Beloved* Therapies: Oprah and the Hollywood Production
 of Maternal Horror 67

4. Prodigal (Non)Citizens: Teen Pregnancy and Public Health
 at the Border 91

5. Breeding Patriotism: The Widows of 9/11 and the Prime-time
 Wombs of National Memory 109

Conclusion: Vivid Defacements 131

Acknowledgments 153

Notes 155

Index 193

Race, Death, and the Maternal in American Visual Culture

O N SEPTEMBER 11, 2001, Roman Catholic priest and New York Fire Department chaplain Mychal Judge emerged from the World Trade Center's Ground Zero as the first recorded victim of the terror attacks. Reuters photographer Shannon Stapleton was on site to capture the vision that began immediately circulating the world as an "American *Pietà*."[1] Startling for its simultaneous denotations of action and stillness, muscled response and grief, the picture asked for an interpretation, a reconciling frame stable enough to carry an assuaging meaning into a ground-shattered national context. The pietà was that frame. True to its long-standing historical role of archetypal inspiration, the shadow-shape of the Virgin Mary holding the dead Christ fluidly enveloped the five cradling men and their fallen, saintly hero. Thus recognized, the "American *Pietà*" birthed the terror attacks as the crucifixion of the nation, at the same time rendering concrete and prophesized a maternally sanctioned, masculine response.

The apparent ease with which the pietà frame fit the postmortem photograph of Judge had much to do with Father Mychal's own saintly reputation as a longtime servant to the Catholic church and tireless comforter to the sick and needy. Two book-length biographies, one documentary film, a children's book, and hundreds of online testimonies published since 9/11 render both the impact of Judge's spiritual and material gifts to others during his life and the extremity of personal and national loss represented by his death.[2] After decades of service as a spiritual leader to fellow New Yorkers, Judge died from a blow to his head that occurred while he was in World Trade Center Tower 1 tending to the injured and performing last rites. Having lived and died in a very public role of religious leadership, Judge's bodily self-sacrifice was perhaps bound to be figured in the shape of Christ. Indeed, very little of the pietà's traditional religious contours

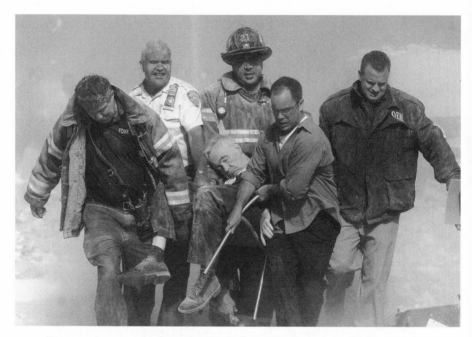

Rescue workers carry fatally injured New York City Fire Department chaplain Father Mychal Judge from one of the World Trade Center towers, September 11, 2001. Philadelphia Weekly *reported the image being referred to as "an American* Pietà.*" REUTERS/Shannon Stapleton.*

needed to shift in order to accommodate the symbolic material of Judge's prone and lifeless body. What did need to shift and stretch, however, was that component of the pietà mold that originally, timelessly contained the Virgin Mother. In a photographic terror-instant, several male, uniformed first responders were put in her place.[3] Circumstances of national emergency floated these five men into a photo-sculpture of compassion: together, they formed one maternal Mary, remarkable for its recasting of the pietà's conventional gendered symbolics.[4] More than anything else, it was Mychal Judge's visual double identity as Christ and terror "Victim 0001" that made distinctly American and apparently gender-transgressive this holy scene of maternal sacrifice, grief, and ordained resurrection/retaliation.

A nationalism bearing the force of religion lent the American-modified pietà its transposing power to put five men in the symbolic image-space

of a holy, grieving maternal body. If it was touched and comforted by the pietà's impressively flexible frame, however, the public at large initially had no knowledge of the degree to which this framing was potentially queer. A fact known to relatively few at the time of his death, Mychal Judge was gay and had for many years served and supported the queer community with his spiritual leadership.[5] That his gay identity was largely closeted meant that homophobia had no opportunity to rear its head before Judge was lovingly cast in the Christ position of the pietà or before the pope accepted Judge's fire helmet on behalf of the Roman Catholic Church.[6] Once news of Judge's gay identity began circulating after his death, however, antigay voices immediately weighed the possibility of Judge's sainthood against his gayness. In an editorial for *Catholic Online*, Dennis Lynch, a self-identified longtime friend of Judge, called the gay community's claiming of Judge as a gay hero a "September 11th hijacking." Citing only the fact that Judge had never told him he was gay during the ten years in which they'd known each other, Lynch declared that Judge was a "heroic, celibate, faithful Catholic priest" who had been sinisterly misappropriated as a homosexual icon.[7] While impressively confused as to the distinction between sexual practice and sexual orientation and identification, Lynch's outrage clearly indexed how the political stakes of Judge's symbolism far exceeded a "merely" nationalist or patriotic frame.

With the release in 2006 of *Saint of 9/11*—a documentary film on Mychal Judge—and later, with the 2008 publication of Judge's personal journals, Judge's gay identity became widely known. Those for whom the printed testimonies of Judge's close friends had not been sufficient evidence now had the words of Judge himself declaring a gay orientation that did not— sources were careful to insist—interfere with his priestly vows of celibacy. Long before this, however, Judge's symbolic force as a "gay saint" had already done significant work on behalf of gay and lesbian communities.[8] In 2002, President George W. Bush signed into law the Mychal Judge Police and Fire Chaplains Public Safety Officers Benefit Act, which amended the 1976 version by adding chaplains to the definition of public safety officers and by making it possible for domestic partners to collect the federal death benefit for such officers killed in the line of duty.[9] Thus, with the backing of his symbol's saintly, national hero status, Judge's death achieved victories on behalf of the gay community that he arguably could not have achieved in life. As "Victim 0001," his image managed to queer a piece of national law, if not—ultimately—the white masculinist picture of the nation.[10]

For all of the queer readings that were held out by an image of an all-male group of officers cradling Judge, the September 11th "American *Pietà*" was also (perhaps just) something far less culturally and politically transgressive. The pietà frame made spiritual the scene of national loss that held Father Mychal at its sacrificed center, simultaneously coding the grievers as stoic maternal *and* as moving, strong, white, masculine *responders*. Seen and felt thus, the five-headed male Mary was—in addition to being an apparently trangressively gendered maternal figuration—a sacralized, hypervisible, embodied mark of nationalism's long-standing possession and appropriation of maternal space and visual maternal discourses in states of war and emergency.

Twenty-first-Century American Pietàs

Twenty-first-century digital image cultures circulated the "American *Pietà*" globally, reproducing the maternally shaped, timeless justification for the war on terror along with its saintly, centered object(ive) many times over. There were, of course, a wide range of interpretations and active interactions with Judge's postmortem image, but its life as a maternalized, photographic war memorial is—for the present analysis—the most illuminating. Referencing the picture in a column titled "Why We Should Support This War" on September 22, 2001, gay conservative political writer Andrew Sullivan celebrated the "integrative moment" marked by the hypervisible joining of Father Mychal's gayness with American heroism. He described the moment as one wherein "gay and lesbian warriors"—a label he applied to gay and lesbian military personnel, as well as to Mychal Judge—could now fully participate in the nation's battles against the "terrorist monsters."[11] An obvious, overt appropriation of Stapleton's photograph in the vein of violent patriotism, Sullivan's engagement with "American *Pietà*" displayed the "democratic" versatility of twenty-first-century visual nationalism and the apparent fluidity of its maternal figurations in contexts of death and memorialization.[12] The digital information age and the imperatives of a global war had rebirthed and revisualized the pietà for an apparently expanding population of spectator-citizens. The universal appeal and would-be increasingly universal address of this new figuring was thus formed at the intersection of its historical status as an icon with which everyone was familiar *and* its reference to a national body unmoored by terror and the possibilities of digital information. As people around the

globe "watch[ed] the world change" on September 11, 2001, this iconic and innovative pietà of "Victim 0001" occupied familiar and newly necessary national(ist) structures of feeling.[13]

Early- and mid-twentieth-century Europe had seen countless plastic art renderings of war memorial pietàs, wherein soldiers replaced Christ and feminized figures stood in for grief-stricken but resilient nations.[14] In contrast to the conventionalized, embodied gender scripts of these materially static pietàs, late-twentieth- and early-twenty-first-century digital media technologies produced visual contexts wherein maternally themed memorials could be made from rapidly circulating ephemeral material, unearthing considerably different possibilities for gendered, nationalist signification. In the United States, scenes of the nation's leveling at the hands of terror produced distinctly "American" pietàs, wherein journalistically photographed firemen occupied the place held traditionally, iconically for the grieving mother. For example, the Pulitzer Prize–winning image that immediately came to symbolize the tragedy of the 1995 bombing at the Alfred P. Murrah Federal Building in Oklahoma City was a photograph of dying infant Baylee Almon in the arms of firefighter Chris Fields.[15] While the photograph itself was powerful as a symbol that encapsulated the nation's disastrous "loss of innocence," the association of it with the pietà compelled countless artists to render it in more "solid," traditional pietà forms. Painterly and sculptured replicas of the firefighter cradling the dying infant abounded, and it was proposed that such a sculpture be adopted as the official memorial for the tragedy.[16] Like the photograph of Chris Fields cradling Baylee Almon, the pietà-inflected scene of Stapleton's 9/11 photograph was one wherein nationalistically inspired visions of the grieving maternal body became overt scenes of masculinist penetration. As official representatives of the nation, as embodied evidence of both its leveling and its hopes for recovery, white male first responders were hypervisibly cited/sighted in a place where before they'd existed only through the ideologically coded female, white maternal body.[17] In the case of the 9/11 pietà of Mychal Judge, uniformed officers were framed within a mourning, maternal space, turning the hard, brutal, and necessary response of the racialized global war on terror into a sentimentally sanctioned course of action, an urgent spiritual mission with a seemingly timeless justification.[18]

In September 2005, a photographer for the Orange County *Register* submitted his own American pietà photograph to the image repertoire of U.S. national tragedy. Accompanying National Guard search-and-rescue

workers in the Broadmoor neighborhood of New Orleans after Hurricane Katrina, Bruce Chambers took a picture of seventy-four-year-old African American Edgar Hollingsworth being removed from his home after having been alone without food or water for sixteen days. The search team found Hollingsworth only as a result of disobeying FEMA's orders to not break into any homes to look for inaudible or invisible (from the outside) victims. Deciding that the news value of the photograph outweighed its potential risk of being "outside the bounds of taste"—Hollingsworth was emaciated and almost entirely nude—the Orange County *Register* ran the photograph on its front page, as did twenty other newspapers across the United States.[19] Luis Rios, the director of photography for the Miami *Herald,* explained the paper's decision to use Hollingsworth's image and the story of his rescue: "This is one photo that really captured, in a dignified way, someone who lived through Katrina, through the embarrassment of the response, and was carried out." The San Antonio *Express-News* photo editor, Rick McFarland, reported that his paper would not have published the image had Hollingsworth died shortly after he was rescued. Hollingsworth was indeed alive when the photograph ran, but he died two days later.[20]

Bruce Chambers's statement that his photo immediately reminded him of Michelangelo's *Pietà* elides the distinction between the deceased "matter" at the center of the traditional pietà and the fact of Hollingsworth's *living,* suffering body. The ascription of pietà status to the immediacy of a photojournalistic snapshot compels viewers to look outside the frame of the image-event to understand the historical matter of long-standing racial social death that is not merely Hollingsworth's, but Katrina's, picture. Indeed, Chambers's projection of the pietà onto a photo of a would-be rescue foreshadows Hollingsworth's death as the outcome of both the long history of racialized social and economic inequalities in New Orleans and the event of FEMA's "immediate" nonresponse.[21] Like the postmortem photograph of Mychal Judge, the image of Hollingsworth's rescue contained multiple public servants in the place of the cradling maternal: Specialist Alfred Ramos, a National Guard soldier from a San Diego unit, occupies the centered place of Mary, as he lifts Hollingsworth onto an ambulance gurney. To their left, two New Orleans medics (one of them apparently male, the other hidden from view but for her/his hands) assist with a breathing mask and an IV bag. Another medic on the right helps guide Hollingsworth onto the gurney, her hands cupped under his

knees. An additional male National Guard soldier stands at the left edge of the frame, head bowed.[22]

Affirming Chambers's own interpretation, the multiracial, dual-gendered scene of "rescue" found its way into the left blogosphere as an "American pietà," where critics in September 2005 referenced the image as an icon of national shame, consistently pointing out that Hollingsworth was a Korean War veteran and that his country had failed miserably to honor him appropriately.[23] Such commentary on Chambers's photograph, however, became a digital archive roughly contiguous with Hollingsworth's death: there are no blog posts or comments dated after September 2005 on those Internet sites that initially engaged the photograph. In marked contrast, Stapleton's pietà has continued to generate online conversations and memorializations, unabated since September 2001.[24] Applied to Chambers's photograph, the title "American pietà" could not officially hold (to) the nation the way that Stapleton's photograph of Mychal Judge could, and does. The 9/11 pietà is and was "American" because its white, male subjects were able to collectively constitute a symbol of the nation itself, a nation whose holy center was wounded by foreign "terrorist monsters."[25] The Katrina pietà is and was "American" because its subject of obscene racial neglect is distinctly national—the subject is, in fact, constitutive of the nation's history, and perhaps in that way remains unremarkable. As a critique of racism outside the context of any official war, and belonging to what we might call the genre of "protest pietàs," its nonstatus as a popularly adopted memorial was overdetermined.[26]

Discussing the history of racial, social death at the country's shunned center, Henry Giroux considers how the presence and images of dead bodies in the wake of Katrina could not do the same political work that Emmett Till's open casket did in 1955.[27] Till had been tortured, mutilated, and killed by white racists in Mississippi for allegedly whistling at a white woman. His mother, Mamie Till Bradley, insisted that his coffin be kept open so that her son's destroyed life and body could testify to the obscene racist violence still everywhere present, and everywhere threatening, in a nation that systematically dehumanized African Americans. Although mainstream news organizations at the time did not visually facilitate the powerful social critique that Mamie Till Bradley offered with and through her son's body, both *Jet* magazine and the *Chicago Defender* published photographs of the young Till's corpse.[28] His image, his body, and the brutal facts of his death became flash points for the civil rights movement.

Photographs of lynched African Americans had been circulating among racist whites for decades, fusing together the public and private formations of whiteness and binding them to black death.[29] In contrast, the production and circulation of images of Emmett Till's body on the part of Mamie Till Bradley and the African American community meant to reveal and combat the racial brutality that had long made blacks the material with which whites constructed a national body in their own image. The blatant nature of racism in 1955 provided a context in which Till's obscenely violent death could speak through its image to something concrete, to a racism that was present, deliberate, and unchecked in all political and cultural spheres of the moment. The post-civil rights, early-twenty-first-century moment is a considerably different one. Compared to the 1950s, the mechanisms of racial social and material death in the twenty-first century are relatively obscured by "color-blind" institutionalizations of power and privilege.[30] What Giroux terms the current "biopolitics of disposability" attending this "postracial" moment therefore produces distinct roles and possibilities for its embodied and imaged evidence.[31] He writes:

> Emmett Till's body allowed the racism that destroyed it to be made visible, to speak to the systemic character of American racial injustice. The bodies of the Katrina victims could not speak with the same directness to the state of American racist violence but they did reveal and shatter the conservative fiction of living in a color-blind society. The bodies of the Katrina victims laid bare the racial and class fault lines that mark an increasingly damaged and withering democracy and revealed the emergence of a new kind of politics, one in which entire populations are now considered disposable, an unnecessary burden on state coffers, and consigned to fend for themselves.[32]

While the contemporary moment and its attendant new "biopolitics of disposability" does indeed produce new images of racial death for new, albeit still racialized, visualities, we must consider closely Giroux's placement of the onus to testify on the corpses and images of the disenfranchised.[33] The photographed bodies of Katrina's victims, such as the photographed body of Edgar Hollingsworth, unmistakably bear the force of some evidence. But our assumption of their presence and successful political work as the "return of the (racial) repressed" evidences a faith in the possibili-

ties of what Ariella Azoulay calls the "Civil Contract of Photography" that we may deem unjustified when we read closely the discrepancies in the power to incite between different images of different deaths. Treating the experiences of Palestinians and women—social bodies to whom only "flawed citizenship" has been granted by the racial and gender politics of their respective national political cultures—Azoulay argues that photographic statements of plight on behalf of these communities may become claims of emergency or calls for protection only if the "addressee" of the photographs recognizes that what these images represent is not something that "she already knows."[34] Without a framing that interrupts this sense of already knowing the crisis being imaged, the always-already-devalued signification of aggrieved subjects' corporealities makes public emergency an impossible element of/within their images. Framed with this understanding, the post-Katrina photograph of Edgar Hollingsworth's rescued but dying body could not signify the same degree of official national tragedy or heroism as Shannon Stapleton's photograph of Mychal Judge. Bruce Chambers's desire to find a space for Hollingsworth's image in the iconic space of the pietà, however, indexed a hope that the maternal frame could do for the photograph what the photograph could not do for its twenty-first-century racialized subject—compel, as it did in the civil rights movement's maternal offering of Emmett Till's body, a maternally re-dressed vision of national shame and a racially redressing visuality.[35]

Revisiting American Pietàs

The address of Chambers's American pietà was an implicit reference not only to Stapleton's photograph, but also to a long history both in the United States and globally of political image making that seeks to mark and protest death—along with its material mechanisms and social threats—through images of the maternal. Pietàs have a long history in U.S. public culture as both critiques and visual salves of national crises, and race has always been a materially constitutive element of these works' manifest and ideological contents. This is as true for those lesser-known pietàs as it is for those that are hypervisible and reproduced many times over.

In 1941, to the chagrin of elite art critics, the inconveniences of World War II forced the Carnegie Institute's annual international competition to go strictly national in its solicitations and themes. The result was that little-known American muralist Tom Loftin Johnson won first prize in the contest

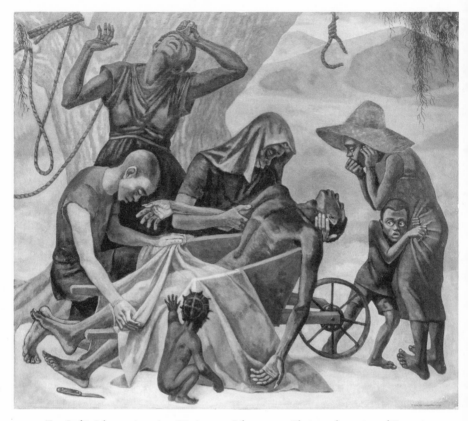

Tom Loftin Johnson, American Pietà, *1944. Oil on canvas. Photograph courtesy of Carnegie Museum of Art, Pittsburgh, Pennsylvania.*

for *American Pietà,* a painting that depicted the aftermath of a lynching.[36] Joining the widespread lamentation over the absence of European art that had previously graced the prestigious Carnegie International, one juror's final assessment of the show took the form of a desperate national prayer: "I looked at nearly 5,000 pictures and if they are American art God help America."[37] The majority of the published reviews of the "experimental" exhibition, titled "Directions in American Painting," took the same patronizing tone.[38] That Johnson's "conventional" and "pedantic" work garnered the one thousand-dollar first prize was therefore perhaps an outcome entirely befitting the mediocre stage of the event.[39]

Millard Sheets—the juror who dropped to his metaphorical knees

to ask for divine intervention on behalf of America's painterly canvas—encapsulated the reviewers' central grievance: that an exhibition meant to point to future American "directions" lacked any decipherable common aesthetic or thematic approach. Even worse, the first-prize-winning artist explicitly claimed in postcontest interviews that social justice was a central focus of his work, an orientation to art that, one critic lamented, "tend[s] to obscure pure aesthetic enjoyment."[40] Thankfully, for this same critic, *American Pietà*'s "line, shape, and color" did not ultimately suffer from the misguidedness of Johnson's social-realist inspirations. In fact, she concluded that the piece "dispose[d]" its forms "in the rhythm of grandeur which renders so much of Italian painting deservedly 'sublime.'" She observed: "The forms ... begin humanly with the tentative gesture of the haloed pig-tailed pickaninnie squatting in the leftcenter foreground against crimson calico. They move on to the dynamic grief of the father standing against the tree ... [and] come to focus in the static figure in the green wheelbarrow."[41]

While the political form of Johnson's painting did indeed begin "humanly," the "pickaninnie"-inflected humanity that constitutes its cultural and aesthetic premise makes it an uneasy fit within both genres—antilynching art and the pietà—to which it belongs. Johnson was certainly not the first to represent the atrocity of lynching in paintings, but he was, if not the first, then certainly among the first white American painters to garner substantial publicity, however lukewarm or negative, for doing so in the explicit form of the pietà. Following the historical and political path of antilynching artistic protests long articulated in poetry, song, literature, photography, and painting, Johnson—like many other artists who portrayed lynching victims as Christlike—fused religious iconography to an explicitly American trend of racial murder.[42] Clearly influenced not only by "deservedly sublime" Italian art, but also by the social-realist imperatives of two prominent antilynching art exhibitions held just six years prior to the Carnegie competition,[43] Johnson's work carved out some national political, social, and artistic "directions" that pointed to the past as well as to the future.

By entering his painting in a contest with an explicitly national theme, Johnson intended it to compel national ownership of the "great race problem of the United States."[44] His critique of this problem was multipronged. In a letter to the acting director of the Department of Fine Arts at the Carnegie Institute about the painting, he wrote that "the half white

mulatto boy [presumably the crouching figure in the left foreground] is intended to show that all the mischief was not done by the negros."[45] A gloss on the historical prevalence of the rape of black women by white men, the statement, like his painting, reaches toward an indictment of the "race problem" as *the* great American pity, *the* great American shame. A sign of the sexual and sexualized "mischief" of racism, the mixed-race boy lays a red shroud (parallel in form and color to that worn by the maternal figure) over the naked sex of, and the sexualized violence against, the lynching victim. This narrative component of *American Pietà* recalls both the historical fact of bloodily violent castrations that accompanied the lynching of black men and the graphic, heroic presentation of their bodies in painterly representations of lynchings.[46]

The published reception of Johnson's painting that ranged from lukewarm to scathing did not, however, compare it to its antilynching painterly predecessors, nor did it take issue with the discordant relationship of its racial stereotypes to its mission of racial justice. Trading in the caricatures of crouching postures, stunned gazes, and bug eyes, the "pickaninnie" presentation of the figures at the perimeter of the painting's central sorrow highlights the marginal relationship of blackness to any sympathetic presentation of maternity, family, and suffering that is not white. Imbued with no hint of the intentional aesthetic abstraction characteristic of much social-realist art,[47] the caricatured figures look upon the austere, "still," "eternal" ones, wanting entry to its human portrait, indexing the racialized visualities that haunt Johnson's would-be antiracist vision. Literally and figuratively, the pietà's expression of sublime maternal sorrow is here punctuated with cartoonish features.

American Pietà's prize-winning status, however begrudgingly granted and received, predicted some important future social and political directions, as well as some signal artistic and historical pasts, of America itself. The directions Johnson marked are perhaps now best understood as intersections that would long persist on the visual canvas of American tragedy. Looking at Johnson's 1941 painting from the vantage point of the September 11 and Hurricane Katrina photographs that assumed its title, the *"American Pietà"* emerges as an understudied genre of U.S. visual culture, a transhistorical, intermedial site where maternal imaginaries harness race and death to picture the nation in both critical and reverential lights.

Bruce Chambers's photograph of Edgar Hollingsworth references Johnson's 1941 painting as much as it references Stapleton's 9/11 image

of Mychal Judge. More than sixty years after Johnson garnered a luke-warm first prize for his attempt at social-realist and racial critique, Bruce Chambers's digital photojournalistic pietà of Edgar Hollingsworth used a different realist medium to indict different (still distinctly American) institutions of racial death. Chambers's photograph circulated widely, ini-tially, and earned him an "Award of Excellence" in the "Pictures of the Year International" competition.[48] It continues to exist in archived newspapers and Internet blogs, all dated back to September 2005. The relatively stalled lives of Johnson's and Chambers's "American pietàs" compared to that of Stapleton's photograph of Mychal Judge compels us to consider the pos-sible utilities of refigured pairings of death and the maternal in contexts of national tragedy and the role of race in determining them. Juxtaposed, these pietàs form a constelled vision of a nation's crises and crimes look-ing for an image-space of/for articulation, one that refers to the past but is always invested with the hope of (re)generating certain politics, certain fu-tures. Whether these futures are violently patriotic or radically critical, the pietà frame that they share illumines their historical dialogic relationships and sites them, collectively, in a racialized, maternalized space of death.

Death and its images have been rigorously contextualized in both social-scientific and humanistic inquiry, made to occupy historical and theoretical object sets, to tell us specific and crucial stories about particular practices at precise moments. Modern death making, however, has always happened in and through dynamic and relational forms, transhistorically and transnationally rendering bodies disposable according to visual fixa-tions of race, ethnicity, sexuality, gender, class, and (non)citizenship sta-tus.[49] In this framework, the role of images that construct death and their relationships to other images in both national and global contexts are remarkably complex and our theorizations of visual culture must adapt to account for them. Death emerges, and must therefore appear in our analyses of visual culture, *between and beyond* the material frames of single image-texts or the historical frames of bounded image practices. Indeed, being able to see *how* we see and know death depends on a rigorous study of bodies in haunting and deathly relation—in relation to other(ed) im-aged and material bodies, and in relation to the materialities of national history and memory making.[50]

In order to comprehend these important relations thoroughly, we re-quire a reworking of André Bazin's famous formulation in order to con-ceptualize an ontology of U.S. production and obfuscation of images of

the dead.[51] Scholars have begun to analyze the historical relationships
of U.S. visual representations of death and to pursue critical race stud-
ies of how images of the dead and visual productions of social death are
projected, used, and allegorized across different groups. This work is es-
sential and ongoing, its theoretical and methodological frames develop-
ing along many different disciplinary and interdisciplinary lines, includ-
ing considerations of lynching photographs, familial memorialization
practices, postcards and other ephemera, traveling exhibitions, funerary
materials, wartime propaganda, civil rights campaigns, photojournalism,
avant-gardism, and much more.[52] Indeed, if we care to comprehend
cultures of death in U.S. history—a history made with and through the
material relations of race—we must find frames of understanding ap-
propriate to death's practices, ways of looking at images that attend, in
particular, to their scattered deployment in the name of both racialized
monuments and murders. The present study asserts that a cross-media
analysis of maternal imagery is one such possible frame. Looking closely
at the ideological work of a range of maternal figurations, we witness the
imaged chaos of death settle into something affectively assimilable, and
we may perhaps take a critical cue—if not comfort—in this, the fact that
"the mother" always assuages some *thing* and that, with an urgent visual-
ity, this thing can be coaxed to appear. That maternal images provide an
analytic frame within which to illumine and comprehend death comes
clear only through practicing visualities-in-relation, through juxtaposing
visual objects in ways that parallel and reveal the ideologies that differen-
tially fix maternal bodies in material and discursive proximity to racial-
ized threats of annihilation and promises of resurrection. This is the work
of this book: it might—as it has, historically—begin in any number of
places, spaces, bodies, and times.

The Intermedial Spaces of Race, Death, and the Maternal

Focused on the intersection of race, death, and the maternal in U.S. visual
cultures at the turn of the twenty-first century, *American Pietàs* owes much
to previous theoretical articulations of death as not only a physical experi-
ence, but as a social condition or "threshold that allows for illumination as
well as extinction."[53] My analyses of post–Cold War images of death con-
joined to pictures of the maternal, however, neither journey into death ex-
periences (im)proper nor venture a subjectivity for the dead, the haunted,

or the haunting. Rather, I wish to chart the production and negotiation of death imagery as assurance *against* extinction for the contemporary racialized nation and its chosen subjects. In this sense, the "space of death" that I examine is a relational space of racial reproduction and annihilation, obliteration and restoration.[54] In order to frame this space, and thereby to introduce the theoretical and methodological aims of the following chapters, I began with the "American *Pietà*" as an intermedial image-site that displays the (trans)historical, visual coproduction of race, death, and the maternal in its manifest content.

While the overt theme of the pietà—that subject of Christian art depicting the Virgin Mary holding the body of the dead Christ—is the conjoining of death and the maternal, the presence of race and the mechanics of racialization in this joining are not so obvious in common imaginaries of the work. That the white-marbled, Renaissance subjects of the pietà were phenotypically white may appear to be a most obvious marker of race within its iconography, but this visual property does not in fact index the racializing work of either the pietà or its legacies. Given that the origins of the pietà's visual imagery have been traced back to at least the thirteenth century—a time when race as we know it did not exist—any attempt to illuminate the specifically racial imperatives it has since served must engage how it has been imported and elaborated in historical and (inter)national contexts wherein race is institutionally formative.[55] Whereas reading race and racialization in historical contexts contemporary to the pietà's initial circulation is difficult, if not impossible, modernity brought with it countless and varied opportunities to do exactly this.[56]

The affective symbolics of the pietà are indeed profoundly complex and have been articulated in scholarship and criticism ranging from literature to religious studies to art history to psychoanalytic cultural critique. But we may also look critically at the feeling work of the pietà as an iconic object of visual culture itself, one that has variously produced its "universal" subjects—death and the maternal—with and through the powerful and dynamic material of race and nation. Such an approach benefits from illuminating the pietà as a site whose sacredness stems significantly from its display of a physicalized maternal sorrow coupled *and coupling with* the embodiment of collective salvation.[57] From this perspective, our observations about the feeling work of such a profoundly touching image begin to register its more historically and nationally specific invocations. Indeed, the universally recognizable and affectively provocative form of the pietà

is precisely what both permits and obscures its racializing work on death and the maternal within national(ist) contexts.

Artistic imaginings of Mary's sorrow at the crucifixion inspired literary texts as early as the ninth century, bequeathing to succeeding generations and to a variety of image genres the quintessential shape of death and the maternal. Drama, poetry, and wood sculpture constituted the pietà's medieval forms, which appeared during that period in such diverse locations as the Rhineland (Germany), the Low Countries (Belgium), France, and Italy. In 1499, the pietà was prevalent enough in the European artistic imaginary to inspire Michelangelo's Renaissance masterpiece in precisely this shape: the Virgin Mary cradles the dead Christ, her face beautifully serene, her posture assured. Deathly still, whitely shining, the marbled pair immortalizes the transcendent purpose of maternal sacrifice: the giving over of progeny in the name of collective salvation. Whereas the pietà highlighted the Christian nature and imperatives of this salvation, its symbolism spoke powerfully, also, to peoplehood and to its death and regeneration more generally. The life-sized, three dimensionality of Michelangelo's sculptural rendition literally materialized the pietà's affective significance. It was beautifully there, unmistakable, an irrefutable body of feeling.

Whereas the Bible would have been the most likely literary source to figure the pietà, it in fact contains no mention of Mary holding Christ after the crucifixion. The elaboration of Mary's maternal sacrifice into an immanently visual, embodied offering thus required a semiotics beyond the frame of the New Testament.[58] It was with the material of desires that exceeded the strictly scriptured symbolic that Michelangelo—and countless artists before and after him—formed the pietà. This material was social and psychic, aesthetic and political, ethereal and tactile: it was nothing less than the maternal and its promise. Like images of the Madonna and Child, this representation hosted and compelled sentiments that resonated in apparently universal ways, but the resonances of the pietà were significantly distinct in that the held object of these images (the Man-Child) was dead, and that the desired object (the Mother) was grieving. The Mother of the pietà was much more than a body absorbing the most tragic of deaths, however. The feeling she hosted and performed on behalf of all ensured a re-membering, and a resurrection. She was thus an essential presence, marking the magnitude and purpose of this death and the certainty of future life precisely in and through *the face of her loss.*[59]

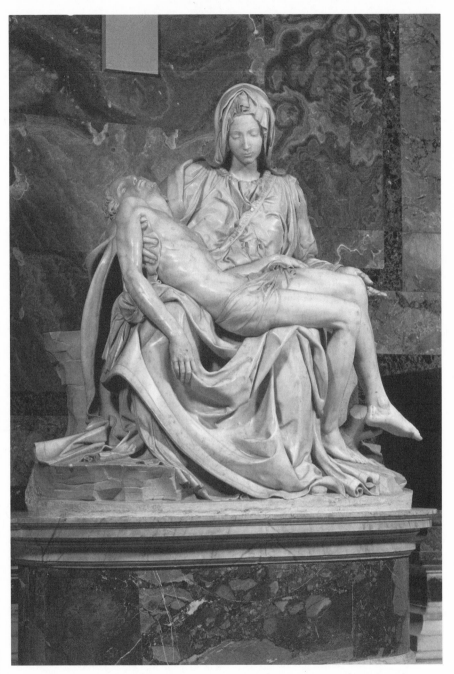

Michelangelo Buonarroti, La Pietà, 1498–99. Marble, 68½ x 76⅘ inches (174 x 195 cm). St. Peter's Basilica, Rome. Scala/Art Resource, New York.

Molded, chiseled, touching in every one of her manifestations, what the pietà's Virgin has thus freighted since its still-contested originary moment are the heavy projections of maternal desire—desire ascribed to the maternal, desire for the maternal, desire shaped around the maternal. The historical and cultural origins and manifestations of this desire are nowhere near universal, but the centrality of the maternal in *shaping* desire itself—by beckoning anxious identifications, hosting hopes for wholeness and fantasies of restoration—would appear to be. The impossibility of indifference to maternal representations is clear in treatments of them that span a startlingly broad range of historical periods and discourses, from religious to secular, feminist to misogynist, psychoanalytic to sociological, familial to nationalist.[60] In this sense, the essential constituent of the pietà's timeless function as a fleshed-out screen is neither the body of Christ nor an appeal to a specifically Christian sensibility; rather, it is the maternal body and its inextricable relationship to the threat of death and the promise of resurrection.[61] *American Pietàs* seeks to engage the role of race in producing this threat and in constructing the visible contours of its promise within U.S. visual nationalism. Whether we locate the pietà's inspirational ground in the religious, psychic, or social sphere, or in the in-between meeting spaces of the three, its erected manifestation seeks to do consistent work at the feeling level of racialized being and identity: it reflects and bounds desire, loss, and fear and it inspires hope for resurrection and restoration. Indeed, the shape of a grieving maternalized figure holding her dead child/son negotiates—even as it compels and reproduces—so much essential, affective experience.[62] The "infantile" nature of American citizenship, as Lauren Berlant refers to it, thus seeks comfort and containment in maternal images and maternal fantasies.[63] Race, I argue, is an essential projection of, upon, and within these images and fantasies.

These images and fantasies, these affective constructions of citizenship, look to *be* some place: they seek out narratives, bodies, and visions within which they can play, be held, let go, and return. In the contemporary national context, these self-stories, these desires, get taken up by and worked through—among other specters and spectacles—the "ghostly imaginings" that animate such abstractions as "global war" and patriotism, family and home, terror and security.[64] As the prevalence of pietà imagery from the Middle Ages to the present day affirms, maternal figures that vividly mediate our relationship to life and death are ideal, sentiment-ready ob-

jects upon and through which to project these imaginings.[65] In her own work on *Motherhood and Representation,* E. Ann Kaplan observes that often, the imaginary mother comes to dominate representations when some threat has emerged through social changes.[66] Centered on visual texts produced since the mid-1990s, *American Pietàs* examines the domination of representations of "the mother" in the contexts of what were and are profound social changes. The racial demographic effects of the 1965 Immigration Act, and the responses to it via the racial hysteria of such state-level measures as California's Proposition 187 and the racial logics of the Immigration Reform and Immigrant Responsibility Act of 1996 were just one index of the social changes needing to be managed in the cultural sphere at the turn of the twenty-first century. Visual representations and regulations of maternal bodies along racial lines were and are, as they have been historically, sites wherein these changes are negotiated, "hosts" for heteronormative anxieties and fears about losing ground to difference.

To examine the visual discourses and imaged intersections of race, death, and the maternal in contexts of national memory, reinscription, and reconstitution is thus to bring to light an intertextual, intermedial, cross-racial sphere of maternally inflected image crossings, co-constituted spaces of identity crises and formations compelled by, and then also *obscured* by, so much apparently natural and transparent feeling. The would-be self-evident nature of *a* mother's feeling, *a* mother's grief, *a* mother's comforting presence is complicated by the racialized facts of womanhood and motherhood themselves. The racialized productions of womanhood and motherhood, and images of the maternal, are essential breeding grounds in the U.S. nation's attempt to achieve a racially coherent, white "self."[67]

As the quintessential image-frame of death and the maternal, the pietà casts a formal shadow—literally, an iconic shape—that hosts social and political investments and struggles as much as, and at the same time that, it hosts religious and spiritual narrative. Just as Italian nationalism inspired an effort to establish Michelangelo's *Pietà* as, first and foremost, an *Italian* masterpiece, the politics of national culture has long located itself in and around images of death and the maternal.[68] To put it differently, visual and material embodiments of death and the maternal are often claimed, possessed even, by the politics of national culture. In the context of modern nation-states, and most certainly within the United States, the politics of race and the unsettled materialities of racialization look for a home in the shape of death conjoined to the maternal. The pietà manifests this

conjoining in one of the most obvious, literal, seemingly timeless forms. Its shape—the shape of a mother or a maternalized figure (as in the case of Stapleton's and Chambers's photographs) holding a/her dead child—has historically been filled in with varying material, citing different tragedies and victims, inspiring hopes for different kinds of resurrections and restorations. Although the shape remains, this "different" and differently felt material helps determine for whom its honored and beloved contours are legible.[69]

In *Raising the Dead,* Sharon Holland illumines the dark spaces of racialized subjectivity against which full humanity takes shape in modern nations. She urges us to listen to the living dead, to those nonbeings whose histories of enslavement and oppression are simultaneously justified and erased by a national imaginary that has incorporated neither its racial crimes nor its victims.[70] As Holland argues, these deeds and victims— disavowed and repudiated—are not without effect: they are the U.S. nation's constitutive outside, the always-already other that is forever present and against which full subjectivity, full humanity, is differentiated. By expanding the notion of death experiences to include not only the experiences of the deceased and their survivors and grievers, but also the experiences of those relegated by national histories to the space/place of social death,[71] we come to understand the essential relationship between death, discourse, and nation building.

Indeed, the exclusion of "other" subjects from national communities and official historical narratives never occurs through clean erasures or absolute disappearances. Rather, these subjects are often the focus of much social and individual hysteria, their absolute difference looming large in the fear spaces of those whose very identity requires cultural propriety. Treating these "ghostly matters," Avery Gordon applies Ralph Ellison's observation that "hypervisibility is a persistent alibi for the mechanisms that render one *un*-visible"[72] to examine how "the mediums of public image making and visibility are inextricably wedded to the co-joined mechanisms that systematically render certain groups of people apparently *privately* poor, uneducated, ill, and disenfranchised."[73] Whereas this incisive discussion of the relationship between publicly hypervisible images and invisible truths takes as its primary objects the images and erasures of marginalized groups, we can extend it to a discussion of hypervisible images of maternal bodies along with their haunting figurations and social consequences. Gordon observes that "to write ghost stories implies that ghosts

are real, that is to say, that they produce material effects."[74] My analyses of the ghosts bred at the intersection of maternal images assumes that their haunting work cannot be decoded by looking at these images in isolation, or by assuming that the hypervisible "white" properties of some of them—like the 9/11 "American *Pietà*" of Mychal Judge—are the theoretical point. The dangerous nature of such a visual politics of maternalized reverence is not only that it may make invisible—by taking media and official historical attention away from—"other mothers" or other maternalized figures meant to soothe other tragedies, but also that it seeks to sanctify those ideologies of patriotism and white supremacy that continue to support racialized, global technologies of memory, death, and ghosting.

The Methods and Objects of American Pietàs

Visual representations and productions of death and resurrection have historically appeared not only within and between images of corpses and angels, but also within and between images of mothers, families, citizens, and homes. The "tender violence" of sentimentality in nineteenth-century images of enslaved African American "nursemaids and their charges" and "Americanized" American Indians at boarding schools revealed the kind of ideological death work that "picturing" other bodies has long performed in the United States.[75] Following Laura Wexler's work on the racialized violence of domestic images and the inestimable contributions to theorizing racialized subjectivities and subjections of scholars like Sharon Holland and Saidiya Hartman, one must—if one desires to take seriously questions of race in U.S. visual culture—face directly the issues of racial social death in white self-making. White self-making in the United States is ultimately the object of this book: white self-making through the social death and "obliterations of the other" it entails is its bigger picture.[76] The notion of social death that I use derives from Orlando Patterson's application of the term to enslaved persons, but I use it more broadly to refer to the negation of full humanity of nonwhites in the context of a nation (the United States) that accords humanity through institutionalized productions of racialized citizenship.[77] The book's structure, methods, sites, and arguments depend on the framing of whiteness as it is produced and reproduced in racialized images of the maternal. Focusing on late-twentieth- and early-twenty-first-century maternal representations in a variety of visual and textual forms—including photography, film, and popular (print

and televisual) journalism—the following chapters examine the racialized coproduction of images that simultaneously "stall" death and "fix" the maternal in the production and revision of U.S. national(ist) narratives of history, memory, and identity. This work goes beyond charting the relationship between fixed notions of race and positive/negative representations of motherhood. Instead, it reveals the complex relationship between visual *intertexts* and the sentiments that attend the incorporation and rejection of racialized bodies within contexts of death and re-membering.

To engage this constellation of visual maternal discourses is not merely to engage with how dominant ideologies of race structure the differences between "normal" and "deviant" motherhood, between popular understandings of "good" versus "bad" mothers. Indeed, there is something far more complex, more insidious, and more fundamental to racialized visions of the maternal than the crude visual stereotyping that in popular culture makes African American women crack addicts, Latinas hypersexual, and middle- and upper-class white women simply mothers would indicate. Engaging with this network is to move beyond even the crucial acknowledgment of those experiences and representations of history, memory, and maternal experiences that racial atrocities have made fundamentally "different" for marginalized communities. To engage the racialization of history, memory, and the maternal in visual discourse—as both representation and *practice*—is to *begin* with the fact long recognized by African American feminist critics such as Hazel Carby, Anne duCille, Hortense Spillers, and Patricia Hill Collins that the very categories of woman and mother do not exist, and have never existed, independently of race.[78]

Although the universally revered notions of "womanhood" and "motherhood" have been denied outright to African American women since the institution of racialized slavery, the social fact and costs of these denials continued long after abolition. That "the consequences of being a slave woman . . . haunted the texts of black women throughout the nineteenth century and into the twentieth"[79] is testimony not only to the psychic and cultural residues of racialized slavery and their material manifestation in cultural production, but also to the continued, violent intersections of racial and gender ideologies upon the bodies of African American women and other women of color.[80]

The historical tropic trinity of race, death, and the maternal in U.S. visual culture may be read in and across a perhaps endless variety of texts, but *American Pietàs* chooses to focus on their manifestation as millennial

intertexts, highlighting the ideological work they co-perform to mend and resurrect the U.S. national subject in a particular image during specific moments and events of cultural, social, and political rupture. Via a sustained engagement with Roland Barthes's suturing of race, death, and the maternal in *Camera Lucida,* I begin by establishing that, whatever the medium of "her" representation, there is something primarily *photographic* (with regard to a *fixing* logic) about not only race and death, but the *maternal* as well. Although the commentary on racialized visualities within Barthes's *Camera Lucida* has yet to be sufficiently decoded, the text indeed shows, even if it does not *tell,* much about the visual coproductions of race, death, and the maternal. Barthes's description of the contradictory essence of the photograph as both signifier of death and guarantor of resurrection is particularly instructive, as it suggests a logic that—like the racial logics deployed in white self-making—fixes and creates, reflects and produces. As compounded and compounding cultural elements that share manners of invocation, that have in common the ways in which they are deployed—often simultaneously—to make national histories, memories, and identities, the visual projects of race, death, and the maternal are indeed all bound together by their photographic logics, if not by the many photographs and other media texts in which they have historically, collectively appeared.

I then proceed to explore the implications of this argument for the cultural consumption and critical analyses of racialized productions of death and the maternal in the context of specific visual epistemologies and mediums: the commemoration of Princess Diana in U.S. magazines; the intertext of Toni Morrison's and Hollywood's *Beloved;* the racialized practices of social and cultural death within which "teen pregnancy" is imaged and regulated in California's Partnership for Responsible Parenting campaigns; and popular constructions of the "Widows of 9/11" in print and televisual journalism, all representational forms that have produced and been deployed to work through this trinity (race, death, and the maternal) at the turn of the twenty-first century.

Acknowledging the complexity of images as material forces, Victor Burgin's exploration *Place and Memory in Visual Culture* importantly distinguishes between an analytic approach that examines visual cultural productions within the "separate confines of the supposed 'specificity' of their objects" and one that "take[s] its objects as it finds them ... in pieces."[81] *American Pietàs* affirms the co-constitutive and intertextual relationship

between apparently separate sites of visual production. Images derive part of their force from their relationship to and with other images. Seemingly isolated representations garner the power to persuade and to move viewers toward more (or less) feeling when they work to reinforce one another. Seemingly disparate and unrelated visual media texts all function in this study as cultural artifacts and as visual nodes in a larger network of racialized productions of maternal bodies in contexts of national death and remembering. To engage this network, however, is not merely to interrogate how dominant visual discourses of race structure the difference between those maternal bodies we consume with reverence and those we engage with disdain. Rather, it is (also) to ask how and toward what end the racial project of the nation imbues some maternal bodies with resurrecting power and leaves others for (the) dead. It is in the spaces between these different maternities that U.S. citizen-subjects are born and reborn.

Analyzing *Camera Lucida*'s incorporation of the maternal in its treatment of the photographic, chapter 1 establishes that Barthes's reflections on photography teach us something more than how this particular visual technology captures its beloved objects of/for (dis)identification. Barthes's meditation on the photographic image sutures race and death to the romanticized maternal, giving us a clue as to how maternal visualities themselves deploy race and death in their preservation of a particular (image of) self. Taking a cue from Barthes's declaration in *Camera Lucida* that "[he] decided to derive [his] theory from the only photograph which existed for [him] (a photograph of his mother as a child)," this chapter begins its theorizations of maternal visualities with evidence of a pattern, evidence of a tropic trinity—race, death, and the maternal— that appears, again and again, to mediate visual encounters with threats of physical, cultural, and spiritual annihilation. This trinity has historically appeared via a variety of imaging technologies, including (but by no means limited to) photography. Yet it is Barthes's reflections on photography that illuminate the "fixing" logics of racial and maternal ideologies, as well as the fixing relationships between race, death, and maternal that proliferate in all mediums of visual culture in moments of identificatory crises, both large and small.

Chapter 2 analyzes "official" and "commemorative" images of Diana Spencer for how they invoke tropes of charity and sympathy to produce racialized mediations of history, memory, motherhood, and U.S. national identity. Drawing from cultural theory that establishes visual technolo-

gies of memory and forgetting as material forces, the chapter reads images of Diana appearing in "Collector's Editions" of such "American" popular magazines as *People* and *Life* to illumine the visual scripts of race that demarcate the relative social value(s) of maternity and reproduction. I argue that understanding visual culture as a force that is both structured by and structuring of hierarchies of power enables us to see how the posthumous circulating images of "Our Princess" are indeed not ideologically innocent memorializations. Rather, these images are the physical, embodied material of a (trans)national monument that provides faithful "visitors" an affective connection to historically idealized notions of whiteness, motherhood, and the family. This chapter both identifies the visual production of these ideals and suggests that they are coproduced and reinforced by different media forms and genres, and across/with apparently individual texts. By first illuminating the racialized material of history, memory, and motherhood out of which "The Queen of Our Hearts" (Diana) is posthumously constructed in popular journalism, I set the stage to investigate this material as it is intertextually, dialogically produced with other visual forms.

In chapter 3, I read the visual adaptation of Toni Morrison's novel *Beloved* into the 1998 Hollywood film, exploring whether or not it can convey alternative experiences and meanings of the maternal within and despite the racialized discursive terrains within which the construction and reception of its narrative occurs. I treat the maternal media persona of Oprah Winfrey and consider how her publicly granted titles of "America's psychiatrist" and "The Conscience of Our Times" impact the sentimental racial codes through which the film's productions of history, memory, and motherhood are read.

Chapter 4 draws upon the work of both critical-race theorists and feminist sociologists to analyze how the California Department of Health Services' "Partnership for Responsible Parenting" disguises national and local concerns about changing racial demographics and nontraditional family structures within the rhetoric of the "teenage pregnancy" problem. The discourses that mark the maternal bodies of women of color as racialized, sexualized threats to moral and civic "responsibility," "family values," and "public health" are not limited to just those visual texts that, for instance, depict an obviously pregnant Latina teen standing in front of a mirror, being asked by a huge, overseeing caption: "ARE THESE THE KIND OF CURVES YOU WANT?" Rather, such inductions to publicly healthy

and morally sound behavior achieve their distinctly racialized charac-
ter and racializing function through, and because of, their status as one
link in a chain of signifiers of deviant sexuality, deficient motherhood,
and—because of California's geographic and imaginary status as a border
space—national economic and social threat and burden. By locating the
visual print media components of state-authored teen pregnancy preven-
tion initiatives within the same public "screening space" as other U.S. vi-
sual (filmic, televisual, journalistic) constructions of maternal bodies, I
hope to demonstrates the important relationship between seemingly dis-
parate cultural sites and institutional practices, as well as the imperative
for interdisciplinary methodological and theoretical investigations of race,
gender, and nation.

The final chapter traces popular representations—in U.S. television
specials, popular magazines, and newspapers—of the women who lost
spouses and co-parents to the terrorist attacks of September 11 for how
these vastly diverse images work together to reproduce a memory of the
events in the service of heteronormative formations of family, mother-
hood, and the nation. Working with and against the tropes traditionally
used to render single motherhood in the United States, the sentimental vi-
sual discourses that invited sympathy with appropriately maternal widows
eventually rendered mothers and widows who developed stances critical
of the government irrelevant to any patriotic purpose or objective spurred
by September 11. Central to this discussion of those who have been popu-
larly labeled "The Widows of 9/11" is a comparative analysis of the imaging
practices used to render these women as, alternately, sympathetic figures
in whose name vengeance and war are waged and supported and demon-
ized voices demanding administrative accountability.

In the still-emerging field of visual culture, critical theorists of the
image and its social work have begun to extricate their object of study from
questions of its production and consumption in and through individual
mediums, and to re-place it within its sociohistorical context of simultane-
ous interlocution with a variety of media forms.[82] Adopting this theory
behind the method, *American Pietàs* de-corporealizes the "maternal body"
to examine an intermedial *body of maternal images,* to highlight the diffuse
discursive and ideological material out of which it is comprised and the
racializing work that it does precisely through its scattered properties. At
the same time, my analyses seek to remove this body from the distinct vi-
sual theoretical and disciplinary domains within which its meanings have

thus far been analyzed and understood. My choices of textual objects and analytic approaches to them are thus governed as much by an aspiration to treat visual culture as a discursive field/object-in-itself as they are by an attempt to address specific questions about the relationships between race, death, and the maternal as they are constructed by particular visual genres and technologies.

The racialized maternal is a difficult but crucial concept to analyze, and it becomes all the more so when we grant that it is produced within and across different visual technologies, within and across a variety of cultural and theoretical discourses. Religion and religious studies, art, art history and art criticism, psychology and psychoanalysis, ethnic studies, feminist criticism, and cultural studies: all of these discourses, and many more, offer us ideas about mothers, motherhood, and the maternal. What I explore and assert here about the racialized maternal will likely resonate at different points with a variety of these discourses. Ultimately, I'm concerned with the maternal as something both embodied (fleshed out, visual, visible, although not always whole) and ephemeral (idea, ideology, hauntology) that bears, hosts, and resurrects whiteness on behalf of the nation. This is the maternal we turn to, piece together, hide under, revere, disdain, erect when we want to recuperate our selves as pure and proper citizen-subjects, as well when we want to protest our exclusion from this category. "She" is not a body, but she assumes a multitude of shapes. Barren, fecund, weeping, breeding, sterilized: the American national body needs her in every way. Neither race nor death has ever been very far from her or her ghostly manifestations. Her most sophisticated work is done across and at the interstices of texts, media, and criticism, and we therefore have to probe exactly there to even begin to see it.

Maternal Visions, Racial Seeing

Theories of the Photographic in Barthes's *Camera Lucida*

Death is the eidos of the photograph.

—Roland Barthes, *Camera Lucida*

Photography has something to do with resurrection.

—Roland Barthes, *Camera Lucida*

S INCE ITS PUBLICATION IN 1980, Roland Barthes's *Camera Lucida* has been somewhere present in almost every critical treatment of photography. His raw, personal reflections on how certain photographs have no profound effect on him at the same time that others touch him deeply offer us an indispensable way to understand the radically contextualized meanings and effects of photographs. Despite its first-person voice and its emphasis on the individualized work of photographs, *Camera Lucida* offers a theory of photographic visuality that applies far beyond the realm of the personal and far beyond photographs.

For all the authority that *Camera Lucida* lends to treatments of photography, it is recognized far less frequently for the narrative it presents about the maternal, both within and in relationship to the photographic.[1] Early in the text, Barthes reiterates Freud's observation about the maternal body: "that there is no other place about which one can say with such certainty that one has already been there."[2] This assertion implicates not only the maternal body but the one/self who, in recognizing the certainty of this embodiment, affirms that *I am here because I was there* and, relatedly, *I am here (as a differentiated subject) because I am no longer there*. Like the assurances the maternal body and our relationship to it provides, the *photograph* also assures us of a something having certainly been *there*: a

body, object, space, place that is a reference point for one's identifications and disidentifications. Through photographic representation, the subject/imaged object—*like the maternal body itself*—simultaneously references death and promises life. In this logic system, *the photographic is maternal and the maternal is photographic.*

Yet, to follow the death–life analogy of the photographic experience to that of the abject maternal to its furthermost point,[3] to conclude, in fact, that *the photographic is maternal and the maternal is photographic,* is *not* to speak about the subject/object that any particular photograph or photographic genre depicts, or even necessarily to speak about photographs at all.[4] Even though *Camera Lucida* finds it essential, as does the present study, to engage the photographic properties that adhere in still images of "actual," sometimes "ideal" mothers, photographs themselves are only one of many mediums in which the photographic *logics* of the racialized maternal appear in visual culture. These logics do indeed work in conjunctive, often compounding ways across a variety of visual media and texts, to *host, fix, resurrect,* and *restore* memories, histories, and identities.

Simultaneous to its overt presentation of how photographs work, Barthes's *Camera Lucida* performs its own visuality, a visuality that traces the photographic logics of race in/and maternal space, and that we can usefully apply to understand and examine maternal figurings that manifest with—*as well as outside of*—those images that happen to be photographs. Illumining this visuality requires a substantial re-vision of *Camera Lucida* with regard to how it has thus far been applied to studies of photography, as well as to how it has been applied (much more rarely) to studies of visuality in relationship to the maternal. Thus, rather than as a definitive theory of how the photograph works, in what follows I read *Camera Lucida* as a narrative about the relationship between looking and feeling, a story about how the maternal drives this looking and feeling, and a performance of how *difference*—particularly racial and ethnic difference—frames this looking and feeling.

What does it mean to say that *the maternal is photographic*? One must first consider the realism historically ascribed to photographs, the value placed on their ability to represent things *as they are,* to record a thing in its actual detail, to freeze a moment and capture its singularity, to actually carry into succeeding viewing and "holding" moments something *real.* Given this, what is maternal about the photographic is that the spectator's relationship to it—just as with the child's original relationship to the

mother—can be felt as unmediated and immediate. This real effect of the photograph, what Barthes describes as the *adherence* of its referent, makes it such that nothing apparent interrupts the relationship between the photograph and its viewer: the image's affects are close, direct, without any middle term, fast and true.[5] If a photograph were to have an essence, this would be it: it shows without mediating, it gives without qualification, it asks for nothing in return and, at the same time, it compels and satisfies feeling, attachment, longing, and desire.[6] In these ways, *the photographic is maternal and the maternal is photographic.*

The analogous, affective properties and effects of these technologies extend even further, however, into a realm that is different but not separate from the immediate assurance, a kind of warm evidence, that attends them both. The photographic and the maternal meet, also, where the unmistakable life/preservation that they promise inevitably references the possibility of the subject's annihilation, in that felt space where their mutual powers of death making qualify them both as sites of *abjection.*[7] Indeed, *Camera Lucida* is elaborate, lucid, and poetic in its treatment of the photograph as an "agent of death."[8] The text illuminates the abject properties of the maternal and of race, however, in ways that are profoundly less direct. That Barthes feels— even if he quite deliberately refuses to show—the death threat of the generic maternal body is clear in his insistent distinction between the Family and *his* family, between the Mother and *his* mother: "And no more than I would reduce my family to the Family, would I reduce my mother to the Mother."[9] That *racial* abjections compel his theoretical, textual (non)engagements with the photographic as well comes clear—in a way that would appear to be obvious but, remarkably, is not—by paying attention to the image-narrative that bounds his deliberate, written photographic theory making, and by looking closely at the actual pictures that the text treats and considering *how* it treats them. From this vantage point, race, death, and the maternal emerge as co-constitutive—if variously and differentially acknowledged— inspirational forces at work in shaping *Camera Lucida.*

Performing Theory: Speaker/Spectator/Son

Camera Lucida articulates its photographic theory through/as, fundamentally, an affective experience. In it, rawness and reflection appear together, feeling and thinking merge. We might begin to understand these dual, seemingly contradictory, performances better if we attend to the pretext of

Barthes's "actual" (if substantively and stylistically subversive) autobiography: "It must all be considered as if spoken by a character in a novel."[10]

The narrator of *Camera Lucida* approaches his *Reflections on Photography* as the theorist he knows himself to be—Roland Barthes—an astute reader of culture who desires to articulate the essence of photography: "I wanted to learn at all costs what Photography was 'in itself,' by what essential feature it was to be distinguished from the community of images."[11] Very early in the narrative, however, he intentionally and declaratively abandons the critical distance that conventionally attends theory making and, in doing so, arrives at photography's "essence," what it is "in itself": "Whatever it grants to vision and whatever its manner, a photograph is always invisible: it is not it that we see. In short, the referent adheres."[12] Thus foregrounding the difficulty of penetrating a technology the "nature" and difference (from other visual mediums) of which lies in its simultaneous invisibility *and* visual, affective presentation of the real, the narrator deserts his critical, "sociological" imperatives: "So I make myself the measure of photographic 'knowledge.' What does *my body* know of Photography?"[13]

With this, the *structure* of photography is revealed to be one of *feeling embodied,* what Raymond Williams articulates in a different context as *"thought as felt and feeling as thought."*[14] Indeed, it is *through* feeling that Barthes thinks photography because, as he asserts, feeling is inextricable from the science of its work, a work that—in turn and simultaneously—depends on material forms, on bodies, on things. Of photography's three perspectives—"Operator," "Spectator," and "the target"—he chooses ultimately to occupy the feeling-space of the Spectator, the ghost-subject of photography that finds a body in the looking, whose body *knows* and becomes (itself) by looking.[15] From this place, as this body-in-formation, Barthes as a theorizing, narrating Spectator uncovers the photograph as not only a technology of imaging, but one of primary identification in reference to "the desired object, the beloved body,"[16] *as well as to,* I argue, "the detestable body."[17]

The Flat Death of Photography

As systems that grant knowing and being in reference to "other" objects in our world, the photographic and maternal logics of transparency and immediacy work very similarly to the logics that produce race as a self-evident (written clearly on the body) signifier of essence. This

is why photographic technologies have historically lent so well to technologies of racialization.[18] Race fixes essence, photography captures it. Both are mediums of truth, and the objects/products of each technology become more vivid, more true when layered over the objects/products of the other. Barthes writes that "when I discover myself in the product of this—[photography's]—operation, what I see is that I have become Total-Image, which is to say, Death in person; others—the Other—do not dispossess me of myself, they turn me, ferociously, into an object."[19] Barthes's description of how "others'" engagement with an image, a surface, flattens the personhood of its otherwise human content resonates powerfully with Frantz Fanon's earlier articulation of race as an effacing and dehumanizing technology. In *Black Skin, White Masks,* Fanon observed that the European colonial imaginary had created and deployed the "Fact of Blackness"—the "overdetermin[ation] from without" of his and other racialized peoples' essence—in order to fix a "natural" equation between blackness and inferiority. To illumine the extent to which this racial imaginary structured material reality, both the social and the psychic, he asserted that he "was a slave not of the 'idea' that others have of [him] but of [his] own appearance."[20] Hence, his racial epidermal schema provided the map to his and other black people's meaning, an idea fleshed out and made real by the fact of its own physicality, its visible *right-there-ness.*[21] Fanon's meditation on race focused on the mechanics of colonial institutions' eradication of black people's subjectivity, but his observation that he "was a slave not of [an] idea" but rather of his own phenotype articulated the flat "truth" of essence that perpetually manifests in—*as*—the skin of racial difference.[22] What we can understand, therefore, as a *double death* emerges at the visual and theoretical collisions of Barthes's notion of photography's "flat death" and Fanon's concept of the subject-obliterating "fact of blackness."

As theory performed through the character of Spectator/son, *Camera Lucida* pursues the logics of race only indirectly. The narrator is fascinated with and terrified of the murderous potential of photographic "capture," determined to communicate how it is that "all those young photographers who are at work in the world ... are agents of death."[23] His photographic death talk is as vivid as the faces and bodies that the book reproduces, those same faces and bodies that a close reading of the narrative's image-text compels us to understand, effectively, as death's evidence—indeed, as death's *real.* In her essay on "Barthes' Mistaken

Identification," Margaret Olin incisively observes that "marginalized figures take up a large share of the illustrations in *Camera Lucida*, including among its twenty-five photographs, a gypsy, retarded people, a condemned man, slum children from Little Italy, three African-Americans including James Van Der Zee's sitters, and an African."[24] How are we to understand this image-conflation of marginalized bodies with textual explications of death in/and the photograph? Was Barthes, the critical theorist, simply unaware of the social death to which his narrative of photography pointed and which it reproduced? I don't think so. Barthes as the *character* "Spectator/son," however, was most certainly unaware in these respects, for he approached his reflections on photography from "the situation of a naive man, outside culture, someone untutored who would be constantly astonished by photography."[25]

Barthes thus establishes this astonishment as the characteristically uncritical mode through which everyday people (i.e., the naive man) interact with photographs. In this way, the Spectator position he embodies is not outside or immune to *socialization*, but rather "outside culture" in the sense that he is outside/without the critical acumen possessed by cultural theorists such as Roland Barthes. For example, as Olin points out, "the rhetorical analyst Barthes, of an earlier moment, would have unmasked his comments about [James Van Der Zee's portrait of an African American family] as an example of mythological thinking; the earlier Barthes, however, wrote essays."[26] The Barthes of *Camera Lucida*, however, is first and foremost a naive man, a Spectator/son, a body upon which photography does its most basic, essential, but nonetheless astonishing work.

Significantly, however, none but the image that Barthes refuses to reproduce astonishes him in its entirety. None but the Winter Garden photograph of his mother as a young girl pierces from all its points, pierces as a whole. For the Spectator/son, the difference between the photograph of the mother and photographs of social and identified/identifying *others* is, I argue, the difference between *punctum* (that thing in a photograph which "pierces") and the *studium* ("good historical scenes").[27] It is this difference that in fact *generates* the feeling and felt disparities between what wounds the Spectator/son *as punctum* and what populates his visual and identificatory image field as background, as picture(d) contexts, as *studium*. He establishes the photograph's two affective and differentially affecting modes thus, treating the *punctum* first:

[There is] this element which rises from the scene, shoots out of it like an arrow, and pierces me. A Latin word exists to designate this wound, this prick, this mark made by a pointed instrument: the word suits me all the better in that it also refers to the notion of punctuation, and because the photographs I am speaking of are in effect punctuated, sometimes even speckled with these sensitive points; precisely, these marks, these wounds are so many *points* . . . I shall therefore call [it] *punctum;* for *punctum* is also: sting, speck, cut, little hole—and also a cast of the dice. A photograph's *punctum* is that accident which pricks me (but also bruises me, is poignant to me) . . .

Even among those [photographs] which have some existence in my eyes, most provoke only a general and, so to speak, *polite* interest: they have no *puntum* in them: they are invested with no more than *studium*. The *studium* is that very wide field of unconcerned desire, of various interest, of inconsequential taste: *I like/I don't like*. The *studium* is of the order of *liking*, not of *loving;* it mobilizes a half desire, a demi-volition; it is the same sort of vague, slippery irresponsible interest one takes in the people, the entertainments, the books, the clothes one finds "all right." (26–27)

Of that group of photographs in *Camera Lucida* that represent *studium*—those that are "of the order of *liking*, not *loving*"—portraits of marginalized subjects do indeed, as Olin observes, comprise a large number. The narrator takes (no more than) a "polite interest" in these images, the particular subjects of which are soldiers and nuns in the context of "a rebellion in Nicaragua"; a Nicaraguan child's corpse surrounded by parents and friends; Russians in Moscow on May Day 1959; "William Casby, Born a Slave"; Sander's "Notary," whose face belonged to those "'faces of the period' [that] did not correspond to the aesthetic of the Nazi race"; an African American family; children smiling in Little Italy, New York, one with a toy gun held to his head; a violinist in a "straggling village" in Hungary; "Idiot Children in an Institution" in New Jersey; Italian colonial hero Savorgnan de Brazza, flanked by two young black men in (apparently) naval attire, and civil rights activist A. Philip Randolph.

The Spectator-theorist "without culture" ostensibly includes these portraits because they are examples of *studium*, images that show something

of "general historical interest," but that nevertheless catch his eye enough for them to "exist" for him, unlike the thousands of other photographs that bombard his vision, but with which he does not interface. Despite their existence as *studium,* however, some of these images contain within them a specific detail that, when engaged, is particularly affecting, metonymic, leading (him) elsewhere. His brief meditations on such photographs call this thing the *punctum.* The first *punctum* of the text he finds in a portrait by James Van Der Zee. This portrait, this "spectacle [which] interests [him] but does not prick [him]," "utters respectability, family life, conformism, Sunday best, an effort of social advancement in order to assume the White Man's attributes (an effort touching by reason of its naiveté)" (43). Within the spectacle, a young woman's shoes—her "strapped pumps"—at first constitute the *punctum* that leads him elsewhere: ten pages later, after the *punctum* has "worked within" him, he realizes that the "real *punctum*" is the necklace around that same woman's neck, the "same necklace which [he] had seen worn by someone in [his] own family, and which, once she died, remained shut up in a family box of old jewelry" (53).

The "real *punctum*" in this "moving" photograph of an African American family is that thing which leads the Spectator back to feelings of tenderness for an aunt who "never married, [who] lived with her mother as an old maid," whose "dreary life" saddened him whenever he thought of it (ibid.). The "real *punctum*" is that thing which leads him back to his own family's aspirations to a bourgeois lifestyle, aspirations "touching by reason of [their] naiveté" (43), for Barthes's childhood was an economically impoverished one.[28] The *punctum* is thus that thing which transports him back to himself, carries him through feeling to some originary space, a space where identification is or was born. That Barthes, as a gay man, would have felt an identification with his unmarried aunt based on their mutual exclusion from the sexual reproduction of the family is perhaps the pricking detail that gives shape to this particular *punctum.*

Continuing to establish the originary, identificatory material of the *punctum,* Barthes writes that "the *punctum* shows no preference for morality or good taste: the *punctum* can be ill-bred" (ibid.). In William Klein's photograph of children in Little Italy, "one child's bad teeth" (45) constitute this "ill-bred" *punctum.* As a sign of ill-*breeding,* a marker of a materially deprived existence, this child's "bad teeth" must recall the Spectator's own deprived childhood. The *punctum* here is indeed something that is in the picture, but which he also brings to it in the way of unconscious iden-

tification with the fear/shame of that *in him* that is "ill-bred." He writes none of this, however, nothing beyond his point that the *punctum* may originate from suspect sources.

The *punctum's* suspect sources can also be suspect by way of their "ill-bred" politics, however. Similar to the patronizing, superior gaze referenced by the first *punctum* in Van Der Zee's portrait—the woman's strapped pumps—the "ill-bred" fascination and abjecting gaze with which Barthes, as a Spectator/son guided by a "common" sense, takes in Little Italy's underprivileged children is a gaze bred in culture, in ethnic chauvinism, classism, and racism. The collection of images to which Van Der Zee's and Klein's photographs belong indeed exemplify "nothing more" than *studium,* but the Spectator nevertheless feels something, is made *into* some *thing,* in and through his relationship with them. Later in the text he writes, "I feel that the photograph creates my body or mortifies it, according to its caprice" (11), Thus feeling another case of mere *studium* in Kertesz's 1921 portrait "The Violinist's Tune," he writes "I recognize, *with my whole body,* the struggling villages I passed through on my long-ago travels in Hungary and Rumania" (49; emphasis added).

The Spectator/son's realization of his own body, of himself *as* a body in relation to the differentiating body of photography, is perhaps never so evident as it is in his treatment of Richard Avedon's 1963 photograph titled "William Casby, Born in Slavery." On first mention of this image, Barthes writes only that "the image of slavery is here laid bare: the mask is the meaning, insofar as it is absolutely pure (as it was in the ancient theater)" (34). He then reproduces the photograph on the following page with no further commentary on it until more than forty pages later, when its effects on the theorizing Spectator rise to feeling and legibility. The Casby portrait testifies to the historical fact of slavery. It testifies in its manifest content *as a photograph,* without mediation, and—as Barthes writes—without method. The photograph, as would-be testimony to a violent history, nevertheless takes history out of the relationship between its own skin and the skin of William Casby. In titling the portrait, Avedon asserted that William Casby was "Born in Slavery," but the theorizing Spectator who knows photography by feeling its work *on the body,* feels/knows that its masking material takes *slavery as history, race as institution and science,* out of the image's name. *Camera Lucida* announces the same essential equivalence between William Casby's (non)being and slavery that the image's revised title declares: William Casby was simply, and as definitively

as the photograph works, "Born a Slave" (35):[29] "[T]he essence of slavery is here laid bare: the mask is the meaning, insofar as it is absolutely pure." The photograph's pure production of "flat death" and "Total-image" thus recalls and reproduces the skinning/masking that Fanon named—and that the Spectator feels—as the work of race. As a narrating character in a story about photography's work, the Spectator/son is touched by the intruding spectral appearance of Casby's image in his theoretical frame of photographic visuality: he returns to it, textually, long after its flat death appears an an image.[30] The larger work of *Camera Lucida* thereby suggests, with the help of its "other" "Total-image(s)," that race and the photographic are essentially, mutually co-constitutive, coproductive, and *reproductive.*[31]

The Photograph's Conceptions: Race, Death, and the (Absent) Maternal

Reading *Camera Lucida* from the perspective of the naive man, the observation that "death is the *eidos* of the photograph" indeed takes on a racial meaning, projects a racial knowledge (15). This knowledge is performed alongside an essential, intricate connection to the felt and parallel knowledge that the photograph shares something with the maternal, that the maternal is indeed photographic. The visual technologies of race are photographic, as well. In a photograph, the referent adheres: an object sticks to film. In a racialized vision, the referent also adheres: the object-not-person sticks to skin, bone, and sinew. The thing in each is there, and what is there is a thing. In this way, the truth-effects and the death-effects of race and photography have historically compounded one another. The flattening of the subjectivity of "criminal types" in the racist classificatory systems of Francis Galton, Cesare Lombroso, and Alphonse Bertillon in the late nineteenth and early twentieth centuries is just one salient example of how this double death has historically been put to work.[32] Still, the truth- and death-effects of photography and race are not static, absolute, or permanent. Barthes writes that "there is that something in every photograph: the *return* of the dead,"[33] and, sardonically referring to the role of photography in reinforcing biologistic notions of race, that "photography is an uncertain art, as would be (if one were to attempt to establish such a thing) a science of desirable or detestable bodies."[34]

Barthes's comparison of photography to a "science of desirable or de-

testable bodies" is but one of many clues that *Camera Lucida* was as en-
gaged with images as hosts for ideology as was the author's earlier and
more explicitly political *Mythologies*.[35] Even without any overt discussion
of the institutional power hidden in second-order significations, the visual
narrative of *Camera Lucida* marks profound social implications of appar-
ently private and individual acts of looking. On the surface, it reflects and
theorizes specifically through and around the "only photograph which
assuredly existed for [Barthes]"[36]—the infamous Winter Garden photo-
graph of his then deceased mother, taken when she was a young girl.[37] In
its visual etchings *around* this photograph, however, the text traces those
figural and ephemeral excesses within and beyond seemingly individual
image-frames that inform *the photographic*. Deciphering these etchings
reveals that the abjections of race and death appear somehow essentially
connected to, if not constitutive of, maternal space, maternal vision(s).
These unwritten but nevertheless *performed* abjections appear, also, to be
constitutive of Barthes's narrative of photography itself. Indeed, there is a
great deal more informing these *Reflections on Photography* than is articu-
lated in their word-text, much in addition to and beyond Barthes's own
re-membered, but invisible, mother that is moving and touching.

Perhaps it is the temporal proximity of Barthes's mother's death to
the production of *Camera Lucida* that has lent so heavily to critics' read-
ing of it as a performance or reflection of his personal mourning process.
Henriette Barthes did in fact die in 1977, just two years before Roland
wrote *Camera Lucida*.[38] In one way or another, extended engagements
with the text frequently take for granted its fidelity to the "real" feelings
Barthes experienced in the wake of losing his mother. It is as if the mater-
nal material that Barthes names the origin of his theory of photography
is so universally close that it precludes a critical distance *from* his theory
enough to entertain its performativity.[39] In this way, invocations of *Camera
Lucida* appear to follow the logic of transparency that obtains in the
photographic, suggesting that this logic often also obtains wherever and
whenever the context is maternal. This logic proceeds: if something is (in)
a photograph, it is or has been real. Analogously, modern constructions of
maternal sentiment—meaning how the ideal mother feels and, especially,
how we have been taught to feel about the ideal mother—make the ma-
ternal presence *itself* an apparent locus of the real, yet another mirror of
and repository for the natural, for what simply *is*. That the ideal maternal
connotes a fidelity to nature, that it allows and invites transparency, that it

does not host untruths—especially with regard to *feeling*—makes it diffi-
cult, even for critical theorists, to imagine that there was more to Barthes's
discussion of the mother, and of the photographic, than he made clear in
Camera Lucida.

There is plenty in *Camera Lucida,* as well as in all published accounts
of Barthes's relationship with his mother, to establish that her death did in
fact (perhaps of course) pain him greatly. Marking the importance of this
loss to Barthes, Louis-Jean Calvet's biography titles the section of his book
that narrates this loss "The First Death."[40] It follows that *Camera Lucida's*
first-person ruminations on death and "my mother" index genuine grief,
that they evidence real mourning. Barthes's loss was unquestionably *real,*
but/and he performed his recuperation from it through reconceiving the
referential technologies of photography, the deathly flat emergence of pho-
tography's quintessential subjects: race and the maternal.

What Barthes as Spectator/son does not show but nevertheless dis-
cusses at length as the fundamental inspiration for the text's photographic
vision/theory—the Mother—works in essential relationship to that which
is shown but to which he *appears* largely indifferent: bodies of *studium,*
many of which society has established are "detestable" by virtue of their
race, ethnicity, class, and/or (dis)ability. All but three of the photographs
in *Camera Lucida* are *of* bodies. Save for the overtly domestically themed
"Polaroid of an Empty Room" (Daniel Boudinet, 1979), a Charles Clifford's
"Alhambra" house in Granada (1854–56), and Niepce's 1823 "The Dinner
Table," the book's photographic targets are bone, flesh, and skin in distinct,
distant, and varied settings. The truly beloved body, however, never appears
within the text's frame. Performing the affective experiences of Spectator
and son, Barthes eventually arrives at and articulates the imperative of this
absence, but only after he engages with those imminently visible bodies,
those abject shadows that pre-face the maternal.

In part 2 of *Camera Lucida,* Barthes turns his "knowing body" from
photographs that, as a "naïve man," have no real effect upon him to con-
sider what is ultimately "the only photograph which assuredly existed for
[him]."[41] He remains in this space for the duration of the text, at a pierc-
ing point that is, in fact, the *punctum* of his entire theory of photography:
an image-idea in the field of images that is much too precious to be seen,
whose very sighting/siting within a photographic field threatens its exis-
tence.[42] The Spectator/son's narratorial voice is henceforth raw, desperate,
defensive, poetic—indeed, open and wounded. His words work against

the fixing of *his* mother within any general maternal or photographic frame. As he struggles to assimilate the real and moving fact of her death, he does not, will not, risk for her (or himself) the flat death that invariably attends the photographic:

> I cannot reproduce the Winter Garden Photograph. It exists only for me. For you, it would be nothing but an indifferent picture, one of the thousand manifestations of the "ordinary"; it cannot in any way constitute the visible object of a science; it cannot establish an objectivity, in the positive sense of the term; at most I would interest your *studium:* period, clothes, photogeny; but in it, for you, no wound.[43]

The Spectator/son thus secures his beloved outside the bounds of photographic and generic maternal visions: from her space outside the visual frame, as an unreproduced image of herself long before her body signified either reproduction *or* annihilation—the Winter Garden picture shows her as a little girl, *pre-maternal*—she radiates essential knowledge about the reproductive and annihilating power of language and image. Indeed, she is his unthreatening, female child.[44] Thus idealized, thus unshown, thus unspeaking ("she never made a single observation"),[45] she is extracted from the image-idea of the abject and castrating mother. She remains with him in what Julia Kristeva terms the *chora,* the womb-space that precedes language, the time-space before maternal-child separation, inside a home absent of "observation," naming and fixing. Because the abject maternal, as death threat, is photographic, the Spectator/son protects the image-idea of *his* mother by keeping her maternal body outside of any photographic frame. Subjected to a photograph, the purity of his maternal experience would be corrupted. Were he to fix her in the reader's view, the undifferentiated space of him/her would be obliterated. She must not appear.

Within this context, the unreproduced image of Barthes's mother brings to light the fact that invisible, not immediately evident, material structures visuality. That this invisible object, this particular beloved object—the remembered and idealized, but never "shown" mother—inspires a (theory of photographic) seeing lends credence to Avery Gordon's assertion that "haunting is a social force."[46] However, what haunts Barthes's text is not only his deceased mother, but the *racialized and classed social death* that make the "detestable bodies" imaged in *Camera Lucida* the marginal but

constitutive material of the ideal maternal body. In this respect, Barthes's *Reflections on Photography* are valuable far beyond treatments of "just" the photographic and, even, far beyond treatments of mourning and maternal loss. Indeed, they index—even if they do not define or explicate—the shared ideologies and *visual logics* of race, death, and the maternal.

Commemorating Whiteness

The Ghost of Diana in the U.S. Popular Press

Above all, we give thanks for the life of a woman I am so proud to be able to call my sister: the unique, the complex, the extraordinary and irreplaceable Diana, whose beauty, both internal and external, will never be extinguished from our minds.

—Earl Spencer, eulogy for Princess Diana

What the memory repudiates controls the human being.

—James Baldwin, *The Evidence of Things Not Seen*

IMMEDIATELY FOLLOWING THE AUTOMOBILE ACCIDENT that caused the death of both Diana Spencer and Dodi Al-Fayed on August 31, 1997, newspaper headlines around the globe began announcing a "World in Grief" over the loss of "The People's Princess." Television, radio, and print media everywhere crowned her the "Queen of Our Hearts," while Internet pathways saw "Tears Flow Across Nations,"[1] symbolizing a universal human connection inspired by our "Guardian Angel" and her "Legend of Love."[2] The media event of her funeral attracted an estimated 1 billion viewers worldwide, not including the thousands who actually gathered to watch the procession.[3] As part of the ceremony, singer-songwriter Elton John performed "Candle in the Wind '97," a version of the song he had written in memory of Marilyn Monroe in 1973, and reworked with Bernie Taupin. The lyrics that once lamented the death of "Norma Jean" now expressed a painful good-bye to "England's Rose," memorializing her as "the grace that placed itself / where lives were torn apart." During the first week after its release, the single sold a record-setting 3.4 million copies in the U.S. alone.[4]

At each anniversary of Diana's death, the media and consumer frenzy over her has been reinvigorated, with newspapers, magazines, and television specials reminding us, again, to remember "Our Princess" always.[5] Official commemorative plates and dolls and books that began circulating almost immediately after her death remain popular aids in immortalizing the woman "whose beauty will never be extinguished from our minds."[6] In contrast to this beauty—which popular cultural texts devoted to commemorating and commodifying "The Princess" *ensure* will never be extinguished from our minds—is the repudiated material of other "nonspectacular" lives and deaths, material that, as the epigraph from James Baldwin above asserts, ultimately "controls the human being."[7] Indeed, it is this material that forms the backdrop to the seemingly perpetual resurrections, in visual and print media, of Diana as the "Queen of Our Hearts."

Invoking the tropes of charity, sympathy, and motherhood, "official" and immediately "commemorative" images of Diana that appeared after her death in U.S. popular magazines such as *People* and *Life* performed and reproduced *racialized* scripts of family, femininity, and, interestingly—given her British nationality and royal status—an "American" national memory that demarcated the relative social value(s) of lives and deaths. The continuing spectacle surrounding Diana's death remains neither an unmediated popular tribute to the "People's Princess" nor simply a universal capitalist media event, but rather part of larger discourses that shape memory in the name of constructing memorializable subjects over and against raced, classed, gendered, and sexualized others.

While the meaning of Diana and the spectacle of her death are subjects of great contestation,[8] the inscribed meanings within certain widely circulated visual texts clearly figure here into a sign of domesticity and sentiment upon and through which heteronormativity has been historically (re)produced. Images of Diana published in "official" texts of immediate commemoration such as *Life*'s "Collector's Edition,"[9] and *People Weekly*'s "Commemorative Edition"—both published less than one month after Diana's death—are a small sample of the millions of objects that meant to immortalize the sentimental nature and global reach of her maternal "Magic Touch."[10] While there now exist perhaps enough critical treatments of "The Princess" and her global representations to constitute a whole field of "Diana studies,"[11] the particular histories of both *Life* and *People* as self-appointed narrators of American identity make these two

particular editions timelessly important sites within which to examine the relationship between the spectacle of her death and those discursive structures called upon, immediately, to commodify a U.S.-authored memory of her as "*Our* Princess."[12] If indeed, as her brother Earl Spencer's eulogy predicted, her "beauty will never be extinguished from our minds," then we must work to decode those racialized visual technologies that worked immediately to transnationalize and immortalize this "beauty."[13]

The "Collector's Edition" of *Life,* published in November 1997 and subtitled "The Week the World Wept: The Final Journeys of Mother Teresa and Princess Di," repeats the discursive techniques that were deployed in all forms of international media to link the lives of Diana Spencer and Mother Teresa at the moment of each one's death.[14] Read closely, these discourses established much more than these women's shared life commitment to acts of charity and their concurrent untimely passings. Spoken through the narrative framing and syntax of these images is a narrative of race and class that links American memorializations of Diana and Mother Teresa in a relationship of *difference.* Ultimately, while both are represented as self-sacrificing, loving, and nurturing mothers, Mother Teresa herself emerges (ironically) from these representations as lacking the characteristics of "true" womanhood and motherhood, for she has neither a husband nor children, and because she cannot perform a salable femininity.[15]

Even as they coded these differences, U.S. popular media exploited the temporal proximity of the death of Diana and that of Mother Teresa to suture these two passings, and to associate Diana all the more with the self-sacrificing and angelic nature for which Mother Teresa was honored.[16] The text of the section of *Life* titled "Farewell to a Princess, and to an Angel," begins: "Death is among the most compelling arguments for ritual."[17] This statement thus establishes the context for the ritual that follows, which is one that discursively links the "Princess of Our Hearts" (Diana) to the "Angel of Mercy" (Mother Teresa). The text goes on to assert that while "[l]ife seldom linked Mother Teresa, 87, and Princess Diana, 36, . . . an accident of timing links them in death. Rarely had the founder of the Missionaries of Charity seemed so much a celebrity, or the Princess of Wales so saintly. Comparisons that would otherwise never have occurred suddenly felt inevitable."[18] The "inevitable" comparison thus begins with a close-up image of Diana's closed coffin placed directly adjacent to, but separated from (with a thin, horizontal, white line), a long-shot image of Mother Teresa's body placed in an open casket.

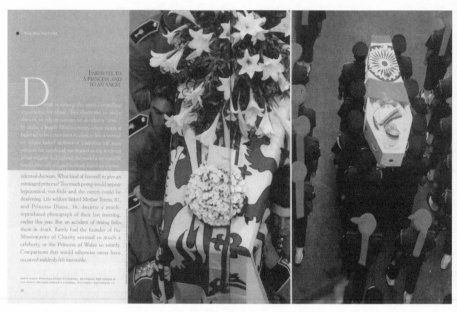

Diana's coffin emerges and Mother Teresa's recedes. Life, *Collector's Edition, November 1997.*

In this first photographic spread, Diana's coffin is elevated by a group of male pallbearers and elaborately adorned with flowers and a small card that reads "Mummy," explicitly referring to Diana as "Mother" or "Mommy," but connoting also, a sort of *preservation.* The pallbearers, three of whose faces are visible, appear to be carrying the coffin that holds Diana out toward the viewer. The brightness of the image and the life connoted by the flowers that appear to be blooming out and beyond it suggest an emergence, a continuing beyond both the frame of the image and the "inevitable" fact of death that is its context. This emergence is further facilitated by a reversal in the point of view of the image of Mother Teresa's body that is placed directly adjacent and to the right of that of Diana's coffin. In this juxtaposing image, which is shot from a longer range, the finality of Mother Teresa's death is conveyed and reinforced not only by the appearance of her corpse, clad simply in a white nun's uniform, but also by the facelessness and lifelessness connoted by the pallbearers who are dressed in black and wearing black hats, carrying the body away from the viewer.

While both images are of funerals, and, more specifically, of coffins, the

inevitability or finality of death that this "Farewell" narrative uses to link the event of Diana's passing to that of Mother Teresa is ultimately associated with *only* Mother Teresa's death.[19] The contrasting elements of these two photos, "naturally" placed together because of their obviously common objects, produce a third effect, a meaning that is not produced by either image alone.[20] The depiction of Mother Teresa's corpse which appears to be moving away from the viewer, juxtaposed to Diana, as "Mummy," whose casket is being carried *toward* the viewer, contributes to this third effect, suggesting that indeed Mother Teresa has "passed" while Princess Diana continues on, beyond the frame of the image and beyond, also, the fact of death. For all their similarities—including their commitment to works of charity, their globally recognized generous hearts, their untimely deaths— the *difference* between the two women is marked with the appearance and/ or absence of certain faces, bodies, and colors. This difference, as the im- ages that follow convey, is both classed and racialized, and, in the end, it is what determines which angel gets to be commemorated as a ghost.[21]

The remainder of the "Farewell" in *Life*'s "Collector's Edition" con- tains more photographs of the funeral processions, as well as images of the homes, burial sites, mourners, and "family" of each. Pairs of images, like the first one of the coffins, compose the rest of the inevitable narra- tive, and are placed adjacent to one another, each set (of two) compos- ing a two-page spread that (re)produces the third effect established in the first images of the caskets. These successive spreads (six in total) are also linked discursively by the apparent similarity of the objects represented and anchored by the written text that appears, in each case, to the left of the photographs.

A pair of images depicting and contrasting the survivors of Diana's and Mother Teresa's deaths includes a small, colorful photo of just the royal male mourners of Diana: "Diana's brother, Earl Spencer; Princes William, Harry and Charles."[22] Directly to the right, "Mother Teresa lies in state," her corpse foregrounded in a large, borderless image whose shadowed background includes many nameless nuns.[23] Her spiritual sisters, in con- trast to the male members of Diana's family depicted in the adjacent photo, are related visually, textually to Mother Teresa only by the uniforms they wear, each identical to the next and identical, as well, to that which adorns the corpse. The corpse itself is accentuated by the contrast of light shone on it against the darkness that comprises the rest of the image, enveloping its other "objects."

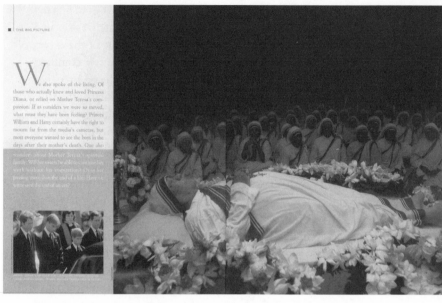

Diana's male mourners juxtaposed with Mother Teresa and her shadowed sisters. Life,
Collector's Edition, November 1997.

The contrasting elements of these images, placed together, attribute a
white heteronormativity to the womanhood that Diana represents. The
mourners depicted possess distinct identities—as brother, son(s), and
ex-husband—in heteronormative familial relation to Diana.[24] Her value
and memory as sister/mother/wife will unquestionably be carried and
(re)produced through and *because of* these relations. In contradistinction,
Mother Teresa has only a "spiritual family,"[25] all the members of which are
gendered female but desexualized. Their heads are covered with habits,
their faces are shadowed, and their bodies appear to be fading, blend-
ing into the black of the image's background. The "inevitable" fact of
Mother Teresa's death is thus, again, established against the life-carried-
on—through the relations that characterize a model femininity—of The
Princess.

The pair of images that follows consist of a wide-angle black-and-white
shot of a group of individuals lining a sidewalk of a street in Calcutta,
"waiting to view Mother Teresa's body."[26] Foregrounded in the image is a

row of preadolescent girls, all adorned exactly alike in flower-print dresses. This image is placed directly atop a wide-angle full-color shot of a "floral tribute to Diana,"[27] which, besides flowers, includes many handwritten notes, candles, and other small offerings to the princess. The written text to the left of these images establishes flowers as a linking theme:

> Flower petals rained from windows above Calcutta, and a portrait of Mother Teresa was drawn on the ground with white blossoms. London florists reported a shortage as mourners left a million bouquets for Diana. Flowers offer a way of bidding farewell that is eloquent in its brevity. As far back as the Neanderthal era, flowers were left for the dead. Flowers remind us of two truths: Life is fragile and withers sooner than anyone would like: but even in tragedy, a trace of beauty remains.[28]

In this manner, the flower-print cloth covering the bodies of the young girls "waiting to view Mother Teresa's Body" is likened to those brilliantly composing a "floral tribute to Diana."[29] The repetition of imaged objects used to link the deaths and processes of mourning the two women serves, also, to diminish the personhood of the girls in the top photo. The black-and-white film, the lack of "real" flowers in the image, and the absence of any written trace or good-bye such as those that appear in Diana's tribute all work together to suggest that these young girls are *themselves,* like Mother Teresa, "flowers . . . left for (the) dead." In contradistinction, the image and caption of the colorful flowers left in honor of Diana make no mention of her body or corpse. Rather, the handwritten notes left among the full-color flowers address Diana by name, re-membering her alive, and back into *life* through "trace(s) of beauty" that the black-and-white image of Mother Teresa's mourners cannot capture.

The most obvious way in which Diana is made to embody ideology is through her own coded corporeality, through and with her own racialized (white), classed (aristocratic), and gendered (woman) body.[30] With the dominant media's posthumous imaging of Diana into an angel watching over us, however, Diana's own physicality is resurrected into a different meaning, into a performance of ideology whose staging and reception was specific to the historical moment of her passing. In her cogent analysis of the "postmodern condition" of the family, Judith Stacey described this moment as one in which "rampant nostalgia for

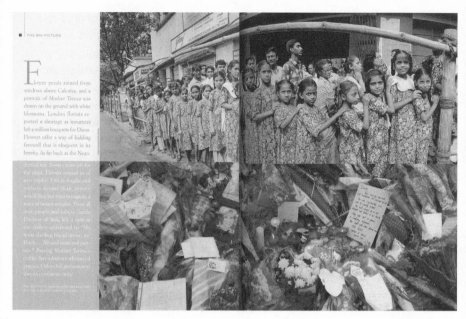

Black-and-white flower-print dresses above a full-color floral tribute to Diana. Life, Collector's Edition, November 1997.

the modern family system . . . has become an increasingly potent ideological force."[31] The effects over the last half of the twentieth century of postindustrial social and economic transformations upon the "modern family regime" rendered the patriarchal conjugal institution a thing of the past, even for members of the white "mainstream" who had historically constituted its ideal subjects. The social and cultural flux produced by global capitalist practices so disrupted the patterns and revealed the contradictions of the modern family that relationships of work and sexuality were no longer governed by, or perceived to be in the control of, a "male breadwinner." Stacey points out that in 1996, the Bureau of Labor Statistics documented that "more than three-fifths of married women with dependent children were in the labor force, as well as a majority of mothers of infants, while there are more than twice as many single-mother families as married, homemaker-mom families."[32] The extremity of these structural transformations with regard to "middle-American" relationships of work and family is apparent when we consider that in

1950, three-fifths of U.S. households consisted of a working male and a female homemaker.[33]

The "predicament" of the family that attends such drastic restructuring produced an anxiety on which conservative politics continues to capitalize. Rather than attribute national conditions of economic and social strife to an increasingly unequal distribution and unpredictable movement of capital, political leaders invoke "family-values" rhetoric to assess these problems as a breakdown of an otherwise historically moral and efficient institution. This discourse obscures the fact that the modern family—as an offspring of imperialism—was always an institution structured by and productive of inequalities based on gender, race, and class.

The rhetoric of "family values" hatefully indicts queer and female-led households, as well as those of single mothers, and its particularly racialized aspects—evident as early as the mid-1960s in the infamous Moynihan Report—are used increasingly in popular, legal, and political discourse to blame the disenfranchised for the postindustrial problems of unemployment, poverty, and crime.[34] The "rampant nostalgia" for the modern family regime that Stacey identifies as part of the postmodern condition manifests itself not only in the conservative imagining and attacking of "gays," "matriarchs," and "welfare queens," but in popular cultural depictions of, and instructions toward, a "legitimate" heterosexual and properly procreating womanhood and motherhood. While Diana's lifestyle was a far cry from traditional images of white middle-classness, her posthumous representations in U.S. popular cultural texts as "Our Princess" beg the question of what ideologies have historically constituted and supported her "rule" over a postrevolutionary "democratic" American popular culture.[35]

Monumental Material: Discourses of Domesticity and the "Culture of Sentiment"

While the meaning of Diana is indeed not fixed, and while various and conflicting discourses work to construct this meaning, modern notions of the family (however they are interpreted or subverted through the reception of certain images of Diana) appear as consistent ideological frames to her representations in popular visual culture. Within the United States, representations of Diana as the "Princess of the People," as a woman just like every other woman, depend on the depiction of Diana performing

a middle-class femininity of the sort practiced in "democratic" national contexts.

The idea that Diana popularized royalty by bringing it (herself) to "the people" suggests a disruption of class-based hierarchies, but this perception runs the risk of foreclosing an understanding of how popularized royalty, in the U.S. context, signifies white, middle-class domination. Indeed, in a nation where the ruling or otherwise "royal" class *is* the middle-class, representations of Diana as a beautiful and white "everywoman" depend for their construction on historically oppressive, bourgeois ideologies of femininity and family.

In *White, Male, and Middle Class,* Catherine Hall examines the nature of the historic lure of bourgeois ideologies of the family, providing a way in which we might interpret the construction and "universal" popular appeal of certain immediately posthumous representations of Diana as a figure of familial morality.[36] Her discussion of the "Early Formation of Victorian Domestic Ideology" traces the cultural mechanisms through which the ideologies of the family and domesticity came to obscure class relations, locating their historical origins in the mid-nineteenth century.[37] During the early 1800s, an evangelical religious movement began in England as an attempt to negotiate the tensions wrought by the economic structural transformations from mercantilism to industrialism, and, more specifically, to curb the "moral" threat posed by these rapid and drastic changes. The recent French Revolution had exacerbated this threat, as it produced debates concerning the role of women, as well as the conditions and rights of the working classes in all of Europe. Within this context, evangelicals began chastising the aristocratic ideals of family, woman, and motherhood, whose focus on gentility curtailed women's active exercise of their "natural" moral powers and virtues toward educating their families and nation away from "sin." The leading men of the movement therefore established the role of women as the "moral regenerators of the nation."[38] Women were to "demonstrate by example"[39] moral virtues, to teach these virtues to the rest of their family, and to take them outside of their domestic sphere and exercise them through acts of charity. This national spiritual "replenishing," which began, nominally, as a strictly religious movement was, by the 1830s and 1840s, productively appropriated to more specifically capitalist ideologies and needs. The transformations of gender roles that had been encouraged in the name of God thus solidified under the guise

and structure of middle-class identity formation, themselves becoming sites and units of commercial (re)production.

Influenced by this identity formation was the nineteenth-century American "Culture of Sentiment." Shirley Samuels discusses sentimentality in this era as a project that was about "imagining the nation's bodies and the national body."[40] Attempting to deal with the question of how "relations of sympathy are connected to relations of power," theorists of the Culture of Sentiment suggest that the cult of domesticity and notions of white, middle-class femininity that arose in this period were able to find a type of productive expression in the American domestic literary realm that was impossible in any other sphere. Laura Wexler differentiates the "expansive, imperial project of sentimentalism" from the cult of domesticity by pointing out that sentimentalism was "an *externalized* aggression that was sadistic, not masochistic, in flavor."[41]

While discourses of domesticity served to socialize the white middle-class to an ideal (re)productive norm, sentimentalism was a project based on difference and aimed toward differentiation. Wexler writes that

> the energies [sentimentalism] developed were intended as a tool for the control of others, not merely as aid in the conquest of the self. This element of the enterprise was not oriented toward white, middle-class readers and their fictional alter egos at all ... Rather, it aimed at the subjection of different classes and even races who were compelled to play not the leading roles but the human scenery before which the melodrama of middle-class redemption could be enacted, for the enlightenment of an audience that was not even themselves.[42]

Reading photographic representations of Native American objects of educational reform during the late 1880s, Wexler analyzes the complexity of the violence perpetrated against them, pointing out the ways in which the indoctrination of sentimentalism among, primarily, white, middle-class women institutionalized white racial domination. Sentimental projects demanded, first and foremost, a white racial consciousness that took for granted European superiority and privilege, and assumed an ability to redeem "others." Members of the national body were thus distinguished from nonmembers according to their ability to execute and identify with sentimental projects. As objects of reform and "liberation," people of color were

automatically excluded from this execution and identification: they were intended to participate, as Wexler writes, only as the "human scenery before which the melodrama of middle-class redemption could be enacted."[43] In this way, sentimentalism—in its objectification of all nonwhites—was a racialized, externalized elaboration of the cult of domesticity, the oppressed subjects of which have historically been identified as white, middle-class women themselves.[44]

The circumstances out of which the nineteenth-century Culture of Sentiment arose were specific to the national identity and moral crises of that period. The Culture assumed its forms according to developments occurring in literary, anthropological, and other institutional spheres. When the sentimental literary movement began to lose its momentum, the socializing work of othering continued in photographic representations of "successful" educational campaigns. Certain "before" and "after" shots of objects of reform were sent to potential benefactors of "Indian schools," in addition to being sold as stereographic slide collections used for popular and family entertainment.[45] The commercial and the sentimental thus existed in a successfully (co)productive relationship. The imagining (and imaging) of these objects was profitable not only in terms of the justification that such othering provided for imperial violence, but also because evidence of nonwhite inferiority *sold*. The production and consumption of such images were ensured through white people's seeking of their own salvation from what they defined as the more primitive stages of humanity, as well as from the racial crimes they had committed to compose the "human scenery" against which they imagined themselves superior. Examining the structures of sentimentality incorporated in images of Diana illumines how, just as it did in the nineteenth century, the Culture of Sentiment still works as a privileged, racialized discourse that prioritizes white self-making in its globally hypervisible performances of charity.

The ways in which cultural and racial inferiority is invoked as "human scenery" in the late twentieth and early twenty-first centuries are, in certain frames, much less overt than they were during the advent of popular, racialized sentimentality in the nineteenth century. The advances toward social equality made during the civil rights era, the political mobilizations and cultural critiques advanced by underrepresented groups, and the institutionalization of multiculturalism—for all its problems—have done much to combat the violences of cultural chauvinism within the United States, but the violences of racialized benevolence continue to proliferate

nationally and globally. There is no dearth of sentimental discourses, visual or textual, in which benevolent whiteness is screened upon nonwhite bodies to produce racial superiority and to occlude obscene economic and social inequalities. Globalization and its attendant postmodern image cultures scatter the melodrama of white redemption and reification far and wide, situating power and humanity within a web of feeling whose ideological constitutions are difficult to untangle. Theorizations of the nineteenth-century Culture of Sentiment therefore remain indispensable as frameworks within which to illuminate its postmodern manifestations in popular culture.

Global Tears and Magic Touches: The *People*'s Diana

In the Commemorative Edition of *People Weekly* titled *The Diana Years*, Diana Spencer's life is narrated as a fairy tale, with certain recycled images packaged into sections whose titles include "Once Upon a Time," "Wales to Woe," and "Hands-on Mom," among others. The first section, titled "Farewell," tells us that "amid overwhelming shock and grief, the world paid a fittingly emotional and elegant tribute to the princess of its heart," and begins with an image of thousands of flower bouquets comprising a "Sea of Love" at the front gate of Kensington Palace followed by a photograph of pallbearers balancing the casket upon which the male survivors of Diana's family look from a shadowed distance.[46]

The image immediately following and opposing that of the casket is a small shot of the casket's centerpiece that holds a card that reads "Mummy."[47] Both the image and the long caption/narrative centered below it are backgrounded in black, producing a framing effect that both bounds the meaning of the image to the words that appear contained within it and allows the hugeness of the sense of loss (of a "Mummy") to continually expand *and* remain continuous. With this, it is presumably established that "the void left by the remarkable woman ... aptly anointed 'The People's Princess'"[48] encompasses all of the *feeling* world, where feeling itself—rather, the ability to feel—is based on an identification with the ideal picture of white femininity that Diana represents.

To the extent that the grief surrounding Diana's death can be understood as universal, it would appear that the rigid boundaries set in the nineteenth century between feeling subjects and objects of feeling have become considerably blurred.[49] Indeed, the observation—printed as the caption to

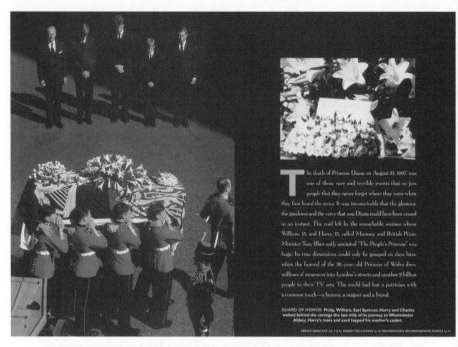

The death of Princess Diana on August 31, 1997, was one of those rare and terrible events that so jars people that they never forget where they were when they first heard the news. It was inconceivable that the glamour, the goodness and the verve that Diana could have been erased in an instant. The void left by the remarkable woman whom William, 15, and Harry, 12, called Mummy and British Prime Minister Tony Blair aptly anointed "The People's Princess" was huge. Its true dimensions could only be grasped six days later, when the funeral of the 36-year-old Princess of Wales drew millions of mourners into London's streets and another 2 billion people to their TV sets. The world had lost a patrician with a common touch—a beacon, a magnet and a friend.

GUARD OF HONOR Philip, William, Earl Spencer, Harry and Charles walked behind the cortege the last mile of its journey to Westminster Abbey; Harry's roses and card topped his mother's casket.

ADRIAN DENNIS/AP (pp. 4 & 7); ROBERT WALLIS/SABA (p. 4); REUTERS/CHRIS HELGREN/ARCHIVE PHOTOS (p. 7)

Diana's coffin hoisted and her male family members aligned. The card at right is addressed to Mummy. People Weekly: The Diana Years, *Commemorative Edition, 1997.*

an image titled "Universal Grief"—that "the people who jammed London's streets to honor Diana's memory traversed lines of age, race, sexual orientation and gender"[50] appears to grant the privilege of sentiment to everyone, equally. The privilege that is granted, however, is that of mourning an object of feeling (Diana) that is a representative of European imperial rule, and its more "domesticated" facets in the form of white, middle-class femininity, family, and nation.

According to this picture of "mourning," which includes a black woman crying, sharing grief in tears with three white women, every woman is entitled to mourn the passing of the most ideal performer of womanhood itself. That this performance is actually restricted by virtue of its distinctly raced and classed nature is a fact obscured by the media's inundating representations of a *universally* shared sense of loss. When we examine the image closely, however, there is an "other" black woman standing behind

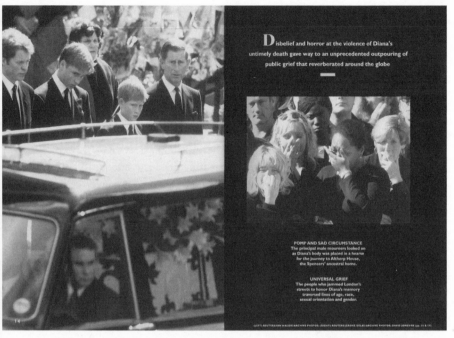

The hearse carrying Diana's body and a picture of "universal grief." People Weekly: The Diana Years, *Commemorative Edition, 1997.*

the four crying women—straight-faced like the white men flanking her, and therefore not performing grief in the normative "feminine" manner. Acknowledging her apparently different feeling, we grasp the possibility that Diana and her death produce contested meanings among the global population of women. Whether this particular woman's expression is one of sadness or anger, or some other feeling of distress, she clearly returns the gaze of the camera back to/at its point of view, compelling a reexamination of what would otherwise be a simple picture of women feeling, together, the loss of a shared heroine.

As it works around "Lady Di," sentimentalism does not appear as a hegemonic force as clearly as it did in the nineteenth century, because *she* herself is an object of feeling, and the feeling for her—as both a symbol of a fairy-tale life and a contested representative of feminism—offers a comfortably flexible screen for middle-class women's identification. At

the same time, the commemorative narratives published immediately after her death reined in even her tenuous feminism, and reinforced the rule of royal heteronormativity. Indeed, the majority of media projects labeled "official" or "commemorative" make little or no mention of Diana's involvement with Dodi Fayed, but rather focus on the narrative of the royal fairy tale of her marriage to and life with Prince Charles, however it was or was not realized. Consistently, commemorative representations of the courtship, the marriage, the divorce—and all of Diana's charitable activities throughout—constructed her upon her death as always pious and generous, nobly bearing whatever difficulties she encountered, from the royal family's shunning of her to her battle with anorexia. By telling us that the "Queen of Our Hearts" is to be remembered as a self-sacrificing human being, the popular media's representation of Diana upon her death attempted to ensure that she remain a model of selfless, maternal, and only *reproductively* sexual femininity.

A section from *People Weekly's The Diana Years* titled "Magic Touch" includes a series of photographs depicting Diana performing her duties as England's "Good Will Ambassador."[51] The image titled "Crusader" that shows her "magically touching" three young Angolan land-mine victims is especially powerful.

The caption to the photograph reads:

> During a January 1997, Red Cross mission to Angola, Diana visited a rehabilitation center to comfort victims of the nation's devastating 20-year civil war. "That was very traumatic, as a mother, to witness," she told the BBC, raising consciousness worldwide on land mines and propelling the signing of a 100-nation treaty outlawing their use.[52]

Thus, the written text tells us that the same maternal sensibility that made her a credible witness to these children's devastating experience makes the witnessing itself a traumatic experience for Diana. What the actual witnessing is that takes place is not explained in the text of story, but by virtue of her (posed) physical proximity to these black children—all of whom have been somehow physically injured by land-mine explosions—Diana becomes associated with, and herself a victim of, the same atrocities that these children experience. The fact that she was not, and never *had* to be, present for the actual traumatic moments in which these children were se-

CRUSADER During a January 1997, Red Cross mission to Angola, Diana visited a rehabilitation center to comfort victims of the nation's devastating 20-year civil war. "That was very traumatic, as a mother, to witness," she told the BBC, raising consciousness worldwide on land mines and propelling the signing of a 100-nation treaty outlawing their use.

139

Diana, a Crusader, with young land-mine victims in Angola. People Weekly: The Diana Years, *Commemorative Edition, 1997.*

verely wounded is not something that the image—along with the caption that anchors its meaning—encourages us to consider. Rather, the point of view from which this sentimental image is, itself, witnessed is one attended by the meaning of Diana as an angelic healer, whose limitless ability to feel is equal to the privileged power she has to "share" and comfort others through trauma.

What is also occluded by Diana's statement regarding what she witnessed and how is the fact that, despite her assumed ability to identify with

these Angolan children's pain "as a mother," she would never have had to deal with the continual threat that land mines would someday mutilate her own children's bodies. That the experience of motherhood—which bourgeois ideology would have us take to be universal—is itself racialized is a reality visually erased by Diana's "magic touch." She appears, in what is posed as an intimate moment, as a capable body, nurturing and completing these younger, darker, obviously less capable ones.[53] The absence of these children's own mothers is, in this context, conspicuous.

In her work *Scenes of Subjection*, Saidiya Hartman historicizes the type of racialized "violence of identification" enacted by Diana's empathy and perpetuated by the circulation of such images as those depicting her benevolent crusades.[54] Examining the relationship between violence and pleasure—which together, as Hartman observes, constituted *enjoyment* for those free subjects witnessing the "peculiar institution" of chattel slavery—she points out that the very act of witnessing and empathizing is a racialized privilege, as well as a racialized violence. Those who went so far as to imagine themselves in the position of slaves and to write and circulate such imaginings as abolitionist protest, "in making the other's suffering [their] own," occluded this suffering by obliterating the other.[55] Just as abolitionists such as John Rankin, by imagining himself and his family enslaved, began to "feel for himself rather than for those whom his exercise in imagination presumably [was] designed to reach," so do images of Diana, identifying "as a mother" with traumas affecting children of war-torn nations, effectively erase the historical material conditions that produce those traumas in the first place.[56]

The violence of identification that representations of Diana perform, however, goes beyond that of occluding the real suffering of victims of racial (domestic and international) warfare. To the same degree that the performance of bourgeois identity is commodified in images and objects representing Diana, so too is the obliteration from history of those "others" upon which the convergence of violence and pleasure produce enjoyment for those who consume these images and objects in the name of preserving Diana's "magic touch." What is apparently being bought and sold, then, as *only* material commemoration *of Diana* is *also*, in actuality, the erasure of the subjectivity of all those who are made to appear in need of this "magic touch." For instance, the centerpiece of the image of Diana in Angola, holding on her lap the young girl who has been dismembered by the land-mine explosion, illumines another aspect of what Hartman

observes with regard to the violence of identification, namely, that it is only the "white or near white body that makes the captive's suffering visible and discernible."[57]

Indeed, the suffering of these very same Angolan children was actually literally invisible to London's *Sunday Times* reporter Christina Lamb, who was "struck by how [Diana] never turned her head away from injuries so gruesome she herself could not look at them despite years of Third World reporting." Lamb wrote: "She had . . . a kind of aura that made people want to be with her and a completely natural straight-from-the-heart sense of how to bring hope to those who seemed to have little to live for."[58] More than willing to take in the beautiful, empathetic Diana but unable to bear witness to the "objects" of Diana's healing, Lamb's racialized selective vision stands as a vivid example of the "obliteration of the other." She judges—without seeing—the lives of nonwhite war victims as hopeless at the same time that she attributes a magical hope-granting empathy to the princess upon whom her gaze is apparently arrested. Bill Deedes, the editor of London's *Daily Telegraph,* was similarly moved by the "Angel of Mercy": he was struck by her "silent stillness, how good she was at hearing and dealing with grief, simply stretching out a hand to touch, applying her own brand of soothing tranquility."[59] The evacuation of land-mine victims' subjectivities—there is scarce, if any, news coverage of Diana's visit to Angola that provides the names of these persons—thus occurs again and again in the media's fascination with the princess's touch.

Even as the ghosting and commodification of Diana's "magic touch" appears to make problematically visible and discernible the suffering of "others," it effectively dilutes any sense of an urgent need for social change that images of Diana's benevolent acts might purport to convey. As they are recirculated and contextualized as part of "Our Angel's" legacy, representations of Diana's goodwill provide a false sense of security that the pained existence of aggrieved subjects has been somehow, and is still being, relieved. In her discussion of how sentimentalism is experienced, presented, and used in distinctly racialized ways, Lauren Berlant concludes that sentimental ideology, however complex its formations, is ultimately "the public dream work of the bourgeois woman."[60] Images of Diana doing her "work," extending her "magic touch" as England's "goodwill ambassador," encourage and permit the bourgeois woman to do her own "work" without doing anything, without relinquishing her socioeconomic privilege, without having to interact with or even see the victims of those same social

structures that place her, in the first place, in a position to help. In this way, sentimentalism is used to constitute a community of shared redemption (from the erasure of racial and class injustices) through "mere" feeling.

Continuous Messages and Racialized Ghosts: White "Matters" of Memory

Because the work assumed by the nineteenth-century Culture of Sentiment was ideological, its facets and effects necessarily extended beyond observable individual, private acts of charity and beyond, even, institutionalized projects of reform. The effectiveness of the Culture of Sentiment as an ideological structure had everything to do with its sentimental aspects, with those of its components that were about a shared *feeling*. Through all of the complex ways in which it produced and imposed itself upon this collective sentiment, the ideology of white supremacy thus (in)formed—with and against nonwhite objects—what Raymond Williams refers to as a "structure of feeling." As Williams discusses it, a structure of feeling is made up of "affective elements of consciousness and relationships: not feeling against thought, but thought as felt and feeling as thought."[61] Together these elements work as a "set, with specific internal relations, at once interlocking and in tension."[62] But a structure of feeling refers also to "a social experience which is still *in process*, often indeed not yet recognized as social but taken to be private, idiosyncratic, and even isolating, but which in analysis (though rarely otherwise) has its emergent, connecting, and dominant characteristics, indeed its specific hierarchies."[63]

Thus, sentimental acts that appeared, themselves, to be "private, idiosyncratic, and even isolating," were, in the late nineteenth century, actually informed by and formative of relationships of power. Structured already in distinctly racialized and gendered hierarchies, these relationships—in their production of white, middle-class women as feeling subjects over and against "othered" objects of feeling—effectively concealed the malevolence structured under imperialism with apparently "private, isolated" and voluntary acts of benevolence. It was precisely the *feeling* nature of the Culture of Sentiment—*as* a structure of feeling—that characterized its insidiousness and propelled a legacy that lived well beyond the nineteenth century.

The permanent, damaging effects of sentimentalism—as an expression and extension of white privilege—were rarely apparent in any sentimental moment or particular sentimental act. Because the "emergent, connect-

ing, and dominant characteristics" of structures of feeling become more recognizable when they have been built into institutions and formations,[64] the ways in which particular racialized education, reform, and abolitionist efforts worked to exclude certain groups from the national body can only now (at a later historical moment) be identified and analyzed as elements of a Culture of Sentiment that emerged a century ago. Part of the "solid permanence of the consequences of the sentimental campaign"[65] was a feminized adaptation or internalization of the white man's burden, which appears—even at the current historical moment—as a sort of racialized resilience of the heart. Perhaps the most vivid example of this is the "sentiment" still producing the media event of Diana Spencer.

Williams points out that it is only in analysis that a structure of feeling can be recognized, and that even then, its real effects cannot be identified until a new structure of feeling has begun to form.[66] Using what we know about the ways in which the nineteenth-century Culture of Sentiment worked to fortify bourgeois ideologies, we can examine the figuring of Princess Diana—her life and her death—for the structure of feeling that is *in process* at the current moment, and for how it performs its ideological work differently. Both the sentiment surrounding her sudden and tragic death as the end of a fairy tale and the "universal" identification with and praise of a life devoted to acts of charity establish Diana Spencer as a significant component of the postmodern sentimental campaign. The complexity of "feeling(s) as thought" associated with both "real" and manufactured senses of loss are particularly racialized, and even the mass media's observation (read: dictation) that "the world mourns" does not change the fact that the death of Lady Di, and the re-membering of her, is experienced by different groups in different ways.[67]

Despite the many ways in which the felt response to Diana's death differs among and between women, the global commodification of her as mother, as a woman just like every other woman, is an example of what Herbert Marcuse might fatalistically call "the absorption of ideology into reality,"[68] which—in the context of a technically advanced capitalist society—does not signal the "end of ideology," but marks instead the reduction of all thought and action to "one dimension." One-dimensional thought and behavior is the achievement of modern technology, and a most progressive stage of alienation. Within this stage, the needs of capitalist society are internalized within individuals, diminishing not only the possibility of social struggle, but also the ability to even imagine the world

otherwise. In Marcuse's words, this state of existence is one in which "ideas, aspirations, and objectives that, by their content, transcend the established universe of discourse and action are either repelled or reduced to terms of this universe."[69] In the current postmodern age of information, where individuals are constantly inundated with images advertising commodities within which they have learned to recognize their own self-fulfillment, it is no wonder that Diana Spencer comes to be named, loved and *consumed* as "Our Princess." Indeed, the (in)formational nature of the contemporary moment highlights the evolution of Diana as a sign vehicle for structures of feeling, as a consumable object, and ultimately as a ghostly monument carrying the force of material.

This ghosting of Diana in popular culture occurs in some images' actual depiction of her *as* a ghost. For example, the last picture of her in the "Commemorative Edition" of *People Weekly* uses the effect of "snowing" to disseminate the pieces of Diana everywhere, to give the idea of her lingering in our hearts and minds.[70]

Sitting down, her hands placed together in a gesture of prayer, she appears angelic and pious. Her gaze peers outward and beyond us, even as we see inside of and through her snowed pieces, like so many scattered images and messages structuring a (her) whole meaning. In this photo, what Roland Barthes terms the "continuous message"[71] is in fact anchored by the written text's demand that Diana *remain* continuous: "Above all, we give thanks for the life of a woman I am so proud to be able to call my sister: the unique, the complex, the extraordinary and irreplaceable Diana, whose beauty, both internal and external, will never be extinguished from our minds."[72] This message appears in large letters, occupying the entirety of the image's opposing page, restricting her meaning as an immortal performer of those ideologies grounded in and served by her posturing. Through visual technologies of ghosting, Diana thus becomes a mark, an index that locates all of the "continuous messages" and meanings she has come to freight, and figures them (finally) into an "obtuse meaning."

According to Barthes, it is virtually impossible to "give an idea of where [obtuse meaning] is going, where it goes away." He describes the "obtuse meaning" as

a signifier without a signified, hence the difficulty in naming it . . . it does not copy anything . . . [T]he obtuse meaning can be seen as an accent, *the very form of an emergence,* of a fold (a crease even)

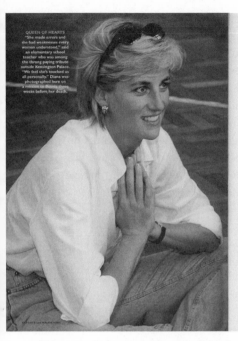

QUEEN OF HEARTS
"She made errors and she had weaknesses every woman understood," said an elementary school teacher who was among the throng paying tribute outside Kensington Palace. "We feel she's touched us all personally." Diana was photographed here on a mission to Bosnia three weeks before her death.

"Above all, we give thanks
for the life of a woman
I am so proud to be able
to call my sister:
the unique, the complex,
the extraordinary and
irreplaceable Diana,
whose beauty, both
internal and external,
will never be extinguished
from our minds."

— EARL SPENCER

The Queen of Hearts sits on the ground, hands in a praying position. People Weekly: The Diana Years, *Commemorative Edition, 1997.*

making the heavy layer of informations and significations. If it could be described, it would have exactly the nature of the Japanese haiku—anaphoric gesture without significant content—a sort of gash razed of meaning . . . This accent outplays meaning, subverts not the content but the whole practice of meaning . . . [It] appears as a luxury, an expenditure with no exchange. *This luxury does not yet belong to today's politics but nevertheless already to tomorrow's.*[73]

Just as the social relations that set the stage for the global mourning over Diana's death and the structures of feeling that become visible through it precondition social dynamics yet to be formed, so too does the "obtuse meaning" generated through her commodified immortalization influence tomorrow's politics. Simultaneously, other deaths that have everything to do with *yesterday's* politics and the legacies left to tomorrow's living often

remain unremembered and unaccounted for. This repudiated material of race, class, gender, and sexuality, although ghosted itself, *matters:* it means, speaks, and sounds, as if to harmonize the history that James Baldwin discovered, in *The Evidence of Things Not Seen,* was "a hymn to White people."[74] Beyond excavating this history for the stories and ghostly figures it represses in the service of racialized structures of feeling, we must also decipher the meaning of those haunting figures that have always been *hyper*visible. Exposing the ideological origins and aspirations of these frightful creations, as well as the technologies of their figuring, brings us closer to understanding the social costs of their mass public roaming.

Beloved Therapies

Oprah and the Hollywood Production of Maternal Horror

The horror film puts the viewing subject's sense of a unified self into crisis, specifically in those moments when the image on the screen becomes too threatening or horrific to watch . . . By not-looking, the spectator is able momentarily to withdraw identification from the image on the screen . . . and reconstitute the "self" which is threatened with disintegration. This process . . . is affirmed by the conventional ending of the horror narrative in which the monster is usually "named" and destroyed.

—Barbara Creed, "Horror and the Monstrous-Feminine"

Everybody knew what she was called, but nobody anywhere knew her name.

—Toni Morrison, *Beloved*

WITH THE 1998 RELEASE of the motion picture *Beloved*, the monsters of Toni Morrison's Pulitzer Prize–winning novel were vividly translated into filmic images, and the "disremembered and unaccounted for" nature of modern racism's ever-present materiality was, yet again, confirmed.[1] As the reviews in newspapers like the *New York Times* and the *Washington Post* noted, the film's failure at the box office indicated the persistence of Hollywood audiences' unwelcoming posture toward movies with "serious black themes."[2] But low ticket sales are an insufficient marker of the nature and ideological implications of both *Beloved*'s failures and its successes.[3] Rather than focusing on how and why *Beloved* assumed a place alongside many other unseen, unremarked-upon "race" films, what follows treats the film as an intertextual cultural artifact and as a site within

which racialized visualities themselves may be read for how they "sight" and obscure potentially alternative discourses and feminist theorizations of history, memory, and motherhood.

Research on the popular reviews of Hollywood's *Beloved* indicate that many who saw the film interpreted the stories it tells about racialized and gendered violence as stories about the *past,* stories having to do with one extended family's painful history and their individual reckonings with and eventual triumphs over this history. Such readings are enabled as much by a national disavowal of racial historical crimes as they are by the seemingly innocent-enough picture of romance (a hug shared by Oprah Winfrey as Sethe and Danny Glover as Paul D) that graced theater kiosks and the jackets of *Beloved*'s VHS and DVD versions. In truth, these two practices of representation—rather, historical erasure—reinforce each other. The embrace shared by Winfrey and Glover brings ease to our engagement with the film's potentially unsettling material: it holds the promise that the historical violence around which the film's narrative is built will be balanced, if not surmounted, by a love story. The settledness that this image promises is the same that both the film's diagetic and extracinematic elements deliver in their melodramatic presentation of past horrors.

While the place of the maternal in melodrama and horror genres has been extensively analyzed in feminist film theory,[4] these representational modes in Hollywood's *Beloved* are complicated by the racial material of both its specific, aberrant maternal visions and their larger discursive context. Indeed, the phenotypic (visual) "site" of race, along with the primacy of the visual in the establishment of popular historical knowledge, influences the nature and effect of these visions in *Beloved* that either (and alternately) comfort or appall. Approaching the film from this perspective, we can therefore ask and begin to answer whether or not it—like Toni Morrison's novel on which the film is based—is able to successfully convey alternative experiences and meanings of the maternal within and despite the racialized *visual* discursive terrains within which the construction and reception of its narrative occurs. For instance, how does the maternal media persona of Oprah Winfrey, with her publicly granted titles of "America's psychiatrist" and "The Conscience of Our Times," impact the sentimental racial codes through which the film's productions of history, memory, and motherhood are read?[5] At the same time, how do popular representations of "pathological" black motherhood so overdetermine the contemporary visual context within which Demme depicts Sethe's infan-

ticide that the film can (only) be categorized as "horror" as opposed to a critical engagement with "history"? How does the proliferation in popular culture of "good" and "bad" maternal imagery inflect the meaning and impact of Toni Morrison's brilliant artistic achievement, as it is "realized" on-screen? Indeed, what *are* the racialized discursive repertoires on which viewers, as individuals and communities, draw to decipher the histories and memories of unspeakable crimes that the film depicts? And how do the unspoken and unaccounted-for histories of racial social death themselves actually structure the differences between what one community sees as criminal and another deems angelic, between what one fears as a monster and another loves as a mother?

In "Melodrama Revised," Linda Williams gives us a useful way of understanding the cooperative, or perhaps indistinguishable, roles of horror and melodrama at play in Hollywood's *Beloved*. She observes that "Melodrama should be viewed . . . not as an excess or an aberration but in many ways as the typical form of American popular narrative in literature, stage, film, and television. It is the best example of American culture's (often hypocritical) notion of itself as the locus of innocence and virtue."[6]

Perhaps no single element of the film reinforces the notion of America as the locus of innocence and virtue as the extracinematic significance of Oprah Winfrey, and "her" importation into the film's diagetic space. Later in this chapter, I analyze the impact of Winfrey's presence on the "nature" and meaning of the film's presentation of horror and melodrama, along with the effects of the film's humanistic narratives of good versus evil, suffering and redemption, and the fulfillment of romantic love. First, however, I treat the monstrosities that fill up the film's melodramatic form.

The Comfort of Horror

Research on the popular critical reception of *Beloved* reveals that mainstream reviews tended to characterize the film in the language of horror,[7] as opposed to popular criticism that interpreted the novel as magical-realist. Often likening the film's supernatural imagery to that of the film *Poltergeist,* such readings demonstrated the effect of *Beloved*'s screenwriters' and director's choices to visualize Morrison's novel in particular ways. The film's attribution of exceptional episodes of violence to the ghost's invisible form, its composition of nightmare and flashback scenes, and its interpretation of Beloved's body as a monstrous abomination—through Thandie Newton's

physical delivery of the character and the camera angles and lighting that Jonathan Demme uses to frame her supernatural activity—together constituted the film's generic horror effects.

The opening scene of the film introduces us to the undead, monstrous matter that haunts it, as the camera floats our point of view, ghostlike, across a graveyard to close in on a tombstone reading "Beloved." The sound track's ethereal chanting fades out along with the tombstone, and becomes a muffled struggle emanating from the gray house that now appears center frame. The successively superimposed locators "Ohio, 1863," "The outskirts of Cincinnati," and "124 Bluestone Road" float us ever closer to the specifity of the haunting, to a house where dogs howl and whine, children shriek, and a mother unnaturally comfortable with blood and broken bodies remains coldly calm.

In the introduction to 124 Bluestone Road, the characters Howard and Buglar frantically escape the dangerous forces of both the invisible monster that launched their dog into a wall and the mother who literally pieces his body back together. Quietly preoccupied with returning Here Boy's eye to its socket and wrapping his broken limbs in tight cloth, Sethe is apparently unaffected by the ghost force that snatches a cake with a small handprint in its frosting out of Howard's reach, throws the front door open, and then hurls a mirror off of a wall and onto the floor. Despite their younger sister Denver's protests, the two boys scamper away into the cold, leaving the horror behind. Denver angrily asks the invisible ghost, "Now, what'd you go and do that for?" Sethe, now finished fixing what she is able to fix, realizes her boys are gone and puts her arms around Denver as they both focus on the distance into which Buglar and Howard ran.

This first scene of the film conflates into the same time and space what the novel's introduction actually narrates as an accumulation of ghostly acts that finally compels both Howard and Buglar to run away, each in his own time. Morrison writes:

> 124 was spiteful. Full of a baby's venom. The women in the house knew it and so did the children. For years each put up with the spite in his own way, but by 1873 Sethe and her daughter Denver were its only victims. The grandmother, Baby Suggs, was dead, and the sons, Howard and Buglar, had run away by the time they were thirteen years old—as soon as merely looking in a mirror shattered it (that was the signal for Buglar); as soon as two tiny hand prints

appeared in the cake (that was it for Howard). Neither boy waited to see more . . . Nor did they wait for one of the relief periods: the weeks, months even, when nothing was disturbed. No. Each one fled at once—the moment the house committed what was for him the one insult not to be borne or witnessed a second time.[8]

Thus, the too-familiar strangeness that each of the boys flees, individually, has become too familiar *over time,* and the final haunting is, in fact, different for each.

By compressing the handprint in the cake, the hurled dog, the slamming door, and the shattered mirror into one horrifying moment, the film denies the historical—where history is *process,* and present everywhere—location of the haunting. It denies the ways in which Howard and Buglar, as well as Denver, Sethe, Baby Suggs, *and those outside of and around 124 Bluestone Road* cohabitate with ghosts that perhaps only sometimes surprise them to the point of fear. While the boy children are afflicted and driven away by so much monstrosity, the film unexplainedly represents the girl child as being (perhaps a little too) comfortable with it. In fact, she and the monster are on speaking terms. The apparent callousness, or indifference, of Sethe's response to this "incident" remains unexplained, and, at least for the (movie's) time being, viewers are made to feel comfortable with attributing it to her nature.

The establishment of the film's supernatural, horror content continues in the second scene, as the character of Paul D enters 124 Bluestone Road and is immediately soaked in a red light and granted an image that explains the hauntedness of the house. He holds up his hands to guard himself from the ugliness: just ahead of him, behind a door that swings open by itself, Sethe holds a slain baby, its blood blending into the light that bathes them.

Through this image, Paul D is given a picture of the aberration that continues to haunt 124 Bluestone Road. Rather than an image of Sweet Home (the plantation from which Paul D and Sethe and her enslaved children escaped), the origin of the haunting is the moment of Sethe's transgression, of her abominable diversion from maternal nature in an act of infanticide. But it is only a flash. Paul D, and the audience, must wait for the story to unfold that identifies—and reduces—the cause of the haunting to a single act of murder and the manifestation of it to a single ghost.

There are, indeed, moments in the film when its characters remember the source of the pain and sadness that afflicts 124 Bluestone Road and

its inhabitants to be more complicated than that explained by a singular atrocity. For instance, we witness Sethe remember how Schoolteacher's boys violated her and took her milk and we see Paul D's nightmare images of himself and his friend, Sethe's husband Halle, in captivity. However, the representation of these moments in the mode of horrific flashback visually disciplines and reduces the historical and present nature of the haunting, of the social materiality of racialized chattel slavery and its legacies, to yet a few more singular moments in the past. That these past experiences of dehumanization intrude, presently, upon the psyches of Sethe and Paul D in the form of flashbacks and nightmares does indeed point to irrefutable traumas and their continuing effects. The film's presentation of these traumatic moments is so horror-fied, so jolting, however, that these moments remain unintelligible instances of past violence. The horror in question thus emerges as the fact *that* the characters remember, not *what* they remember.

The film's use of horror technologies reduces the fleshed-out repudiation of boundaries—between mother and daughter, history and the present, the individual and the collective—that Beloved embodies in Morrison's novel to a single monstrous evil that must be, and can be, exorcised. Unlike the novel's presentation of Beloved as embodying a collective memory-made-material, a history in the present, the film reduces and occludes these processes by locating them within a single, grotesque physicality. Thandie Newton's physical delivery of the ghost-character Beloved presents her as a stumbling, stammering, slobbering figure whose otherworldliness remains certain throughout the film.

Whereas Morrison's literary representation of Beloved calls attention to a slowness in speech and movement that suggests a development arrested in infancy, it does not prohibit Beloved's incorporation into the physical, as well as psychic, space of the family and home at 124 Bluestone Road. While her questions are strange and her desires extreme in both the novel and the film, the novel's rendition of Beloved—her speech, her movement, her sweet and appealing manner—grant her a location within the physical space shared by Sethe, Denver, and Paul D. Her presence does not, as does the body and manner of the film's Beloved, scream of its own displacement. That Morrison's Beloved belongs and is *needed* in the *now* of 124 Bluestone Road *is* the horror: it is the horror of the *history* that she embodies. The film uses the visual logics of normative corporeality to make Beloved's body *itself* the horror. It thus becomes impossible for her

to represent the violent history of racialized enslavement, and the fact of it in the present. Embodied *as* a horror-fied body, the aberration remains locatable within the space of this single house for as long as Beloved remains there, fleshed out, stumbling, croaking, shitting, shrieking, slobbering, and vomiting. What, in Morrison's deliberate illustration of Beloved's and the other characters haunted *interiorities,* is a brilliant rendition of how history bleeds quietly into the flesh and relationships of everyone's present becomes instead, through Beloved's filmic body, a single, spectacular monster.

Even as some reviews lamented the film's use of horror technologies,[9] these technologies undoubtedly reinforced many spectators' readiness to disassociate *Beloved*'s images from any historical, material reality. Given Demme's reliance on jolting visualizations of horror *and* the American historical aversion to movies with "serious black themes," we may speculate that where and when the film beckoned, or was assimilated by, "mainstream" Americans, it was in part because it represented something spectacularly monstrous, because it told a story about many things *fantastic* as opposed to many things *historical.*[10] In this regard, the horror content of the film complemented its melodramatic form. The narrative that reaffirmed America as the locus of innocence and virtue was, in effect, filled up with and complemented by intruding fragments of evil, by unreliable, distant, and *exceptional* images of violence representing aberrations long over and gone.

Thus, examining *Beloved*'s filmic technologies of horror not only allows us to see how and why its producers failed to adequately translate into the visual mainstream Morrison's indictment of America's violent racial past and present, but it also gives us insight into the specific disruptions that considerations of racialized visions cause for generic analysis. It is important to note, however, that the racialized motivation for seeing horror in history, rather than feeling horrified by racial historical crimes, is itself a motivation with its own history.

In "Early American Murder Narratives: The Birth of Horror," Karen Halttunen historicizes the cultural construction of the meaning and popular response to the crime of murder, situating it in relationship to the Enlightenment liberal view of human nature. Unable to account for the horrific act of murder, this view of human nature as "intrinsically comprehensible, reasonable, and endowed with an inborn moral sense" necessitated an understanding of the murderer as a "moral monster."[11] The

popular cultural focus, then—with regard to interpreting and depicting murder—shifted to representations of the *horror*, as opposed to the *crime* of the act and/or the redemption or absolution of the criminal. This shift in the interpretive frame resulted in graphic literary depictions of murder, the horrific details extremely embellished in order to prove its monstrous abnormality and to absolve American society from claiming it as its own. In light of this discussion, we may interpret the filmic technologies and critical reviews that situate *Beloved* as a horror film as those that essentialize the difference between the "horror" it visually depicts and attributes to Sethe, and the racial social crimes that Morrison's historical narrative indicts. Indeed, the most horrifying scene of the film, according to mainstream reviews, was the scene of infanticide. However, those critics who mentioned this failed to contextualize the "crime" within the longer history of slavery's and racism's disruption and exploitation of black women's sexual, reproductive, and "motherly" (in the dominant sense) capacities.[12] This important omission represents a kind of cultural amnesia, a historical neglect, that often plagues even the most incisive critiques of texts that invoke horror in the service of occluding history.

Read against Barbara Creed's argument about how the viewing of "threatening [filmic] images" facilitates the reconstitution of the self,[13] the narrator's declaration at the end of the novel *Beloved* that "everybody knew what she was called but nobody anywhere knew her name"[14] suggests an important disjuncture between the individualized assimilation of *horror* and the social struggle to reckon with *history*. The epigraph from Creed that introduces this chapter is taken from an essay in which she reads horror films' representation of the "monstrous-feminine"—that which *is* sexual difference and thereby threatens castration—as the abject material against which the self is constituted. Quoting Julia Kristeva's "Powers of Horror," Creed defines the abject as "'the place where meaning collapses, the place where "I" am not. It must be radically excluded from the place of the living subject,' propelled away from the body and deposited on the other side of an imaginary border which separates the self from that which threatens the self."[15]

Arguing that the monstrous-feminine is coded in the maternal figures of horror films such as *Psycho, Carrie,* and *Alien,* Creed concludes that the viewing subject's encounters with the monstrous-feminine in such films permit a reconstitution of patriarchal self through the staging and restaging of a constant repudiation of the maternal. Yet the maternal is, of

course, not the only abject material repudiated in the viewing of horror films, or—in the case of *Beloved*—in the viewing of horrific representations of history. Nor is the maternal ever simply a universal formation that threatens castration. A critical analysis of the filmic performance of horror in *Beloved* suggests that we must recognize that the "repudiation of the maternal" in image production and image viewing is always a *racialized* repudiation—meaning that both the act of repudiation and the repudiated material are (in)formed by, and through, an engagement (disavowed or not) with race and histories of racial formation. "Maternal visions" have never not been *racialized* visions: how we perceive the alternately (often simultaneously) comforting and threatening aspects of maternal bodies is determined as much by racial knowledge as it is by ideologies of sex and gender that have long been the central focus of feminist treatments of horror. Indeed, maintaining focus on these intersections that shape our visions of mothers/monsters requires engaging the relationship between psychoanalytically based feminist theories of maternal imagery and the social histories that have ensconced maternal ideologies, along with maternal bodies and experiences—and the *perceiving* of these bodies and experiences—within specifically *racialized* structures of sex and gender. In this regard, new and more nuanced understandings of the dialogics of visual culture experience, and of genre in particular, are necessary. In the case of Hollywood's *Beloved,* such an analytic reveals a cooperative production of "racial healing" on the part of horror, and its unlikely partner, melodrama.

The Monstrosity of Melodrama

Oprah Winfrey's apparently universal, uncontested significance as a therapeutic maternal figure, and, as fleshed-out evidence of America's realization of racial equality, works to smooth the psychic and social ruptures, and disavow the continued violences to which Morrison's *Beloved* attests. But the actual narrative of the film is what recruits Winfrey's popular significance into a virtually seamless melodramatic message about (individualized) experiences of good versus evil, of suffering and redemption, and of—as Winfrey herself puts it—"romantic and mother love."[16]

 The filmic narrative's significant diversions from the sequencing and rhythm of the novel's narrative works to anchor the film's humanistic messages around Baby Suggs as the "good mother" who has overcome a past

that no longer intrudes upon her life, or, importantly, upon her spirit. Baby Suggs's five appearances in the film are separated by almost equal intervals of time. Three of these "separate" scenes depict her in a clearing, preaching different parts of what is apparently the same sermon. Each time, the scene follows and appears to anchor the meaning of scenes depicting Sethe. The same sermon, with its uplifting messages—detached from the circumstances out of which Baby Suggs's words attempt to lift her listeners—reins in the potential unruliness of the film. It is an enlightened and enlightening message that, ultimately, answers the question "What is this film about?" with "It is a story about a history past and overcome." The film speaks its last words through Baby Suggs: "Love your heart . . . this is the prize."

With this ending, the specific, revolutionary nature of the demand that the Baby Suggs of the novel makes (much earlier in the narrative) to those in the clearing to "Love your heart" has already been emptied out by the previous three hours of the movie, which neglected to depict in any voice, image, or suggestion that the "yonder" in which "they do not love your heart . . ." or, as Baby Suggs also points out, "your hands," is *here*. This representation of Baby Suggs thus makes her the embodiment of, and vehicle for, a melodramatic narrative of suffering and redemption that comfortably contains the otherwise horrific content of the film. Working alongside the function of the filmic Beloved to particularize the horrific threat by/as a single body, the filmic Baby Suggs assures us all that, since we are separate from that body, we need only endure its temporary harm, and that its passing will solidify the danger it represents within the past. This "freeing" function of Hollywood's Baby Suggs thus absolves us from penetrating the illusion of times (and crimes) past that Morrison's novel explodes, leaving no one unaffected, no one fully healed or forgiven.

Another melodramatic component of the film is the romance between Paul D and Sethe, which is arguably *the* driving force of the film's narrative. Indeed, the film communicates that the significance of Sethe's crime of infanticide is that *it disrupts the romance between her and Paul D.* Every flashback, memory, or recounting Sethe has in the film is told or confessed to Paul D. While the novel represents these particular scenes in the same way (Sethe remembers to Paul D the taking of her milk and narrates the infanticide to him), Morrison importantly writes in some of Sethe's *other* re-memories, including her re-memories of Sweet Home, as well as Paul D's and Baby Suggs's re-memories of Sweet Home. In addition, the novel provides details of Halle's and Sixo's experiences of being enslaved.

Thus, what the film represents as the disrupted material of the stories it tells is a very traditional notion of romance. The romance is disrupted by an apparently single act (infanticide) and an apparently individual ghost (Beloved). The novel, rather, presents the disrupted material as the very humanity of African Americans, the force of disruption being the brutal mechanisms of racialized slavery.

The film also presents the struggle between good and evil as an element of its melodrama. Its lack of focus on the prevalence and continuity of racialized violence against "emancipated" African Americans, however, makes it unclear to the audience who or what constitutes the evil against which the characters struggle internally. Is the evil exorcised the evil of the single monster, Beloved, or the evil of the single monster/mother, Sethe, who would kill her children and defy the voices of reason and hope that the film speaks through Baby Suggs and Paul D? Indeed, the filmic narrative makes it difficult for the audience to imagine and focus, instead, on the evil represented by the Schoolteacher of Morrison's novel, the evil that endures in and through the ink he used (that Sethe made) to document what he called her "animal characteristics."[17] The etchings of this dehumanization appear to disappear in the film, at the moment when Sethe's good conquers the evil and hurt within her enough to agree with Paul D that she is her "own best thing."

The film *Beloved* performs its "universal" messages within the histories of Enlightenment rationality and individualism, and therefore presents solutions to racial social crises in the vein of liberal individualistic doctrines of *self*—moral, spiritual, and apparently race-less. In contrast, Toni Morrison's novel *Beloved* self-consciously locates itself within complex histories of racial enslavement and dehumanization, marking the differences that render Enlightenment notions of the individual subject, at best, irrelevant to the racialized and gendered selves she engages and, at worst, brutally violent to them and their histories. Thus, the novel presents both communal remedies to the social-historical crimes it reveals and "self"-remedies that require an understanding of self existing always within *community,* within history, and never outside of a racial social that disrupts the "truth" of individual will, and that obliterates the possibility of a psychic or spiritual harmony existing within the context of social death.

Film theorist Vivian Sobchak insists that we pay attention to the "whole correlational structure of the film experience," a task that entails thinking beyond formalist, realist, or ideological critiques of film which treat

the medium, respectively, as expression-in-itself, perception-in-itself, and mediation-in-itself.[18] By understanding film as a complexly produced "subject," she problematizes some of the presumptions shared by classical and contemporary film theory and encourages us to look at the significance of films as performances within and performances upon the world. This approach to understanding filmic language suggests that our analyses of film must go beyond discussions of filmmakers' and spectators' visions to include some examination of the historical, cultural material that is seen and projected by the *film's* eye. In this respect, the cultural significance of any one film is determined by a complex array of viewing and projecting practices, the filmmaker's intentions and the audience's conscious responses being only parts of this complex formation. The film *Beloved* and its extra-cinematic formation presents a particularly useful site within which to explore the unintended or unperceived cultural material—in this case, the *racialized* material of history, memory, and motherhood—out of which certain image-based understandings and misunderstandings, reckonings and disavowals arise.

The Bigger Picture

To recognize Oprah Winfrey's influence on the text of Hollywood's *Beloved* is to do much more than treat her as the picture's lead actress, or to assess the believability, skill, and power of her role-playing. Indeed, the hyper-visible sign of "Oprah" freights powerful associations with race and maternity that exist always already prior to any one of her particular filmmaking or other media projects. Any analyses of "just the film," therefore, must pan extracinematic and intertextual visual spaces in order to decode the complex racial mechanisms by which the history presented in Demme's *Beloved* becomes tamed by horror, and how the affect of this horror, in turn, is managed—or, as Creed might say of the more general filmic "monster," *named*—by and through melodrama.

For every review that discussed the film *Beloved* as a horror film, there were twice as many that read it, favorably, as a melodramatic project of racial reconciliation. In light of Linda Williams's and Christine Gledhill's observation that the category of melodrama is most productively understood not as a genre per se, but as a common modality through which numerous other generic practices are performed,[19] *Beloved's* fusion of melodrama and horror presents a readable, albeit extremely complex, performance of per-

sonal and national resolutions to the intersecting historical crises of race and the maternal. Most of those familiar with Morrison's novel recognized that the ambitious project of realizing the narrative on the Hollywood screen would call for, at the very least, some unconventional approaches to filmic production and promotion. Yet *Beloved*'s creators and many of its viewers ultimately relied upon some tried-and-true bodies of racial knowledge to represent and resolve the "unspeakable" crimes that Morrison's narrative indicts. The casting and marketing decisions of the film's producers, its cinematographic and narrative features, and the racial logics through which it conveyed universal understandings of motherhood all contributed to *Beloved*'s therapeutic, hybrid performance of melodrama and horror, and its reproductions of historical disavowal. Interestingly, the racialized, public maternity brought to the project by the film's producer and lead actress was what, perhaps above all else, encouraged this therapeutic disavowal.

As she tells it, Oprah Winfrey's unyielding determination to name the unnameable was born in 1987, the moment she finished reading Toni Morrison's *Beloved*. "Overcome with the idea of bringing (Sethe) to life," Winfrey phoned Morrison and proposed that she, Winfrey, be the one in command of realizing *Beloved* in a motion picture. She responded to Morrison's important question, "How could this ever be a movie?" by insisting that it could, indeed, and that she knew how to make it happen.[20] The film *Beloved* was in part the product of Winfrey's "knowing," of her intention to help "people be able to feel deeply on a very personal level what it meant to be a slave, what slavery did to a people, and also to be liberated by that knowledge."[21] Winfrey pursued her stated mission by becoming involved in every stage of the project. She not only secured the movie rights from Morrison, but she also successfully recruited Jonathan Demme to be her coproducer and the director of *Beloved*. Perhaps most important—for Winfrey, as well as for the popular reception and cultural significance of the film—she acted in the picture's leading role as Sethe, as the woman whose memories and "thick love" made it impossible for her to see her children returned to the enslaved life she had escaped.[22]

Despite the history of Hollywood audiences' unwelcoming posture toward movies with "serious black themes," Winfrey's hypervisible media presence and popular appeal accorded *Beloved* the possibility of mainstream success. Without a doubt, a large portion of the film's audience was made up of those who were lured to it primarily by the promise of "Oprah," as

well as by her personal, multimillion-dollar marketing efforts that established the project as "my 'Schindler's List.'"[23] The experience promised an ultimately fulfilling and self-actualized—if momentarily disturbing—feeling of reckoning with some unspeakable and historically unspoken experiences of enslaved African Americans. And, more important (for its mainstream, universal audience), it depicted what Winfrey called a "love story," a story of both romantic love and a "love story about how all women feel about their children and the great depths and extent they would go to protect their children."[24] Thus invoking the tropes of romantic and mother love, Winfrey attempted to sell the film to a broader audience than a production foregrounding "racial issues" would otherwise attract.

Consistent with the producers' perception of the film's "universal" importance, some of the most favorable reviews praised it for its success in conveying a timeless and uplifting message about human possibility. Writing for the *Charlotte Observer,* Lawrence Toppman observed that

> the message [of *Beloved*] has been around in roughly the same form since the New Testament: Love yourself, love your neighbor, love the things and people that are enemies to your own peace of mind. Forgive others' sins, and your own. As that message rings through the shaded trees, "Beloved" proves itself a movie for any race or any time.[25]

Thus characterizing the "message" of *Beloved,* Toppman extricates the narrative of the film from history, and the relationships it presents from particular, and particularly violent, *situated* social realities structured by race. Using nonspecific, universal references to "yourself . . . your neighbor . . . things . . . people . . . enemies . . . sins," this interpretation of the film promises an experience of transcendence—transcendence of hardships, and, importantly, transcendence of personal or historical blame. The reviewer promises that *Beloved*'s ultimate "prize" of spiritual gratification is available to *all* races, even if the cast is almost entirely African American, even though the content of the film is brutal, even if (one worries) that she or he will somehow be implicated as an "enemy" or a "sinner."

Since the mid-1980s, when Oprah Winfrey first gained popularity as one of America's most important spiritual teachers, she has been a most effective conveyer of such messages and promises.[26] Her important role and visible presence in the history-making film project of *Beloved* was there-

fore, in part, another opportunity for her image both to promote acts of forgiveness on the part of historically forsaken racialized populations and to offer the certainty of having been forgiven to guilt-afflicted Americans. That the New Testament's message about "forgiving the people that are enemies to your own peace of mind" found a voice in the visual translation of Morrison's novel—a novel interpreted by many to be a metaphoric testimony to the material presence of a nation's racist past—reveals the almost frightening power of the visual to *erase* social realities precisely through the manner in which it purports to accurately *represent* them. And it reveals the unwavering significance of the embodied nature of race that has long been acknowledged by historically racialized subjects.

According to Winfrey, *Beloved* was a "destined" project that chose Morrison, Demme, and herself to make it real.[27] The self-proclaimed rightness of her performance of Sethe came from strong yet unexplainable feelings of identification with the character.[28] That she saw herself in Sethe is a truth supported by virtually all of Winfrey's many testimonies about the significance of bringing *Beloved* to the Hollywood screen. In the photo essay titled *Journey to Beloved,* Winfrey chronicles the making of the film and shares such thoughts as "I felt that she was in some way a part of myself" and (upon seeing Sethe's movie-set house on Bluestone Road), "It's Sethe's home. My home." Yet, for those other than Winfrey who host feelings of identification with the history, figures, and political projects remembered in Morrison's *Beloved,* "Oprah's" resemblance to Sethe is perhaps not so obvious. What the two figures share—one, a beloved multimedia enterprise unto herself and the other, a fugitive slave—is, indeed, not necessarily common sense. For some, however, for those regular viewers and fans of *Oprah* looking to heal wounds of racial pasts, Winfrey's reflection of Sethe makes a certain *therapeutic* sense. While it is impossible to know for sure the cultural and psychological significance of *Beloved* for the individuals who viewed the film, Winfrey's personal "Journey to Beloved," and the media's characterization of her as "America's psychiatrist," are indeed fascinating for what they suggest about the enduring popular relevance of the modern therapeutic mode in this postmodern era.

In *No Place of Grace,* T. J. Jackson Lears traces the historical roots of the therapeutic mode through which the contemporary media figure "Oprah" achieves her greatest cultural significance. As Lears observes, during the late nineteenth century, cultural critics began lamenting the "suffocating ease" of moral and physical life brought about by a new enlightened

centering of the individual and a retreat from religious orthodoxy. The now more tolerant and liberal Protestantism permitted individuals to abandon an endless quest for conversion experiences and to free themselves from the certainty of a truly hellish damnation. With these freedoms came the opportunity (for white middle- and upper-class subjects) to choose more individualized paths to fulfillment. Many intellectuals observed how this expansion of personal choice—amid a general climate of "indiscriminate toleration"—made people more vulnerable to personal and moral corruption.[29] They argued that modern capitalist society, and its accompanying liberal individualistic doctrine, had made both modern character and modern culture "weightless." A "therapeutic worldview" emerged in response to the psychic crises produced by this weightlessness:

> As personal moral responsibility became increasingly problematic, the repressive constraints of a modern superego became less tolerable, its conflicting demands more difficult to fulfill. As respectable Americans slipped into immobilizing, self-punishing depressions they called "neurasthenia," many sought relief in a proliferating variety of therapies. The spread of therapies involved more than faddishness; it signified a shift toward new secular modes of capitalist cultural hegemony. (55)

Rather than solve the problematic of moral responsibility, these new therapies, "by emphasizing techniques rather than ultimate values, and by encouraging [a focus on] immediate emotional requirements," left individuals "mired in morbid introspection" (ibid.). The therapeutic mode's focus on personal growth and experience, along with its "exaltation of unconscious impulses," produced an increasing gap between the pursuit of personal, psychic harmony and the realization of personal responsibility to the social. The treatments originally engineered to remedy white subjects' neurotic responses to their weightless personal and cultural experiences actually exacerbated that weightlessness, setting a historical cultural precedent for therapeutic modes "attuned to the consumer ethos of twentieth-century capitalism" (55–56).

Antimodernists who were critical of both modernity and certain institutional therapeutic approaches to remedying the moral and spiritual emptiness that characterized it unwittingly eased the transition from one stage of capitalism to another. Their quests for the "real life" led them to

focus on and romanticize individual "intense experience," permitting a further evasion of the *social* crises that were produced by the political and economic transformations of the period. In actuality, as Lears observes, the antimodernists—with their therapeutic tendencies—discovered and promoted "new forms of evasiveness for a new social world" (58). Jon Cruz and Nathan Huggins have demonstrated that these new forms of evasiveness were often commodities in the form of racialized cultural productions such as Negro spirituals and theatrical performances of the kind of premodern, "naive" religious faith that was denied to enlightened, unsuperstitious, "sophisticated" subjects.[30]

At the turn of the twentieth century, both modernists and antimodernists adopted liberal individualistic approaches to remedying the psychological and emotional symptoms of modernization. At the turn of the twenty-first century, similar methods are employed to ease the angst and "weightlessness" produced by late, global capitalism. The therapeutic mode continues to be a most favored form of social evasion even as the *mode of the therapeutic* has changed. What, indeed, is new about the "new forms of evasiveness for [this] new social world" is that the evasiveness is achieved through the same media that, in part, produce the need to evade. If the postmodern dissolution of borders between media texts and images, between images and identity formation, has produced an unquiet death of the (coherent) subject, those same media and images that fracture this subject also transmit to it the possibility of regained wholeness through pieces of "intense experience," through pictures of "real life" provided by such racialized, intertextual media bodies as "Oprah."

The crisis of cultural authority that produced nervous conditions for many middle- and upper-class Americans at the end of the nineteenth century was steeped in more general xenophobic and racial anxieties about the unraveling of white political and social supremacy. The U.S. nation's contemporary crisis of cultural authority is steeped in the same anxieties, only now it is exacerbated by the gap between official post–civil rights, multicultural "ideals" and the material reality of increasing racial, class, and gender inequalities. In the film project *Beloved* Winfrey invested the hope that some symptoms of this crisis would be remedied. One was/is the nation's historical avoidance of its racist crimes against blacks under slavery, an avoidance that has altogether obstructed the inclusion of the African American experience from official national narratives.[31] Another, apparently more significant (to Winfrey) symptom of the crisis is the

"bitterness" and "anger" that many African Americans unproductively host, along with their "consum[ption] by hatred and fear because of what happened then."[32] Ironically, Winfrey wanted to convince "every African-American"—through her performance of a character and story originally written by Morrison to depict and indict the "seething presence" of America's racist past—that "all that" is "behind you" and that "now we are truly liberated to create the highest vision for our lives that is possible."[33]

This Horatio Alger-esque, bootstrap doctrine is the same that Winfrey preaches regularly on her self-produced, critically acclaimed talk show *Oprah*. Since the mid-1980s, the show's very personal themes and inspirational tone have helped establish Winfrey as not just a fully integrated model of human perseverance (without the aid of affirmative action),[34] but also as "America's psychiatrist" as an apparently nonracialized popular guide to personal inspiration and self-growth.[35] Her fame as "The Conscience of Our Times"[36] and her reputation as a "teacher"[37] unquestionably carry over into the philosophy and execution of her other media initiatives, including "Oprah's Book Club," which she founded in 1996.

In her discussion of Winfrey's book club, Janice Peck aptly characterizes it and the *Oprah* talk show as a "unity," a kind of cooperative performance of "psychologized spirituality" that I argue also permeates the Hollywood translation of Morrison's *Beloved* and constitutes its fundamental difference from the novel.[38] Together, the three productions of Winfrey's show, her book club, and *Beloved* work to both displace the problems wrought by historically racialized social and economic inequalities from institutions onto individuals, and to locate the remedies to these problems within individual psyches via "positive thoughts."[39] In contrast, Morrison's novel engages the tight and fraught relationship between the social and the psychic, and the histories and memories that host the often-violent engagement of these seemingly separate spheres. Whereas the horrors of the film *Beloved* are made *visually*, obviously (and only) supernatural via horror-genre technological forms—red pulsing light bathing a haunted house, objects moving, the dead coming back to life, and, importantly, a linear narrative that actually achieves resolution—Morrison's novel uncovers the secrets kept, and the price paid for the silence, around the American institution of slavery and the broken promises of emancipation. Likewise, the solutions to the disruptions of personhood, community, and romantic and mother love that the film and the novel propose are fundamentally different.

In the "Production Featurette" of the DVD version of *Beloved*, the film's

actors' and director's commentaries anchor the Hollywood narrative's message about the absolute power of universal, individual mind and heart over social matter. Interspersed with scenes from the movie are short-angle shots of Winfrey, Demme, Danny Glover, Thandie Newton, Kimberly Elise, and Beah Richards all testifying to the truths about personal hardships, self-identity, and individual will that the film offers. Bathed in light and glamorously made up, Winfrey authoritatively conveys the film's most important meaning: she says that it is a story about romantic and mother love, a story about the sacrifices that all mothers make to protect their children. "And it's a ghost story," she asserts. "The haunting of the memories of your past."

Continuing to focus on a nonspecific "you" and "we," the Featurette documents the rest of the starring cast affirming the universal importance of their collective performance. Beah Richards, who plays Baby Suggs in the film, declares that "the question that is raised by this play [sic] is the question of identity. Who are we all? Who are any of us? We are the same. We know that." And director Jonathan Demme shares what inspired his work on *Beloved*: "I'm very very moved by a good person who is faced with a difficult struggle and who perseveres and tries to get to the other side of it." Reflecting on the "destined" nature of the film project, and repeating the same all-important message she delivers to the consumer audiences of her talk show and book club, Winfrey's popular voice ends the Featurette: "Jonathan Demme was destined to direct this. As I was destined to be a part of it. As Toni Morrison was destined to write it. It all fell into place after a decade to come to the right time and space to create our *Beloved*. The very theme and message of this movie is exactly what I do in my life every day. Try to get people to see that you are your own best thing. You're it."

Winfrey's intertextual media presence across radio waves, popular daytime television and literary "criticism," and magazines (Winfrey's periodical *O!*) has thus offered, and continues to offer, a hypervisible, embodied testimony to the primacy of individual will over social, institutional hierarchies of class, gender, and race.

The influence of Winfrey's extracinematic identity thus lent the film project *Beloved* a mass therapeutic potential the likes of which the daily televisual and literary experience of *Oprah* provides for its predominantly white, middle-class viewers.

What makes Winfrey "Everywoman"[40] for her daily mass consumers is the same racial logic that permits her to be "Every-"(rather "Any") *black*

"woman," such that—rather than Winfrey's competent acting skills making her into a believable "Sethe"—Sethe, once an economically, sexually, psychologically abused slave, is able to become "Oprah," in all of her liberating and triumphant glory. For many who are aware of Winfrey's own childhood history of poverty and sexual abuse—which she revealed on one of her early shows and has since continued to discuss publicly[41]— Winfrey's role in *Beloved* may work to establish the oppressive conditions re-membered through Morrison's Sethe as unquestionably surmountable. But viewers of the film need not be aware of Winfrey's painful past experiences—from which she has quite visibly risen—to attribute a past-tense quality to the racial traumas endured by the African American community with which Winfrey is identified. The promise of a past irrefutably *passed* is held out by Winfrey's racialized intertextual media body, a body that both possesses a (black) physicality associated with the African American community and whose hypervisible privilege can be read as social and economic progress for the same community.

This progression is not only that of Winfrey's own individual success as a media star and self-made millionaire, but also that of an American cultural progression: from political institutional racism to a post–civil rights age of multicultural "equality." Whereas Toni Morrison's fictional character Sethe cannot reflect proof of this equality, Winfrey's visual media presence can, and does. Thus, across the face of a narrative and character written, in part, to depict the impossibility that institutionalized racism accords to certain performances of motherly and romantic loves, Winfrey's own hypervisible, public maternity induces the film *Beloved* to write a different, more hopeful story.

In "Caregivers of Color in the Age of Multiculturalism," Sau-ling Wong explicates the kind of "ideological caregiving" that a figure like Winfrey provides for a rapidly transforming, "multicultural" society. Speaking of 1980s films featuring "'motherly' caregivers of color of both genders," Wong asserts that

> in a society undergoing radical demographic and economic
> changes, the figure of the person of color patiently mothering white
> folks serves to allay racial anxieties: those who fear the erosion of
> their dominance and the vengeance of the oppressed can exorcise
> their dread in displaced forms . . . By conceding a certain amount of
> spiritual or even physical dependence on people of color—as helpers, healers, guardians, mediators, educators, or advisors—without

ceding actual structural privilege, the care-receiver preserves the illusion of equality and reciprocity with the caregiver.[42]

Given Winfrey's daily, public role as this sort of ideological caregiver, it's reasonable to assume that what might otherwise be an audience's highly conflicted perception and interpretation of Sethe and her history becomes somewhat domesticated and determined by Winfrey's signification of a particular kind of racialized, therapeutic motherhood. Indeed, the figure of Winfrey facilitates the audience's critically unreflective feeling of resolution regarding the historical crimes of slavery and its legacy of the racialized exploitation and disruption of black women's sexual and reproductive capacities. However, it is not only Winfrey's highly visible and influential roles in the production and promotion of the film that enable this feeling of a racist past, horrible as it was, having passed. The problem of translation, from literary language to mainstream Hollywood generic visual language, itself facilitates this.

The visually fixed temporal and geographic setting of the filmic narrative—combined with the screenplay's omission of Sethe's mind-voice testifying to the always present, *daily* "serious work of beating back the past"—comfortably place the film's images and their referents firmly, already in the past. Of course, Morrison's novel also constructs a particular setting with regard to time and place; but her skillful disruption of linearity and innovative presentation of Sethe's and the other characters' interiority allows her to attribute a continuity to racial trauma, a continuity alive in memory and alive in the material present. In the novel, the fleshed-out past carried in the figure Beloved does indeed disappear, but the forgetting of her is a deliberate, troubled, and threatened forgetting:

> So they forgot her. Like an unpleasant dream during a troubling sleep. Occasionally, however, the rustle of a skirt hushes when they wake, and the knuckles brushing a cheek in sleep seem to belong to the sleeper. Sometimes the photograph of a close friend or relative— looked at too long—shifts, and something more familiar than the dear face itself moves there. They can touch it if they like, but don't, because they know things will never be the same if they do.
> This is not a story to pass on.[43]

In the novel, *Beloved*'s status as merely a memory object is threatened by the history and historical continuity of racism that she, in part, signifies.

This is not a story to pass on, because it disables life-sustaining, hope-sustaining technologies of forgetting. But, and at the same time, it is also not a story to *pass* on, because it is not, in truth, a story about the past. Its images are not containable or locatable in a particular moment, because its referents are not. Significantly, the filmic narrative attributes a past-tense and almost singular quality to the racial crimes that made Sethe's rough choice—infanticide—indeed the most logical and loving choice. It does this, interestingly enough, by anchoring the narrative's meaning through the character Baby Suggs as the good mother, the one who we see horrified at Sethe's "transgression," but who we don't, as we do in the novel, hear say, "The only bad luck in the world is whitepeople."[44]

In the film, Baby Suggs is the mother who we see take in and care for Sethe and her own children, but who we don't hear remember, as we do in the novel, that

> What she called the nastiness of life was the shock she received
> upon learning that nobody stopped playing checkers just because
> the pieces included her children. Or that her son Halle was . . .
> given to her to make up for hearing that her two girls were sold and
> gone and she had not been able to wave goodbye. To make up for
> coupling with a straw boss for four months in exchange for keeping
> her third child, a boy, with her—only to find him traded for lumber
> in the spring of the next year and to find herself pregnant by the
> man who promised not to and did. That child she could not love
> and the rest she would not.[45]

By leaving out *this* story of *this* mother, the story that conveys a *history* of racialized experiences of motherhood, and the racialized *meaning* of motherhood, the film encourages viewers, as individuals and communities, to draw on their own (racialized) discursive repertoires to decipher the meaning of the "unspeakable" crimes that the film depicts. Without some different anchoring, without, for instance, an ending message that isn't simply a call to "love your heart" or the (albeit important) declaration that "you are your own best thing," the unspoken and unaccounted-for histories of racial social death, alone, get to structure the difference between what one viewer of the film sees as criminal and another deems angelic, between what one fears as a monster and another loves as a mother.

In her groundbreaking engagement with the historically racialized

(de)gendering and (de)sexualizing of African American females, Hortense Spillers writes that "under a system of enslavement, from the master's family to the captive enclave ... the customary lexis of sexuality, including, 'reproduction,' 'motherhood,' 'pleasure,' and 'desire' are thrown into unrelieved crisis."[46] It is precisely this historical and *historically* unrelieved crisis as a condition and product of racialized and gendered dehumanization that makes impossible a reading of the Hollywood production *Beloved* as a film about, as lead actress and producer Oprah Winfrey put it, the universal truths of "mother love."[47] And it is also this unrelieved crisis that renders suspect critical analyses of maternal imagery that occlude the historical matter of race. To address this matter in Hollywood's 1998 *Beloved* is to illumine the particular sentimental and therapeutic visions of the film that allow the apparently universal categories of history, memory, and motherhood to perpetuate specific, if ubiquitous, racialized violences through maternal bodies.

Feminist film critics such as Jacqueline Bobo and Christine Gledhill have made the important argument that different viewing subject positions produce interpretations of texts through a process of politically, socially, and historically situated negotiations.[48] While the many meanings of *Beloved* were and are a result of such negotiations, all potential readings are constrained by the implied and inscribed preferred meaning given to the film by Jonathan Demme as director, and the—perhaps more significant—workings of Winfrey's popular therapeutic persona. Not everyone, of course, yields to the logics of the fantastic horror that Demme's direction constructs or the liberal individualism that Winfrey imports into the film; but every viewer must, indeed, negotiate these elements in assigning meaning to the text. Thus, it is a theoretically productive exercise to illumine both the filmic technologies and the extracinematic influences that coproduced *Beloved* in the generic filmic languages of horror and melodrama, and that ultimately failed to adequately translate into the visual mainstream Morrison's literary indictment of America's violent racial past and present. This theoretical exercise is also politically urgent, however. The stakes of reading historical occlusions through the idioms of genre are material, as real as death and maternity, as physical as the racialized bodies that trouble both.

Prodigal (Non)Citizens

Teen Pregnancy and Public Health at the Border

M ANY CULTURAL THEORISTS HAVE ESTABLISHED that the "epidemic" of teen pregnancy in the United States is a socially constructed phenomenon, one that arose with the national economic and cultural anxieties of the 1970s. Until the "Adolescent and Family Life Act" was introduced in 1978, the status of teenagers as a special population that merited special legislative attention and government resources did not fully exist.[1] At this point legislative officials finally responded to the long-standing demands of women's rights advocates to extend the right of women to control their fertility to teenage women.[2] These advocates leveraged their case by putting forth the argument that teenage pregnancy—assumed to be unwanted and "out-of-wedlock" pregnancy—led to poverty. Previously, women's rights advocates had argued the inverse—that poverty led to unwanted pregnancy—in order to make the case for federal funding of contraceptive education and services.[3] Thus, in an effort to combat poverty and, more specifically, to reduce the number of women receiving AFDC (Aid to Families with Dependent Children), legislative officials passed the Adolescent Health, Services, and Pregnancy Prevention and Care Act, which allocated funding to birth-control education and provision.[4]

The rhetoric of a teen pregnancy "epidemic" provided a convenient, albeit inaccurate, explanation and proposed solution for the social, cultural, and economic transformations that were occurring in the United States in the early 1970s. These changes and the fears they induced for mainstream Americans were in great part a result of the countercultural struggles and civil rights victories of the 1960s. They were also a product of national and global economic restructuring that, with the help of the 1965 Immigration Act, significantly transformed the racial demography of the country.[5] This changed landscape, and the long-standing anxiety with regard to

maintaining American racial "purity" that it exacerbated, set the stage for the institutional and popular discursive connections between race, citizenship, and consumption that would determine how the teen pregnancy problem would be imaged through the twentieth century.

Long before teen pregnancy registered on the radar of either legislative or public-health institutions in the United States, discourses of pregnancy, reproduction, motherhood, and family were already firmly enmeshed with the logics of racialization and the politics of consumer citizenship.[6] Important feminist historical and legal research on race and reproduction in the United States confirms that popular and institutional constructions of "welfare queens" and "unwed mothers" stigmatize poor women and women of color who are placed within these categories precisely because of their presumed, and often actual, inability to occupy an "appropriately" consuming identity in the nation and marketplace.[7] Precisely because the categories and experiences of "woman" and "mother" have always been made to both reflect and produce a racialized national body, (un)maternal figures often occupy the center of debates on cultural and economic phenomena that trouble the ready equation of U.S. citizenship with whiteness and consumption.[8] Dominant discourses of deindustrialization, globalization, war, welfare, and immigration inevitably entail an engagement with the threats to heteronormativity that these events carry out upon and through maternal bodies.[9] It is therefore in keeping with a history of nation building in the image of the white, middle-class consumer-citizen that visions of teen pregnancy materialize through race and class.

In her discussion of the politics of AIDS awareness and prevention campaigns during the 1990s, Cindy Patton provides a framework with which we might begin to examine productions of racialized "national pedagogy" within public-health education initiatives. Patton defines national pedagogy as "the mechanisms and logics that frame the evolving concept of citizen," thus highlighting the dynamic relationship between the political-economic and the cultural spheres that regulate citizens according to scripts of race, gender, and sexuality.[10] Although Patton's discussion refers specifically to AIDS education, her observations about the relationships between institutional definitions and promotions of "safe-sex" behavior, and heteronormative expectations about this behavior and its social and material rewards, is useful in uncovering the racializing discipline of California's teen pregnancy prevention initiatives.[11]

Acknowledging the significant role of "supposedly apolitical health

education strategies" in educating and dividing the public into categories of "those who would be formed into citizens through a national pedagogy and those who would be policed or . . . ignored" helps us to situate appropriately the media strategies and texts used in the California Department of Heath Services Partnership for Responsible Parenting campaign within a broader political and cultural discursive context.[12] Not only are these ads part of a larger visual field of representation that defines the sexuality of racialized "others" as excessive and dangerous, they are also signs that represent, refer to, and reinforce political debates that (apparently) have little or nothing to do with teen pregnancy prevention education.[13]

Significantly, the Partnership for Responsible Parenting (PRP) was an initiative that intersected—not only temporally, but also politically and ideologically—with a number of anti-immigrant and antiwelfare legislative measures proposed and enacted at both national and local levels. Founded by Governor Pete Wilson in 1996 and administered by the California State Department of Health Services, the PRP ran simultaneously with the racial discriminatory measures that state and federal government agencies took to enforce and supplement the Personal Responsibility and Work Opportunity Reform Act and the Illegal Immigration Reform and Immigrant Responsibility Act, which were also instituted in 1996. According to the research findings from her study of the effects of these immigration and welfare reform acts on the treatment of low-income immigrant women, Lisa Sun-Hee Park concludes that "the social contexts that helped garner support for such anti-immigrant legislative measures created an environment that essentially criminalized motherhood for [these] women—whether they be undocumented or documented."[14] The social context to which she refers is the historically xenophobic and nativist culture that has become even more prevalent in the United States since the effects of the 1965 Immigration Act and the increasing globalization of the economy have set in upon the racial ideological landscape of the country.[15]

The anxiety displayed at governmental, institutional, and popular cultural levels over the arrival of rising numbers of immigrants from Latin America and Asia has been labeled by reactionaries as the "browning of America," leading to immigration debates that have arisen with cyclical regularity in the late twentieth and early twenty-first century in U.S. national politics.[16] Fears among some Californians of white minoritization and the abuse of public services by nonwhites led prominent political

figures, such as Governor Pete Wilson, to decry what they called overly permissive policies regarding undocumented immigrants as leading to not merely a state dilemma, but also to a national immigration/welfare crisis. As the site of a spectacularized late-twentieth-century revival of nativism, California emerged in the national imaginary through pervasive imagery of "the hyperfertile undocumented immigrant woman centered on the Latina migrant and her children," according to sociologist Lynn Fujiwara.[17]

In California during the 1990s, this anxiety was most evident in anti-Latino and anti-immigration measures, particularly Proposition 187, the "Save Our State" campaign. Proposition 187 sought to deny public benefits, including health care and education, to undocumented immigrants.[18] Although it was never officially implemented, Proposition 187 both symbolically and materially displayed the widespread local and national animosity that was the social context in which California's Department of Health Services defined not only the problems of welfare and immigration, but also the problem of teenage pregnancy.[19] In this context, the California PRP campaign demonstrates the rhetorical imperatives of properly regulated heteronormativity as the preeminent assertion of citizenship. Within immigration debates of the past several decades, discourses of normative sexuality and gendered propriety have structured both state projects of regulation and progressive struggles on behalf of documented and undocumented immigrants. In other words, the teen pregnancy campaign offers an opportunity to consider how antistate activism has been confined by heternormativity as well, by regulating immigrant women's maternity, and reproductive health programs.

In this context, the racialized imagery that has historically defined the social, cultural, and economic perils of immigration in the United States constituted the signifying and interpretive material with which the pictures of pregnant brown women and young brown fathers used in the PRP media campaign were produced and understood.[20] Although the official mission of the campaign was not focused on immigration, its images worked with and called upon the commonsense racial logic that representatives of state and federal government agencies used to threaten immigrants with designation of "public charge" during the Port of Entry Fraud Detection Programs they instituted in California from 1994 to 1999.[21] These programs were designed to help the Immigration and Naturalization Service (INS) and the California Department of Health Services (DHS) to identify immigrants who might have fraudulently used Medi-Cal bene-

fits. Established at the border of Mexico, at the Los Angeles International Airport, and at the San Francisco International Airport, the detection programs depended on the sharing of information between Medi-Cal, the DHS, and the INS, and capitalized on the justified fear that immigrants (both documented and undocumented) had of using public benefits to which many of them had a legal right. At these "port-of-entry" sites, representatives of both the DHS and the INS would question individuals that fit an established profile, a profile that in fact "contrasted sharply with the general profile of people eligible for Medi-Cal programs."[22] A report prepared by the Bureau of State Audits after the programs were terminated found that "ninety-seven percent of all the individuals investigated . . . were women. Eighty-six percent were between twenty-one and forty years old, and eighty-nine percent of cases involved families with children." In addition, the profiles of women chosen for questioning at these "ports of entry" were of "Asian and Latino origin": "Flights from Asia and Latin America, principally Mexico, and women of childbearing age were targeted."[23]

Although the target population of the Partnership for Responsible Parenting's teen pregnancy prevention initiative was, indeed, members of the teenage population and therefore not the same age population as that singled out by the Port of Entry Fraud Detection Programs, the (visual) racial profile of both of the campaigns' target communities was the same. Both the "in-language" ads (ads whose text was in Spanish or select Asian languages) and all of the English ads that belonged to the "abstinence" category depicted nonwhite teenagers. Although the intended audience of the English ads was the general California teenage population, it is highly unlikely that an individual viewing the ad would racially identify the dark brown-haired, brown-eyed teenagers represented in each as unmistakably Caucasian.[24] In the same way that these nonwhite communities were singled out by the Partnership for Responsible Parenting's imaging of the teen pregnancy problem, the women interrogated by the DHS and the INS upon their arrival at the U.S.–Mexico border and the Los Angeles and San Francisco airports were also nonwhite.

The victims of racialized harassment during the port-of-entry investigations symbolized the result of "failed" teen pregnancy prevention initiatives: they were women with children who, according to the DHS and the INS, had likely used public monies to assist their reproduction.[25] Both the Partnership for Responsible Parenting and the Port of Entry Fraud Detection Programs defined the sexuality and reproduction of women

of color as taxpayer burdens. Indeed, the Partnership for Responsible Parenting's informational brochure conveys the primary atrocity (to taxpayers) of teen pregnancy in California with an appeal to the idea of "public charge": "California spends $5–$7 billion per year supporting families begun by teen parents."

That the California Department of Health Services was an administrative arm of both the PRP and the port-of-entry programs—and especially, that it colluded with Medi-Cal and the INS for the fraud detection programs—demonstrates the racialized institutional production and treatment of nonwhite and immigrant women's reproduction and maternity. The relationship between these two programs—one focused on the behavior of immigrants and the other on the behavior of teens—is a relationship based on the racial identification of "undesirables" and the threat of their procreation.

The fertility, sexuality, and motherhood of women of color in the United States have always been understood as the property of the state, and have always been (de)valued according to its economic needs, dominant cultural practices, and racial ideologies.[26] While scholars have rigorously historicized the construction of "teenagers" as a distinct population and "teen pregnancy" as an official national burden warranting legislative attention, these accounts too often fail to identify the inextricable connections—in criminal-legal, political-economic, and popular cultural spheres—between race and reproduction, and therefore, between race and motherhood.[27] These relationships, along with the visual discourses and institutional practices deployed to reinforce them, depend on notions of the "worthy" citizen as white and the good mother as married.

In much the same way that unwed motherhood came to be understood as a threat to the patriarchal, conjugal institution of family in the post–World War II era, teen pregnancy emerged in the 1970s as a similar, if not the exact same, impediment to the ideological and material production of the nation. The reasons for, and remedies proposed to, unwed motherhood in the 1940s and 1950s were dependent on the racialized construction of the perpetrators of this infraction.[28] Contemporarily, commonsense and public health educational discourses of teen pregnancy and (potentially) pregnant teen bodies continue to demonstrate their dependence on historical technologies of racialization that attribute a lesser value to the bodies and children of women of color precisely because of their presumed, and often institutionalized, inability to occupy an identity of "earned" consumption.

In "Race and 'Value': Black and White Illegitimate Babies, 1945–1965," Rickie Solinger documents the history of racialized perceptions and treatments of reproduction and motherhood to which California's Partnership for Responsible Parenting campaign belongs. Prior to World War II, out-of-wedlock pregnancy and maternity in the United States were treated by the public and by social-service institutions in a uniformly punitive manner: generally, both white and black mothers of "illegitimate" children were stigmatized and expected to bear, alone, the "appropriate" punishment of having to birth, raise, and support their children. It was widely believed that the deficient moral and mental character that these women displayed by becoming pregnant while single was passed on to their children: the intergenerational transfer of such characteristics was as biologically determined as was these mothers' natural bond to and with their children.[29] That motherhood itself was immutable meant that the only appropriate place for a child was with his or her biological mother. In the postwar era, however, the biological determinism that had made the adoption of (white, illegitimate) babies both undesirable and unacceptable gave way to psychologized explanations of premarital sex and unwed pregnancy that occurred among white women.

The triumph of the United States in World War II symbolized a victory of American political, economic, and cultural institutions, and the (white, middle-class) family was fundamental to these. Otherwise "legitimate" family units that were equipped to participate in the national body and marketplace as consuming citizens but unable to bear and rear children thus constituted a new and growing market for adoptable white babies. The solution to the increasing nature of premarital sex and the prevalence of out-of-wedlock births in the postwar era required a different discourse of white unwed motherhood. What was previously deemed biological and permanent—a tendency toward moral and mental deficiency—was now environmental and temporary. What was once hardwired and immutable—the biological mother–child bond—was now recognized as a learned behavior, one that could be "adopted" within a nonbiological, normal (white) family unit. As Solinger writes, "[r]eliance on the psychological explanation redeemed both American society and the individual female. Moreover by moving the governing imperative from the body (biology) to the mind (psychology), all of the fixed relationships previously defining white illegitimacy became mutable, indeterminate, even deniable."[30] The need to rationalize or recast the otherwise reprehensible sexual behavior

of young white women meshed with the desires of an increasing number of white men and women aspiring to legitimate family status. The result was a discursive and literal detachment of white illegitimate babies from their biological mothers, and, in turn, a detachment of these mothers from the stigma of out-of-wedlock sex and pregnancy. The adoption of these babies into "normal," white, healthy families—oftentimes against the wishes of these children's biological mothers—thus revised the value of illegitimate births among whites, in essence making the phenomenon of unwed pregnancy among white women itself an institutionally legitimate reinforcement of whiteness as the image of the nation and the family.

The new psychologized discourse of unwed pregnancy and motherhood in the 1950s did not apply to black women and families, however. The explanations for their "deviant" sexuality and moral failures remained located in racialized, culturalist notions of pathological black sexuality, motherhood, and family.[31] Because there was no market for black illegitimate children, and because the biology that made moral deviancy a hereditary fact within discourses about black reproduction, neither the problem of nor the solution to black unwed motherhood could "legitimately" or effectively be addressed with government institutional support or social-welfare programs. Thus, after the war, social workers began using the criterion of race to distinguish between those mothers of illegitimate children who should be cast aside and made to pay for their "mistake" without the benefit of institutional support, and those who would be provided access to adoption services so that they could redeem themselves and continue on their "natural" paths to normal, productive lives as future (married) mothers who would nurture their families' participation in the national, commercial culture.

In her groundbreaking work on the commercial construction and context of identity formations in the United States, Arlene Dávila suggests that the historical linkage between "belonging" and consumption becomes stronger as new populations and commodities enter and flow in and out of the nation:

> The new diversities ensuing from transnationalism and the flow of populations from cultural goods have not only opened possibilities for new pluralities and hybrid identities, but, most significantly, created new demands for establishing "belonging." And two variables seem to be constant in these processes: culture, involving the exis-

tence of particular and lingering hierarchies of race/ethnicity/language/nationality that mediate people's position within any given society; and consumption, insofar as whether as exiles, citizens, permanent residents, or immigrants—individuals are consumers first and foremost.[32]

Citing the work of historians of mass culture, Dávila reminds us of the long-standing equation in the United States of "American citizenship with consumption and the illusions and promises of commercial merchandising."[33] These promises were the incentive to "responsible parenting" (read: parenting within the context of heterosexual partnerships recognized by the state) used in the teen pregnancy prevention and abstinence campaigns of California's PRP's programs.[34]

Indeed, the Partnership for Responsible Parenting's print advertising equated teen pregnancy with unwed motherhood. The six bullet points used in the PRP's brochure to outline the imperative for teen pregnancy prevention programs in California read:

> Every year, nearly 65,000 teens have babies in California—that's one birth every eight minutes; Men over age 20 father 66 percent of teenage births; California spends $5–7 billion per year supporting families begun by teen parents; One-out-of-three California children is born out of wedlock; Two-out-of-three babies born to teen mothers are born out of wedlock. Twenty-two percent of births to teens are repeat births.

The point of these statistics is summarized with the declaration: "Teen pregnancy crosses all racial, ethnic, geographic, and economic boundaries; it's everyone's problem. If you are a concerned Californian, we invite you to join the largest teen pregnancy prevention effort in the nation."[35]

Within the anti-immigrant cultural climate produced by such measures as Proposition 187 and the port-of-entry programs, the assertion that "teen pregnancy is everyone's problem" refers to the fact established in the statistics provided to define the problem: that every legitimate and worthy citizen is affected by the irresponsible sexual behavior of teenagers who, significantly, belong to the same racial, if not national, communities accused of fraudulently using Medi-Cal.

In her incisive analysis of the "ideology of white injury in discourses

of immigration," Lisa Cacho reveals the historical culture of white entitle-
ment undergirding the apparently race-neutral language of Proposition
187. Section 1 of the proposition reads, in part: "The People of California . . .
have suffered and are suffering personal injury and damage by the crimi-
nal conduct of illegal aliens in this state, [and] . . . they have a right to
the protection of their government from any person or persons entering
this country unlawfully."[36] As did Proposition 187, the Partnership for
Responsible Parenting implored "the people of California" to take action
against their own suffering at the hands of irresponsible outsider popula-
tions, whether they be teenagers or people of color, or both. While the
language of the above-mentioned brochure emphasized the "suffering" of
taxpayers at the hands of huge numbers of aberrantly sexual "citizens," the
images in the visual media components of the campaign implied that teen-
age parents would foreclose their own (consumer) citizenship and future
identities as entitled taxpayers if they did not abstain.

In the campaign's mall kiosk poster "Curves"—which, according to sur-
veys conducted to assess the effectiveness of the teen pregnancy prevention
media campaign, was the ad most readily recalled by respondents—we see
the workings of a project that assumes (for the "figures" it depicts) identi-
fication with commercialized notions of beauty and sexuality.[37] This iden-
tification implies or promises a status of belonging at the same time that it
implores this racial "other" to not produce more of those who, like herself,
will never indeed belong.

This image and its caption effectively project onto this young woman's
mind a self-reflection on her own pregnant body, which she must now per-
ceive as less than desirable and, in fact, asexual. It is indeed ironic that the
deterrent to teenage sex is imaged here as the possibility of the loss of sex
appeal. But the values and desires that are ascribed to this young woman
(those that make curves so important to her) assume a particular kind of
sexuality as the norm, as the constitution of (her) worth. Within the con-
text of the other abstinence/teen pregnancy prevention ads, the message
conveyed here about the desire for commercialized sex appeal is one that
fits, whether intentionally or not, the campaign's more general represen-
tation of brown youth seeking gratification, self-worth, and belonging
through material possessions.

The mantra repeated in each and all of these abstinence ads is "Hold
off on sex. Hold on to your future," where "your future" can offer new cars
as opposed to new strollers, pagers that don't sound like the wailing of an

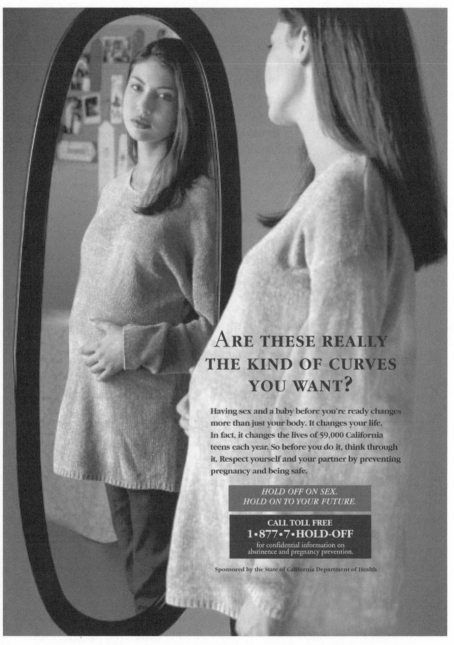

The "Curves" ad: promoting abstinence with the threat of unsexiness. Partnership for Responsible Parenting Campaign, California Department of Health Services, 2000.

unhappy baby, and, of course, sexy curves rather than pregnant ones, if "you" abstain from sex. They are not promoting "safe" sex, but rather abstinence *in the name* of sexiness, because sexiness is assumed to be what these young women and men value.

Whereas the poster "Curves" most directly appeals to the body-image consciousness instilled in teenagers through all forms of media, "Wheels" and "Pager" also hail young men and women concerned with the material possessions—whether they be sexy bodies or sexy commodities—that will make them (as bodies and images themselves) appealing to a potential, presumably heterosexual, mate. As Donald Lowe observes: the "sexual image is a currency, a powerful sign vehicle or signifier to energize the characteristics of any commodity. Conversely, characteristics are designed and packaged into commodities, with the advertising of sexual image in mind."[38] It is in this sense that the wheels that the young man has apparently relinquished to the reality of a baby and her stroller are, in fact, the sign of his sexual image, and the would-be "vehicle" for his (now thwarted) sexual experiences. It is perhaps an all-too-well-known "fact" that guys with "hot" cars get the "hot" girls: the way in which this ad works is, therefore, not the least bit mysterious at the surface level of appeal. Considering that the ad belongs to a series comprising the visual media component of a teen pregnancy prevention (read: abstinence) initiative, however, a more careful interrogation of the sexualization of the commodity, and the "advertising of . . . sexual image," is important.

Although the media components of public-health educational campaigns are not typical advertisements in which a particular material commodity is being marketed, or, in Donald Lowe's terminology, sexualized, the purpose and function of these ads nonetheless is *to sell*. According to the mission statement of the campaign to which they belong, what is being sold, or promoted, is a particular behavior: abstinence first, and safe sex second. To whom this behavior is being sold is another question. According to representatives of the research and media agency that created these ads, the target consumers of their messages were the general teenage population whose sexual behavior and birth-control practices they wished to modify according to the mission of the Department of Health Service's Partnership for Responsible Parenting. Given the particular social, cultural, political, and economic context of California, however, these images sell much more, and to many more individuals and communities than those belonging to the general teenage population.

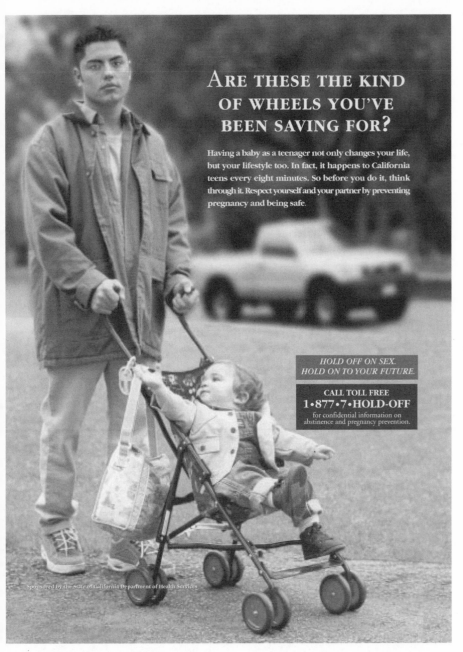

The "Wheels" ad: a truck traded for a stroller. Partnership for Responsible Parenting Campaign, California Department of Health Services, 2000.

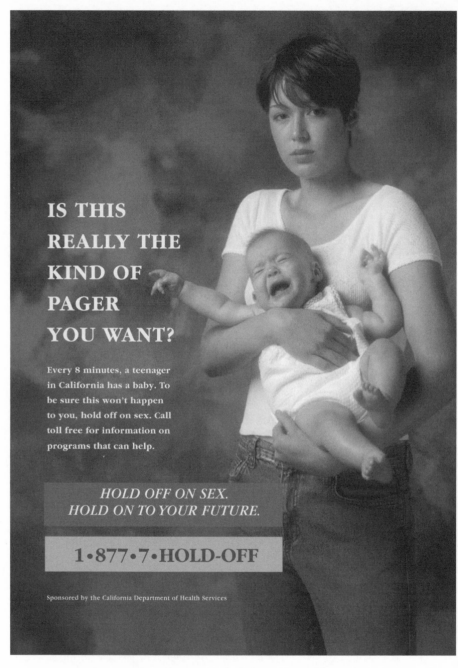

IS THIS REALLY THE KIND OF PAGER YOU WANT?

Every 8 minutes, a teenager in California has a baby. To be sure this won't happen to you, hold off on sex. Call toll free for information on programs that can help.

HOLD OFF ON SEX.
HOLD ON TO YOUR FUTURE.

1•877•7•HOLD-OFF

Sponsored by the California Department of Health Services

The "Pager" ad: a baby's shriek alerts its mother to her limited future. Partnership for Responsible Parenting Campaign, California Department of Health Services, 2000.

Depending on the nature of their composition and distribution, these ads are powerful advertisements for the anti-immigrant sentiment that produced legislation like Proposition 187 and the port-of-entry programs. The three "general market" abstinence ads—"Curves," "Wheels," and "Pager"—were displayed on mall kiosks in ninety-five malls across the state of California, while "Curves" and "Pager" also appeared in two magazines geared toward teen females. The (perhaps obvious) strategy of this marketing tactic depended on the fact that the target population tends to frequent malls regularly and in significant numbers. However, shopping malls are also host to the population of voting adults to whom ideas about not only teen pregnancy prevention, but also welfare reform and immigration, are being imaged in these ads. Working in conjunction with the Spanish-language ads that were simultaneously aired on the radio and displayed on highway billboards, these mall kiosk posters presented yet another "dark" picture of (nonwhite) teen sexual irresponsibility and public burden.[39]

The subject hailed by ads depicting curve-desiring Latinas and placed on shopping-mall directory displays just outside stores such as Macy's is not only the subject belonging to the apparently targeted population. Nor are the billboards like "Ser Padre" (To be a father) and "Fatherhood Is Forever" erected in predominantly African American and Latino neighborhoods speaking only to communities of color. Rather, ocular "proof" of the sexual irresponsibility of racialized women and men occupies the status of commodity in our national cultural economy, as it provides political leaders and middle- and upper-class "citizens" valuable rationalization for the racially stigmatizing nature of public policy and popular cultural debates on welfare and immigration. This is precisely the reason why an intentionalist reading of this particular public-health education initiative cannot illumine the significance of its media campaign to the local or national public. Whether or not the campaign was designed to target an established "at-risk" population or the population at large,[40] its messages and media texts were circulated and distributed widely, and significantly, within a broader visual field of representation that cumulatively figures youth, especially women, of color as deviant, and as "public charges."

Indeed, regardless of the intentions of the Partnership for Responsible Parenting and its research and media associates, the images of teen pregnancy, sexuality, and "responsible parenting" that it constructed and promoted took for granted its audiences' investments in being, or becoming, part of a particular (U.S.) national body as consumer-citizens. Racially

embodying what the creators of the ads claimed to be an "all-world look," the models in the ads geared toward the "general population" were perhaps thought to reflect the now ever-increasing movement of racial and ethnic populations and identities across national borders and across the clearly marked phenotypes that these borders used to seemingly contain. Nevertheless, the clearly nonwhite, albeit (perhaps) otherwise racially ambiguous models in these "general population" ads disciplined the imaging and imagining of not only the country's teenage pregnancy problem, but also the racial and ideological makeup of its desirable citizens.[41]

That the racially "all-world," but phenotypically "brown," and—because of the racial demographics and immigrant population characteristics of California—likely "Latino" or perhaps "Asian" models in the PRP's "general population" abstinence ads desired to be "consumers first and foremost" is irrefutable.[42] But, as Arlene Dávila observes, "even as legal citizens, [U.S. minorities] have not reaped the benefits supposedly afforded by 'citizenship,' while their cultural, racial, and linguistic difference renders them forever suspects and potential threats."[43] The threats posed to a white, English-speaking America by the cultural, racial, and linguistic difference of young Latino and Asian families (whether immigrants or U.S. nationals) loomed large in and through the differences constructed between the PRP's "racial/ethnic specific," "in-language" ads, and the "general population" English ads. That, according to the media agency representatives interviewed, all of the non-English ones were meant to target specific "ethnic" communities and all of the English ones were meant to target the "general population" points not only to the assumption that members of the "general" (read: normative) population are English-speaking. It also points to the ascription of "other" languages to utterly "other" communities whose linguistic and cultural traits merit an entirely different campaign strategy.[44]

The "in-language" abstinence ads of the PRP were posted primarily in demographically appropriate areas, where it was assumed they would have the largest audience and greatest effect. For instance, rather than appearing on mall kiosks (like the "general population" ads), the Spanish-language ads appeared in the commercial districts and neighborhoods with significant populations of Latinos. That they were obviously posted in public spaces—some of them on highway billboards, as well—meant, however, that they also obviously reached non-Spanish-speaking populations. Those who read Spanish had the "benefit" of the ads' captions

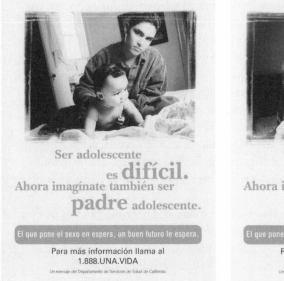
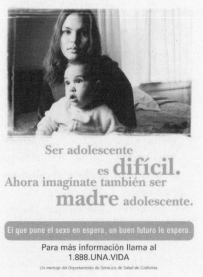

Ser Adolescente ads for young men and women. Partnership for Responsible Parenting Campaign, California Department of Health Services, 2000.

that warned: "Ser adolescente es difícil. Ahora imagínate también ser madre/padre adolescente. El que pone el sexo en espera, un buen futuro le espera."

For those who don't read Spanish, however, the ads could only have the effect of drawing a tight and powerful association between an "other" language and an aberrant sexuality that produces obviously unfortunate consequences. (Note the models' looks of upset.) For those who engage in this unfortunate behavior—presumably those who understand and/or speak Spanish—the unfortunate consequences are apparently the loss of possibly a bright future. For those who don't read Spanish, the unfortunate consequences, for them, of this "other" behavior are—as anti-immigration and antiwelfare discourses attest—the use of their tax dollars to pay for the care of these "babies having babies."

Read with and against the "general population," English-language abstinence ads that depict a consumer-based identity/national citizenship, these "racial/ethnic-specific" ads also visually chart an earlier (perhaps, "primitive") stage on the path to assimilation. Without the facility of the

English language, the figures they represent are much further away, or alienated from the promise of incorporation into the national, consumer culture. They are encouraged to abstain from sex with the vague promise of a better future. But the presumably English-speaking and better-assimilated figures depicted in the "general population" ads—as well as those to whom these ads are meant to appeal—are encouraged to abstain from sex with the very specific promise of inclusion in or threat of exclusion from a citizenry constituted by consumption. Indeed, the threat of never achieving the subjectivity promised through active participation in consumer culture looms large in the English-language abstinence ads that lament the loss of purchasing power (read: sex appeal) to a life of parenting.

Access to the services that make possible not only the fulfillment of idealized roles and responsibilities of mothers, but also make a healthful and safe existence for poor women and their children, has historically been denied to racialized communities. The fertility, sexuality, and motherly capacities and experiences of young women of color are (over)determined by the manners in which these experiences are visualized and made material in the belief systems and voting practices of those who produce and witness them. The anti-immigration legislation and programs that California proposed and implemented in the 1990s evidenced the state's denial of both human and citizenship rights to people of color who did not fit the profile of the worthy consumer. At the same time, the visual discourses of the Partnership for Responsible Parenting and, by extension, the problem of teen pregnancy were colored to match this suspect profile, and to reinforce the equation of (the remote possibility of) true belonging with consumption. While the racialized discourses of immigration, national belonging and reproduction, and pregnancy were especially tightly imbricated throughout the twentieth century, they would become even more twisted, even more publicly and politically visible texts with the dawn of the twenty-first century and the advent of the war on terror.

Breeding Patriotism

The Widows of 9/11 and the
Prime-time Wombs of National Memory

*The domestic realm can be figured as well by a battleship as by a
nursery.*

—Laura Wexler, *Tender Violence*

I N THE WEEKS FOLLOWING THE TERRORIST ATTACKS in the United
States on September 11, 2001, Oprah Winfrey's television talk show fea-
tured pregnant survivors who had lost their spouses. In February 2002,
thirty new mothers—all widowed in the attacks of 9/11—graced the cover
of *People Weekly* magazine, each one cradling an infant. Six months later,
ABC's *Primetime* gathered sixty-one such widows and the children born to
them in the months after the attacks for a photo session at the Brooklyn
Botanic Garden. On the second, and then again on the fifth, anniversary
of the attacks, *Primetime* followed up with these women and their "9/11
babies" in two more television specials. The episode that showed us where
these "babies" were five years after their fathers' deaths included a pro-
fessional photo shoot that mirrored the one conducted four years earlier.
Amid klieg lights, camera equipment, flashbulbs, and a sea of mother–
child pairs, Diane Sawyer proceeded in a serially sentimental fashion to
prompt individual testimonies of "Daddy's" memorialization from the
children and from their mothers, some of whom (as Sawyer's lead-in to
the feature warns/confesses on their behalf) had "even remarried."

Countless local newspapers and nationally distributed popular maga-
zines continue to cover the ongoing lives of individual 9/11 widows and
their sons and daughters, who invariably resemble their dead fathers in
"remarkable" ways. The prevalent figuring of "9/11 widows" as—first and

foremost—heterosexual *mothers* provides a constantly regenerating site on which the American public can project their feelings of loss, fear, anger, and recovery in the wake of the attacks. As Susan Faludi reminded us in her treatment of the 9/11 widows as "Perfect Virgins of Grief," since the Civil War, U.S. widows "have been expected to take the lead in memorializing and exalting the nation's fallen heroes."[1] Indeed, wherever she is represented as a widow of a righteous war, a mother grieving the loss of her husband is an invaluable breeder of patriotic sentiment and fervor.[2] The structures of race, ethnicity, sexuality, and class underlying such maternal exaltations have been much less visible, however.[3]

The deployment of the grieving widow-mother was perhaps never so immediate and hyperbolic, so widespread—and yet so tenuous—in our popular cultural landscape as it became with the "acts of war" constituted by the 9/11 attacks.[4] With astounding speed, the media manufactured maternal war widows out of women whose spouses were not military personnel, and war heroes out of individuals whose professions ranged from rescue worker to custodian to movie producer to investment banker. Just as the flag of the United States was displayed and flown in a manner and on a scale utterly unprecedented in our historical visual landscape, so too it seemed were "the widows of war," as described by *Good Housekeeping,* placed immediately everywhere in our visual and textual fields.[5] Close examination of these images and narratives, however, reveals that the historical, material, and multiple experiential makeup of September 11 widows resisted any untroubled or untroubling insertion into the war-widow and widow-mother niches of masculinist nationalism. Despite this resistance—or perhaps because of it—mainstream and critical media texts and genres wrestled tirelessly with her figuring, attempting to make sense of her proximity to or distance from traditional patriarchal and nationalist scripts of reproduction, recovery, and resurrection within the contexts of terror, war, and death.[6] Almost a decade after the terrorist attacks, the media image archive of 9/11 widows continues to offer up a range of types to our visual cultural field.[7] While clearly not fully accounting for, or being accountable to, the actual range of these women's experiences or their complicated and changing political locations, the form and content of these representations varies to a surprising and interesting degree.[8] Comparatively analyzing the figuring of the widow of 9/11 types as sympathetic maternal and/or outspoken and (un)patriotically politicized illumines the ways in which specific imaging practices fix these and other

women's positions relative to their proper roles as reproducers of the nation through the bodies and memories they carry, host, revise, and recover.

Primetime Healing for the *People:* The Sympathetic Maternal Widow and "9/11 Babies"

As I discuss in chapter 3, the talk show *Oprah* has provided an important venue for maternal sentimentality and liberal humanistic talk therapy since it first aired in the 1980s. Her show was thus perhaps a quite "natural" place to host images of pregnant 9/11 widows almost immediately following the attacks. In her incisive treatment of "Television Culture after 9/11," Lynn Spigel notes that in the episodes of *Oprah* that featured these widows, "the 'talking cure' narrative logic of the talk show format itself was itself strangely derailed by the magnitude of the events: the female guest was so traumatized that she was literally unable to speak . . . The episode presents this woman as having lost not only her husband but also her voice and, with that, her ability to narrate her own story."[9] As a suffering moral victim whose uncontrollably grieving body expresses and compels intense sentiment, the pregnant widow seems an ideal vessel of and for pathos. As Spigel laments, however, "pathos can often be an end in itself; the spectator emerges feeling a sense of righteousness even while justice has not been achieved in reality and even while many people feel completely alienated from and overwhelmed by the actual political sphere."[10]

In a manner utterly unprecedented in the United States, however, the *cultural* political sphere of 9/11 visibly and violently produced the circumstances of these women's widowhood: their fellow citizens witnessed their husbands' deaths on television over and over again, many fearing their own deaths as they participated in the events as both spectators and potential victims. The immediate horror and continuing visual horror-fying of September 11 on computer and television screens troubled the melodramatic narrative that would normally hail us all to watch and weep, and do nothing else, on behalf of nameless widows.[11] In the initial aftermath of September 11, images of widow-mothers' emotional and potentially financial suffering offered the American public a sense of righteousness not only in its engagement with these women's personal stories, but also through how this engagement incited them to a heroic patriotism and support for the "war on terror." Images of devastated widow-mothers begging the question of how they could go on without their husbands and

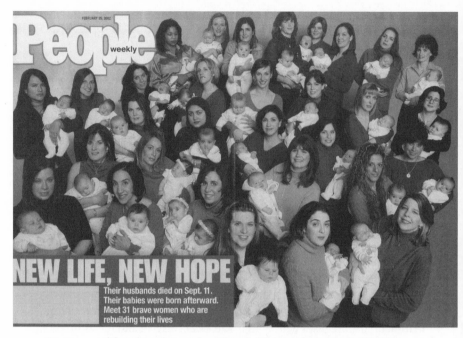

Covering new life and new hope: 9/11 widows hold their infants. People Weekly,
February 2002.

co-parents were deployed in all forms of local and national media to com-
pel intense identification and sympathy for the plight of these women. In
addition, they provided justification for a retaliatory war in Afghanistan,
as they were painful and potentially enraging evidence of the aftermath of
the attacks.[12]

If, as Laura Wexler asserts, "the domestic realm can be figured as well
by a battleship as by a nursery," the nursery can also justify the deploy-
ment of battleships and bombs.[13] Her incisive explication of the "tenderly
violent" historical relationship between home and war helps us see how
it is that *both* are present and co-constitutive in the February 2002 *People
Weekly* cover that included neither homes nor weapons. The caption in-
structs us to focus on "New Life, New Hope": "Their husbands died on
Sept. 11. Their babies were born afterward. Meet 31 brave women who are
rebuilding their lives."

The range of expressions on the widows' faces depicts the range of emo-
tions and experiences that attend their collective procession from grief to

hope. Some are beaming, a few are stoic, a small number look deeply sor-
rowed, and a few appear to be either in a mild state of emotional shock or,
perhaps more tellingly, perplexed at the camera's fascination with them.
This range of displayed emotions, however, is leveled by the patriotic con-
text of the "new life, new hope" that accompanies national(ist) narratives
of recovery in the wake of death. All indices of difference—different fa-
cial and bodily expressions, different manners and colors of dress, differ-
ent racial and ethnic presentations—are flattened by the "cover" of sen-
timentalized maternity in the service of patriarchal, national resilience.[14]
These markers of difference are blurred, as well, by the hypervisible and
uniform(ed) products of their patriotic maternity: brand-new babies, col-
lectively clad in whiteness.

This mass of maternal bodies, the piling of comforting and cradling
arms one set on top of another, the vulnerable yet thriving objects they
bear, all reference and counteract the rubble of Ground Zero death images.
As these widows awaited evidence and recovery of their husbands' bodies
at the sites of the attacks, the visual and textual discourse of September 11
media accounts highlighted piles of bodies and body parts amid mounds
of hot and flattened steel. The terrorist attacks leveled the nation and the
national body: the destruction was visible in carnage and crushed build-
ings, an impenetrable mass of death. These mothers and their newborn
children are imaged as resurrections in the image mold of this same mass.
Dead bodies are replaced with live bodies holding and nurturing new bod-
ies. The collective *national* body is thus recovered and its future hopes lit-
erally held out in one image: a white baby figure, multiplied, unmistakable,
unstoppable, (re)generating. Indeed, the effect of the repeating and relent-
less white-clad and googling masses in each woman's arms is a sprouting
one. The reproductive power of the widows is harnessed and corralled
within the ideological space of the national(ist) collective.[15] Mounds of
death are rescripted in the image of a birthing mass. The vessels—the ma-
ternal bodies—retreat in our visual field as/to mere and messy platforms.

The text of the cover story also effectively levels the widows' different
social identities and experiences of loss. After a brief framing of its subjects
as grief-stricken but brave and loyal wives and new mothers, the article
proceeds to present each woman "in profile." With unfailing consistency,
the details of each brief profile establish each widow's relationship with
her deceased husband as ideal. Almost all of them assert that the memory
of their husbands will be carried within and through their newly born

children.[16] For example, Courtney Acquaviva feels her deceased husband's presence in her children's smiles, those small embodied testimonies to their father's perseverance: "This is how Paul sends me love, when the children smile. He's still here, I've still got him. And no terrorist can take that away from me."[17] Their smiles are thus not only small, embodied testimonies to the perseverance of their father's love. As she describes her children's smiles in this way, Acquaviva establishes that her maternal visuality—*how she sees as a mother*—is a faithful visuality that re-members the husband/father. Seeing him in the joyous expressions of her children is a maternal act that asserts survival and triumph, that restores a patriarchal masculine presence, a wholeness, in the context of a broken and terrorized home/land. Her gaze is thus, itself, restorative, a tender weapon against this home/land's annihilation.

Such defiant, resurrecting maternal visions and visualities appear relentlessly in representations of the 9/11 widows, in narratives of how and when their reproductive acts and maternal experiences conjure the lost husband/father/nation. In the same issue of *People Weekly* that published Acquaviva's widow profile, a story about widow Gigi Nelson presents a rather superhuman double act of reproduction and memorialization, indeed, a quite literal moment of breeding ghosts:

> [When she was] at a memorial service for Peter, who died while responding to the terrorist attacks, [Gigi] Nelson had gone into labor but wouldn't leave. Finally, later that night, near the end of another memorial service for Peter not far from her Long Island home, she stood up and said, "Okay, guys, time to go to the hospital." Three hours later, on Oct. 6, Lyndsi was born. "Right before I gave birth, I looked up to the ceiling and, I swear, I saw Peter," says Nelson. "We all felt his presence, even the doctor."[18]

More vividly than most widow profiles, Nelson's picture of her maternal labor thus resurrects the husband/father. She births his child and simultaneously channels his appearance, raises him from the dead, in such a material way that "even the doctor" felt it.

Nelson's story of her reconnection with her deceased husband is without question a generous invitation into her personal, spiritual experience and one that correlates to the experiences of other pregnant 9/11 widows.[19] Presented in such a clipped profile and distributed en masse, however, the

scene is reduced to a snapshot of a birthing widow so profoundly faith-
ful to and connected to her lost husband's memory that she can conjure
him (back) into the frame. Her maternal vision is thus admirably, aston-
ishingly honed: her brave, devoted, and resurrecting force is vivid, quite
literally written on the wall/ceiling of her birthing room. For Nelson, as
for the other profiled widows, it is her *maternal* experience and identity
that both mark her grief and realize hope with regard to the future. In this
way, motherhood would seem to be a prerequisite for a legitimate, sympa-
thetic, patriotic widowhood: neither the devastating loss (of the husband/
father/nation) nor the courageous will to continue on and to reproduce
(the husband/father/nation) can register without physical evidence of fe-
cundity or progeny.

In fact, Nancy Taylor's widow profile articulated a very clear pattern
of logic connecting the imperative to re-member and resurrect the father
in the aftermath of national terror to a desire to repair and guard fertility:

> Out of the ashes of the Pentagon, where her husband, Kip, died
> on Sept. 11, Nancy Taylor vowed to create hope and renewal. Two
> months later the idea came to her. Fertility treatments at Walter
> Reed Army Medical Center had produced the Taylors' two sons,
> 2-year-old Dean and then Luke, who was born on Oct. 25. So she
> started the Kip Taylor Memorial Fund for infertile military couples,
> which has raised $40,000 from family, friends and neighbors.[20]

Many 9/11 widows were, like Taylor, moved to large-scale charitable and
humanitarian action as a direct result of their painful experiences and their
increasing awareness of a variety of arenas of suffering. Taylor's profile,
like Nelson's, draws a particularly clear parallel between memorialization
of the father in the context of national tragedy and literal, physical fertil-
ity and fecundity. Her active emergence as a widow—and her husband's
continual reemergence as a hero—in the wake of so much loss and death
is realized through *breeding ghosts*. Taylor quite literally funds and champi-
ons fertility in the name of her deceased husband.

That the national public needed to witness, over and over again, the
9/11 widows' reproductive faculties and intentions was obvious almost
immediately upon their husbands' deaths. Much like the February 2002
cover of *People Weekly* that signaled "New Life, New Hope" with an image
of thirty-one babes in widows' arms, ABC's *Primetime* catered to this need

by featuring essentially the same image in episodes aired in August 2002 and August 2003 and then, again, in a "five-year anniversary" episode that aired in September 2006. The first and last of these were structured around the gathering of 9/11 widows and their babies together in one place so that their portraits could be taken and displayed for, and on behalf of, the nation. Recounting the network's efforts to capture the perfect image of the widows with their children in 2002, the *Primetime* script read, in part:

> The group turned the elegant conservatory at the Brooklyn Botanic Garden into happy chaos, the younger babies crying and gurgling (if they weren't sleeping or munching on their blankets), the older ones crawling out of position again and again, mothers and producers running around to catch them. How do you wrangle 26 baby boys and 27 baby girls—ranging in age from three weeks to nearly a year—all into one place and get them to sit still for a photograph?[21]

The determination to "wrangle 26 baby boys and 27 baby girls" into one picture of nationalist hope in the aftermath of a national crisis was immense and long-standing, however. So much so that *Primetime* repeated this portrait making in 2006. In the interim, though, in 2003, *Primetime* did a follow-up—no professional portraits included—with some of the same widows and children that it had displayed in 2002. The camera followed Diane Sawyer as she made the rounds, hugging toddlers and soliciting updates on life, love, and grief from the widows.

Sawyer's 2003 reunion on camera with Jenna Jacobs and her son, Gaby (born six days after his father, Ari Jacobs, died at the World Trade Center), was particularly poignant. Her voice-over reminds us, "We first met Jenna Jacobs as a portrait in anguish." She thus recalls Jacobs's faithful pain and preemptively remolds her in the shape of the pietà, taking the potentially unpatriotic sting out of Jenna's self-report: "I have a new house, I have a new boyfriend, he has a daughter. Things are completely different for me than they were two years ago. *But I'm still me.*" She assures us further: "I still love him. I always will . . . No matter what I do in this life, nothing can separate me from my husband." Jacobs has thus not only maintained for herself an identity as a faithfully grieving widow, she has found love with a new man who "allows" and "expects" this grief from her. "He lets me love my husband and expects me to. And loves me because I do . . . Yeah, he lets me do whatever I need to do."

If it were somehow possible—five years after the terrorist attacks—to represent grieving wives as still and obviously pregnant, the war on terror would have arguably been very well served by a television special that marveled at the miraculous staying power of a few still heroically gestating September 11 widows. Short of this, Diane Sawyer's staging of these widow-mothers sitting silently and nodding approvingly at their now fully verbal "9/11 babies'" narrations of national threat, loss, and heroism in 2006 is important—albeit indirect and limited—evidence of their steadfast maternal commitments to their country and its men. Perhaps more important is the evidence of these commitments provided by the words of the "9/11 babies" themselves.

Now fully in command of language and vivid narrative, these preschooler "babies" recount the circumstances of their fathers' deaths—"A plane crashed into his building and then he died"—and vivid images of their heroic resurrections. One young girl talks of her father as "being with the angels," an "angel fireman." In addition to these, a few other children offer alarmingly articulate testimonies about the circumstances of their fathers' deaths and the narratives they have assimilated to help them make sense of their losses. Within the time-space of the same episode, while loss registers, death without resurrection is warded off. Through the successive flashing of image pairs composed of 9/11 child portraits and pictures of deceased fathers, the screen documents national repair and reconstitution. Diane Sawyer assures us that these children continue to exist in the image of their/the father: "And if the babies looked like their daddies, stop and look at their faces now."

Chosen because their faces carry the phenotypical traces of their fathers, these particular 9/11 babies constitute an impressive feature of the *Primetime* special. The intended product of staging these likenesses is a testimony to the father's ghost-made material in the skin and bones of the children he never saw. Much less arresting would be the highlighted pairing of these children's physicalities with those of their mothers. No longer hosting the progeny-as-memorials in their pregnant bodies, their flesh has nothing to contribute to the ghost forms of the father. Their bodies are now mere vessels, props, for the lines of allegiance and memory that matter most.

In this visual narrative that assures the resurrection of "Daddy" alongside/within the faces and lives of his children, historically embodied impediments to full citizenship are stamped out by a mass maternal, selfless, and self-effacing commitment to nurture an appropriately commemorating

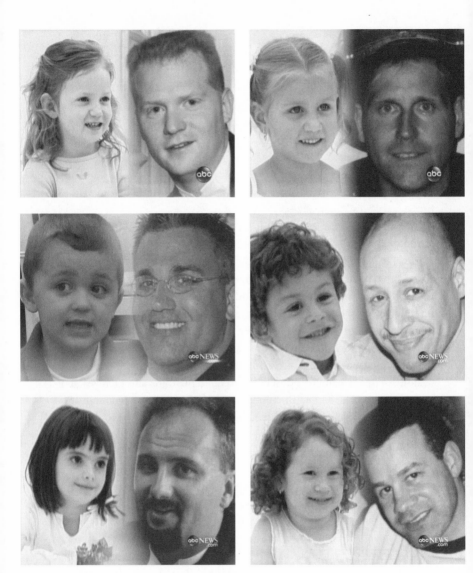

9/11 babies in their fathers' image. Primetime, 2006.

and patriotic future for 9/11 babies. When framed to reflect the identity and host the reincarnation of innocent American Daddy victims of racial terror, phenotype—that historically indelible site of inferiority—becomes the ticket to membership in a beloved national citizenry. Immediately following the child–father pairs depicted here, the *Primetime* special featured brief video footage of African American Jackie Milam and her son, Little Ron, whom she reports often asks about his father. Laid over her report that she tells her son—"If Daddy could be here, he would be here for you"—is Ron Milam's photograph. Countering Jackie's sympathetic acknowledgment to her son that his father is indeed *not* "here," Milam's photograph, which ends the thirty-second segment, situates him as a member in the collective of resurrected 9/11 daddies. As with other visual pairings, the resemblance between father and child is unmistakable. In this way, the Milam family's resemblance to the other war-torn, but regenerating, American families also becomes unquestionable. The likeness of Daddy's face in each and every one of the 9/11 babies offers unmistakable evidence that when war and its terror-objects become global, extranational racial horrors eradicate national ones.

In addition to these pairings of life against death and re-membering against obliteration, the same *Primetime* event produced yet another image of live bodies amassed in the shape of, and replacing, the waste and destruction at Ground Zero.

Similar in formal composition to the February 2002 cover of *People Weekly,* this image from the *Primetime* photo shoot displays the reproductive and patriotic triumphs of the 9/11 widows through smiles, waving hands, and fatherless but vital children's bodies. Diane Sawyer orchestrates, her celebrating demeanor at the image's dead center. The somberness of 2002's winter has passed, the roots of recovery laid with the mass of white-clad infants have clearly taken hold, life and hope are sprouting. The spirits of father and country are maintained in the narratives of memory and loss that Sawyer extracts from the children in her interviews with them, while the photographs offer irrefutable evidence for the restorative seeds of patriotism and patriarchy.

The questions of and imperatives for national recovery played out through the visual representations of 9/11 widows and their children beginning in the fall of 2001 proved to be numerous, complex, and long-lived. The specific national and global contexts that produced the attacks, however, troubled and disrupted the pathos historically obtained so effortlessly

Another photo shoot of growing hope, with Diane Sawyer in center. "9/11 Babies: Five Years Later," Primetime, *2006.*

through the apparently timeless melodrama of the suffering widow and her fatherless children. The relative positioning of every "type" of 9/11 widow, however, consistently occurred and continues to occur with regard to an idealized script of a woman's loyal and patriotic reproduction and self-production.

"What're You, Unpatriotic?": The Jersey Girls and the *Press for Truth*

The cartoon titled "The Unanswered Questions of September 11 Widows" humorously illumines the large-scale about-face performed by many individual and institutional widow supporters when some of these women went public with their unanswered questions about how and why their

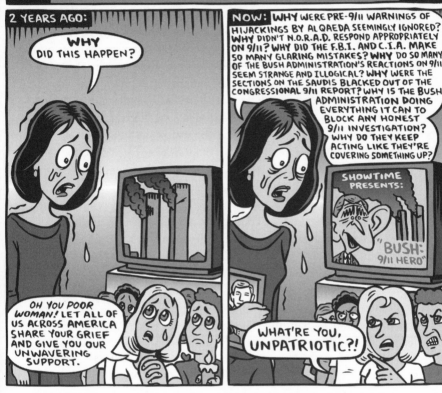

Ward Sutton, "*The Unanswered Questions of September 11 Widows*," Village Voice,
September 9, 2003.

husbands' deaths on 9/11 weren't prevented. Two years after the nation
unified in support of the 9/11 victims' families, it was clear that the behav-
ioral script of the "proper" and "deserving" widow required an only (ever)
apolitical grief. Indeed, the legitimate moral victim that fleshed out the
melodrama of the United States' war on terror could not be embodied by
the likes of such a probing and articulate sufferer.

In the cartoon's right frame, a portrait of the widow's dead husband
buttresses her claim to information about the failures of the presiden-
tial administration and relevant state and local government agencies to

foresee and prevent the September 11 attacks. Her tears and posture are identical in this "Now" moment to those of "2 years ago," but her informed and pointed questions border on self-righteous compared to her originally devastated but fatalistically resigned "Why?" Now savvily wearing her widowhood, she counters the discourse of "Bush: 9/11 Hero" that has come to eclipse the raw facts of the events. Whereas they were once committed to sharing her grief and offering her unwavering support, the public now stands angrily between the widow and the facade of the heroic president. Their tears on her behalf have dried up, their candlelight vigils have been extinguished, and their expressions signal rage and disgust at her lack of patriotism. The grieving and politicized widow in the *Village Voice* cartoon is a caricatured representation of the four women credited for helping bring the 9/11 commission into being despite vehement protests by the presidential administration.[22]

Dubbed with a moniker appropriate to their tough, uncompromising, and very public demand for an investigation into the circumstances of their husbands deaths (as well as to the city of their residence), the group of women now widely known as the "Jersey Girls" are Kristen Breitweiser, Mindy Kleinberg, Lorie Van Auken, and Patty Casazza. Now the iconic representatives of, on the one hand, "widows gone awry" with their politicization and opportunistic deployment of grief and, on the other, brave and untraditionally patriotic voices pressing for truth on behalf of their fellow citizens, these widows' production as tough "girls" interestingly absented their identities as mothers.[23] Whereas the *New York Times* printed a story in 2002 featuring Kristen Breitweiser that featured her with her daughter in her arms,[24] once she and the other Jersey Girls became vocal critics of the U.S. government, the public was hard-pressed to find *any* images of these women with their children. No longer fulfilling the patriotic role of the suffering and apolitical widow-mother, and now fully embodying the angrily politicized woman out for blood, these widow-"girls" could not be productively rendered with children flanking them.

Hell Hath No Fury like a Woman Lied To: The Monstrous (Non)Mothers of September 11

This tough-girl image of Breitweiser and the others was rendered prominently in the cover story of the *New York Times* on April 1, 2004, and again, with the same image (minus Breitweiser, who was not featured in the

The caption accompanying this cover photograph on the New York Times *on April 1, 2004, read: "From right, Kristen Breitweiser, Mindy Kleinberg, Lorie Van Auken, and Patty Casazza (also known as the "Jersey Girls") are on the Family Steering Committee, whose purpose is to monitor the commission investigating the 9/11 incident." Photograph taken by Suchat Pederson on Monday, March 29, 2004.*

film), on the DVD cover of Ray Nowosielski's 2006 documentary *9/11: Press for Truth*.[25]

One of the most extreme representations of the ball-bashing potential of widows gone wrong appeared on a promotional poster for the film. Here, the twin towers are now smoking and the widows-as-femmes fatales—again, no children in tow—appear ominous enough to have been the cause of this massive destruction.

This image of the "9/11 Victims' Families' Relentless Fight for Truth" foregrounds the monstrous maternal again, in part by absenting innocent child-figures from the frame. These women's fatherless children appear only in the word-sign of "families": their innocent faces cannot be reconciled to the angry mothers' project of obtaining and telling the truth. Indeed, the unfaithfulness of the nation/father to their mothers' interests is not

Movie poster for 9/11: Press for Truth.

these babies' business. Despite the film's criticisms of national (in)security policies and the resistance of the administration to the establishment of the 9/11 commission, the promotional campaign for *9/11: Press for Truth* seemed to concur with most major news sources that children's images are effectively called to service only in narratives of patriotism that honor and remember the nation as noble. When and where this nobility

HELL HATH
NO FURY
LIKE A WOMAN
LIED TO.

THE POWERFUL FILM ABOUT
9/11 VICTIMS' FAMILIES'
RELENTLESS FIGHT
FOR TRUTH

9/11
PRESS
FOR TRUTH

www.911PressForTruth.com

*The fury of the Jersey Girls in a movie
poster for 9/11: Press for Truth.*

is in question, "9/11 babies" have no
easy place. In contrast, their mothers'
bodies can be figured to either grieve
or avenge, and the public's reception
of these figures will depend on their
proximity to the idealized patriotism
of the war widow. Far from this ide-
alized patriotism, the Jersey Girls are
easily superimposed in front of burn-
ing buildings and the fury of hell.

As support for the occupation
had continued to dwindle rapidly
five years after the initial U.S. mili-
tary invasion of Iraq, the role that im-
ages of widows play in igniting a na-
tion's masculinist rage at amorphous
Islamic threats of terrorism and fic-
tional weapons of mass destruction
remains complicated and highly contested. Indeed, close interrogation of
this role reveals it to be as, if not more, complex than it has ever been in
American history. As a discourse of and in relation to women's physical
and ideological reproductive roles, as a constellation of sentimental rep-
resentations that are so fundamental to—even as they manage sometimes
to be unbeholden to—patriarchal nationalist imperatives, the maternal
widow continues to bear close examination.

Visual images of the widows of 9/11 have consistently wrestled with
these women's relationship to the reproductive desires of patriarchy and
nationalism, often by insisting on "figuring" their bodies in close prox-
imity to those of their children. For example, the 9/11 preschoolers in the
fifth-year-anniversary *Primetime* were made to revert in the national imagi-
nation to infancy with the story's headline: "9/11 Babies: Five Years Later."
As the individual subjectivities of these children thus regress on behalf of
nationalism, their mother's bodies are re-fused to a singular moment of
collective (re)birth, to September 11 as a defining national moment of ter-
ror, retaliation, and resurrection.

In contrast, the photograph of a pregnant woman in the foreground of
the twin towers' terror scene on September 11 inspires a critical imagina-
tion of a maternal refusal to embody national(ist) imperatives.

Isabel Bessler, pregnant in the foreground of terror. From David Friend,
Watching the World Change: The Stories behind the Images of 9/11, *2006.
Photograph courtesy of Isabel Bessler.*

In August 2006, *Vanity Fair* reproduced the image of a pregnant Isabel
Bessler in a photo essay featuring David Friend's compilation of 9/11 im-
ages, *Watching the World Change.* In both texts, the caption reads: "Not
yet realizing a terrorist attack was in progress, architect and amateur pilot
Isabel Daser Bessler, eight months pregnant, asked a co-worker to take her
portrait as a record of the day."[26] As the twin towers smolder in the back-

ground, Bessler appears unbeholden to the imperatives of the nation and its preservation, even as she carries a child, even as her body appears in the exact image of those pregnant widow bodies that will appear within a few weeks on *Oprah*. The caption here tells us that she did not yet realize a terrorist attack was in progress, perhaps not only because this is true, but also because the idea that a pregnant body could be so unsympathetic to a national crisis, that Bessler's maternal sentiment might not be commanded solely by patriarchy and patriotism, is too much for citizens themselves to bear.

Bessler's pregnant body towers in the same line of sight as the severed World Trade Center, her direct focus on the camera suggesting something, perhaps many things, monstrous about this maternal body. The caption is confused. It does not know exactly what to tell us to think: at the same time that it assures us that Bessler did not yet realize that a terrorist attack was in progress, it also works with her image to compel an incriminating association between this unsympathetic mother-to-be and the violent attack on the nation. Bessler is an architect, but the relevant detail here, the one that can make horrifying sense out of her lack of concern, her nonmaternal response, is that she is also "an amateur pilot," as were the men who carried out the attacks. Despite the fact that she bears no responsibility for these acts of terror, her unsympathetic posture in front of the burning towers bears a threat that registers only, and precisely, because of how and where we expect her to be looking, and toward what end we expect her to be reproducing images and bodies. That Bessler would be looking away from the burning towers—turning her back on, and her womb away from, national tragedy—is impossible. The only hope for her maternal image to be recuperated lies in a caption that explains the misdirection of her look.

Another hypervisible maternal figure that—like the Jersey Girls—does not conform to patriotic expectations is Cindy Lee Miller Sheehan. Sheehan became one of the most familiar names among protesters of President Bush's Iraq War policies, on the basis of her motherhood. Her son, U.S. Army serviceman Casey Sheehan, was killed in April 2004.[27] Along with other grieving military parents, she met with President Bush in June of that year, but reported afterward that they found the president's reasons for going to war inconsistent and unpersuasive. Making strategic and public use of her identity as a mother who had lost her son, she strongly denounced the Iraq War as unjust in demonstrations in early 2005

and cofounded a family support organization calling for the end of the U.S. occupation of Iraq.[28] She became most widely known for traveling to President Bush's Crawford, Texas, ranch and requesting a second meeting with him. When the president refused to speak with her, she set up an impromptu campsite, nicknamed "Camp Casey," and remained there for four weeks, as thousands of supporters congregated daily. Dubbed the "Peace Mom," the "Mother of All Protesters," and the "Rosa Parks of the antiwar movement" by journalists, Sheehan became one of the most widely recognized faces of protest.[29]

However, her deployment of the grieving maternal figure was promoted by journalists only as long as her statements fit the Marian mold of passive suffering and noble outrage. As her statements and actions conveyed greater anger and as street protests featured pitched battles between supporters of and challengers to Iraq War policies, criticism in news media emerged not only from political conservatives, but also from Democratic politicians and journalists.[30] In holding Democrats to their antiwar election-cycle rhetoric and steadfastly calling for the impeachment of President Bush and Vice President Dick Cheney, Sheehan ceased being the grieving mother of the pietà and became an "Attention Whore," as she reflected on her image and submitted her "resignation" as "the 'face' of the American anti-war movement" in a column for the blog *The Daily Kos* in 2007.[31]

While maternal melodrama can play a powerful, patriotic function in its portrayal of redemption through (witnessed) suffering, and while widow-mothers would appear to be ideal moral victims and redemptive channels, their unpatriotically politicized bodies can also refuse them "appropriate" or "legitimate" suffering roles. Visual cultures of the widows of 9/11 and the antiwar mothers of Iraq thus responded and continue to respond to their unruly subjects with profound confusion and contradiction, but with a startling persistence to ground their struggles around the maternal figure. In spite of how they were initially represented—pained, silent, loyal to their lost husbands, their children, and their country, in need of the nation's sympathy—the widows of 9/11 quickly proved to neither perform nor host any easy feelings. Even so, the specificity of their social and economic circumstances before and after their husbands' deaths, the vast range of their ideological commitments, their varying degrees of participation in national and global politics and activism have not deterred the multiple public discourses on them from engaging an idealized, generic

maternal script. Indeed, where the unruliness of gender, race, sexuality, and class cannot be reined in by an avenging, sentimental, patriotic framing, the span of the beloved mother's shadow diminishes and the variety of maternal bodies it can contain dwindles. When we look closely at these moments of limited and limiting maternal possibilities, the historical, ideological inflexibility of the nation's pietà—for all its reproductions—emerges clearly, fixed as an excluding, citizen-making shape.

Vivid Defacements

IN TONI MORRISON'S NOVEL *BELOVED*, a fleshed-out girl ghost poses a desperate question: *How can I say things that are pictures?*[1] The agony of history and the haunting of the real have produced too many unspeakable things unspoken. Only image-memories testify. To animate these with understanding is the purpose of Beloved's physicality, the charge of what appeared to her *in the water and what is down there.*[2] *Down there,* dark and womb-wet, where the trade of human flesh bore her mother a slave and made love out of her murder. Beloved was bred from the horrific, material collision of race, death, and the maternal. Her impossible demand is to be decoded.

Between images and in the interstices of how we have been taught to see, there are so many necessary and invisible forms. As fiercely as we struggle to say things that are pictures, we must work to picture things that are not, the things inside the gaps in images, the content of spaces between time(s), the dynamic imperatives of power taking shape. To animate the relationship between historical violence and visual culture, we must line up the dead alongside the dead, read what is roused, and write those haunting realizations. We have to see what ghosts are bred there and the images they re-member to breed. We have to decipher something reproductive, suture something maternal, and render its abjections. We have to say things that are pictures and picture things that are not.

Morrison's *Beloved* recasts pictures that historically are and have been: it takes its inspiration from the actual experiences of Margaret Garner, an African American woman who escaped from slavery in Kentucky in 1856 and who, before being recaptured, committed a radically maternal murder.[3] *Beloved* animates these historical events, vividly recounting and artistically re-visioning through the characters of Sethe and her family and community what newspapers documented so obsessively in the midnineteenth century.[4] But in rendering the haunted context and haunting aftermath of Sethe's tender violence, *Beloved* also pictures the materiality

of many things ephemeral. It renders the felt heaviness of a racial history's movement and the jarring quietness of its sticking. Indeed, *Beloved* says things that are pictures and pictures things that are not. The novel's ghostly articulations push against the universalizing of such experiences as motherhood, childhood, love, life, and death, thereby approaching a radically race-conscious history.

Beloved declares its stakes as revisionist historical narrative immediately, in the epigraph it takes from Romans 9:25: "I will call them my people which were not my people, and her beloved, which was not beloved." The title character Beloved is an infant girl whose childhood was ghosted twice over—once by its material erasure under the rubric of *chattel,* and again by her mother's act of stealing her baby from inhumanity with a throat cut. Thus dramatizing enslaved women's (non)maternal agency to render their children beloved only in and through death, Morrison illuminates race, death, and the maternal as violently coproductive and colliding historical and identificatory formations. Her purposeful narration of the legacies of slavery in the social, cultural, and psychic landscapes of modernity *through a maternal body and through a body of maternal experiences* beckons us not only to see these bodies where and how they have historically, materially appeared, but also to animate them where their ideological contents blur and bleed into one another, in places where they rub death and make sense of its inextricable relationship to race and nation. Indeed, as cultural theorists Sharon Holland and Avery Gordon have so effectively illuminated, *Beloved* compels us to inhabit the historical breeding ground of racial, deadly, ghostly matters.[5] This ground is extensive, expansive, and elusive: its elements simultaneously scatter and coalesce in the discourses and practices of modern nation building. To read the relative positions of maternal and national bodies in this manner is to take up the critical charge of Morrison's *Beloved:* to illuminate ideology in formation, to uncover a persistent culture of race and death on which the nation's definition and reproduction depends.

Each constructed around annihilating terrors and reproductive desires, race, death, and the maternal are essential, intersecting national(ist) projects. As crucial material in the formation of modern subjectivity, their psychic and discursive manifestations are indispensable to citizen being, as well as to critical interrogations of the same. Images of race, death, and the maternal appear again and again to host our encounters with the nation and its reproductive aspirations, whether these engagements are

compliant, resistant, or indifferent. Where race, death, and the maternal actually appear within the same textual frame—as in the historical case of Margaret Garner, the literary art of *Beloved,* the healing, reviving touches of Oprah and Diana, the figuring of cherished pregnant widows and ruined pregnant teens—are particularly generative sites of cultural and ideological critique. *American Pietàs* has honed in on a number of such texts to illuminate, specifically, the conjunctive *visual* articulations of race, death, and the maternal in contemporary productions and negotiations of U.S. nationalism. Whereas these articulations do in fact occur within single image-texts, and specific, often spectacularized visual cultural productions, they occur also between and across visual frames and across historical events: a critical visuality that registers race, death, and the maternal as coproductions must therefore train itself on intertextual, intermedial, interstitial material to the same degree that it might focus on a photograph or photography, a film or cinema, a painting or an artistic movement. It is perhaps only within such a frame that, for example, the scene of Margaret Garner's infanticide can come into focus as a pietà of radical critical importance.

What, in fact, constitutes the impossible formal equivalence between the scene of Mary's maternal grief and the aftermath of Margaret Garner's maternal murder? What epistemological shifts occur when we put these images—when we *see* these images—within the same frame of historically, relationally constructed maternal visualities? What happens, I argue, is that our visual ways of knowing approach a radical and radically urgent historical consciousness of modern *racialization:* we see what it has formed and what it has erased, what it has realized and what it has denied, and we see how it has done these things in the violent shape and function of universalisms. The vision of Margaret Garner's infanticide as a pietà eludes us for as long as the universalized maternal is made to cover over—at the same time that it is a site for—racial abjection. It eludes us for as long as the Virgin Mary's gentle grief is purely manifest and Margaret Garner's act is incomprehensible, for as long as the racial violence perpetuated by this discrepancy hides in the ideological folds of both revered and reviled maternal visions, and for as long as we refuse to animate the relationship between our dead beloved and our murdered disdained.

In his book *Secure the Shadow: Death and Photography in America,* visual anthropologist Jay Ruby documents "Americans'" attempts since the eighteenth century to use images to "secure the shadows" of their dead

beloved.[6] The *Mater Dolorosa,* the pietà, inspires the formal and—I would argue—the ideological content of a large number of the text's images, but some remarkable differences persist within these forms, within their content.

Both *Rachel Weeping* and *Postmortem photograph of child on lap of mother* appear in *Secure the Shadow.*[7] Although produced in different mediums, separated in time by a century and in Ruby's text by a chapter, the images evidence apparently shared practices of grief and memorialization, and—significantly, for our purposes—the memorialization of a would-be universal and timeless maternal grief. We have no doubt that Rachel wept because, just as it would in a photograph, her weeping referent adheres. Born in a death-instant, immortalized alongside the corpse of her infant girl, Rachel's sorrow clings. Time bears witness like vision: children die, mothers suffer, we see this has always been so.

That Rachel wept is a truth most beautifully obvious. But it is laid and produced over social, historical desires that are spectacularly obscured. Contrary to what the vividly manifest content of *Rachel Weeping* indicates, the actual figure of a weeping Rachel was added to a mortuary portrait of her infant Margaret three years after Charles Willson Peale, husband and father, completed a painting that included just the baby ghost.[8] Margaret died of smallpox in 1772 and was immortalized immediately thereafter, alone in the center of her father's canvas. The weeping came later, when the mother became necessary: Peale added them both to the portrait. By 1776, the size of the canvas had doubled and, as art historian Phoebe Lloyd notes, "what had begun as an intimate family document became suitable for exhibition."[9] The origins and legacies of Rachel's painted sorrow within and beyond the Peale family are truly fascinating. The artist of this sorrow, his personal history, and his enlightened, cultural, and political ideals had much to do with shaping both these origins and these legacies.

Charles Willson Peale was born in 1734 to a poor family and was raised in Queen Anne's County, Maryland, where his first adult profession was that of a saddler. Peale had a passion for art, however, and his determination in this regard eventually brought him to exchange saddles for art lessons. He secured the privilege to study in the studio of the accomplished American painter John Singleton Copley before he traveled to London in 1770, where he continued his formal training under the renowned Benjamin West. Upon his return to Philadelphia in 1776, he painted the first of what would eventually amount to fourteen portraits of George Washington.

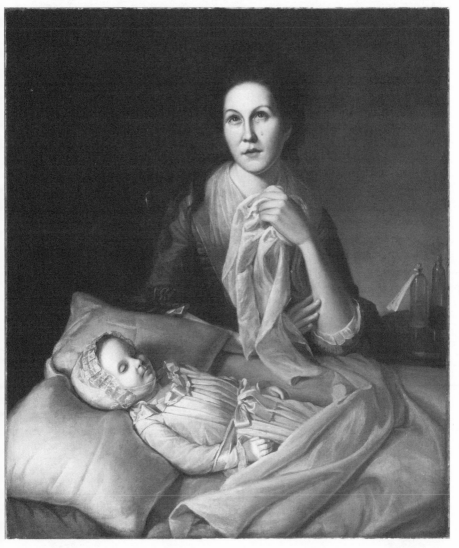

Charles Willson Peale, Rachel Weeping, *1772–76. Oil on canvas, 36 13/16 x 32 1/16 inches (93.5 x 81.4 cm). Philadelphia Museum of Art, Gift of the Barra Foundation, Inc., 1977.*

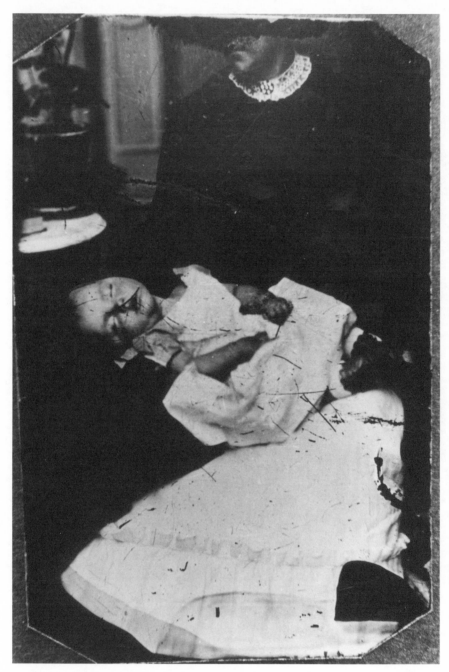

Postmortem photograph of child on lap of mother, *ca. 1870s (photographer unknown).*
Tintype, ¼ plate. Jay Ruby Collection, Special Collections, Pennsylvania State University.

Peale continued to show reverence for the American revolutionary cause and its official heroes by painting a number of military and political leaders over the course of his own service as a volunteer officer in the Continental Army. Not only did he produce a substantial body of paintings featuring these "illustrious Americans," he became the founder of the American Museum in Philadelphia in 1784 that would exhibit these for the first time. In addition to providing a space wherein these national specimens could be displayed, Peale's American Museum hosted the products of his related, enlightened ventures into natural science.[10]

For Peale, paleontology, taxidermy, and portraiture were connected not only because he happened to practice all three, or because he displayed the products of each in the same museum. As Alan Trachtenberg observes, Peale was an "artist, scientist, and fervent supporter of the democratic cause," who "embodied the broad cultural program of revolutionary Enlightenment."[11] It was this broad cultural program that made sense out of his establishment of the first institution in which national and natural specimens would find their place beside one another, together animating an order of things that served, beautifully, the new republic. Thus it was some time before he rendered *Rachel Weeping* that Peale established a career out of marking origins and freezing moments, out of locating and preserving bodies in their proper, immortal spaces.

Indeed, what may have seemed at first a set of quite disparate fascinations, were actually a suite of essential laboratories in Peale's production and location of his own personal and professional body within an emerging, enlightened modern republic. Discussing his 1822 self-portrait *The Artist in His Museum,* he wrote that he meant to paint himself "bring[ing] forth into public view the beauties of Nature and art."[12] Appropriately, therefore, the self-portrait is one of a magisterial figure raising a curtain that separates him inside of his workspace from the exhibition space of the museum's "Long Room." The "Long Room" was where the remains of animals, skillfully stuffed and preserved, took their place below the painted faces of America's most famous men. The workroom was where Peale pieced together his material—organic and ideological—to form a hierarchy of living things and to fix their shapes and shadows.

Charles Willson Peale thus made his life and work out of preserving the dead, out of resurrecting and animating their forms as individual and relational bodies. The fundamental significance of visual culture to these projects was not lost on him or his familial legacy. He named his sons after

famous painters: Rembrandt, Titian, and Raphaelle, all of whom became accomplished painters themselves. These second-generation Peale artists inherited their father's fascination with women's sorrow and familial death. In 1848, Rembrandt painted *Pearl of Grief,* a portrait of a woman crying an immense and heavy tear on behalf of the wives, mothers, and sisters of American male casualties to the Mexican-American War. In 1866, Titian made *News from the Front,* a painting of three women: one faint with grief at the news of a beloved man lost to the Civil War, the other two tending to her suffering. The timing of these two works, each one coinciding with the advent of a new war, was faithful to the pattern that Father Peale had established in producing *Rachel Weeping* at a particularly defining and violent moment in the nation's history.

Rachel Weeping appeared on the eve of the Revolutionary War, *Pearl of Grief* was made at the start of the Mexican-American War, and *News from the Front* appeared during the Civil War. The tears in each of them were made to soothe and suture the family at the precise historical moments when the imperatives of nation building threatened individual family members with death. Only mothers, sisters, and wives could coax loss and suffering to blend, seemingly organically, into the social and political landscape of the fragile nation. Theirs were the only weeping bodies that could promise timelessness and attribute the characteristics of *nature* to what they were made to watch over, as well as to what they were made to overlook.

Charles Willson Peale bequeathed to his artist sons an interest in religious texts that focused not so much on biblical scripture as the word or on the Christian promise of salvation in the afterlife, but rather on the art-historical manifestations of these ideas.[13] This meant that the mourning mothers and wives that each of them painted in the frames of righteous and (re)generative sorrow paid homage to the kind of spiritual, maternal imagery that could be massaged to render the plights of the *living,* secular, but nonetheless "holy" collectives—familial and national—with which they identified. Indeed, the revered image that Peale undoubtedly referenced in his *Rachel Weeping* appeared in the infamous biblical verse known as "Rachel's Lament," wherein Jacob's wife Rachel, dead for a millennium at this point, is heard wailing at the spiritual death of her descendants upon their exile from Jerusalem.

In the process of producing his *Rachel Weeping,* Charles Peale paid particularly close and technical attention to making convincing the contours of a moving maternal sorrow. Not only did his portrait conjure a

mother where there had been no mother before, but it took her expression from, quite literally, a trade manual on the "expression of the passions."[14] As Phoebe Lloyd notes in her incisive reading of *Rachel Weeping,* Charles Peale consulted the English translation of Charles Le Brun's *Traité des Passions* (1649) for a systematic approach to painting maternal sorrow:

> He consulted the book . . . to find an expression appropriate to
> Rachel, for it is obvious that he superimposed on the face of
> his wife Le Brun's standardized image of "Sadness." The telltale
> indication that Peale did not observe his wife from life is to be
> found in the whites of the eyes visible below the rolled up iris, after
> the example of Le Brun. This glance is nearly impossible to hold,
> especially with the head held straight. But, as a graphic formula,
> Le Brun had codified this expression to signal *tristesse.*[15]

Le Brun's text was considered by artists of the period to be the definitive guide to portraying facial expressions that signaled particular emotions. Guided by his book's instructions, drawers and painters codified the embodied contours of their subject's interiorities on paper and canvas and placed them within a shared schema of visual knowledge. Peale thus composed *Rachel Weeping* solidly within the frame of established expectations and needs—emotional, ideological, aesthetic, and affective.

Maternal sorrow fit into the schema of Peale's commercialized art as much as—or because it also—fit into the schemata of whiteness and the family within the context of a new, democratic America. Art, for Peale, was above all "a domestic symbol," the place wherein the organization of family and home life was displayed, studied, consumed.[16] *Rachel Weeping* imported the iconic *Mater Dolorosa* into Peale's oeuvre and put her on view as a universal sign of powerful and profitable sentiment. We know much less about the place and value of the nameless, headless *mother* in the *Postmortem photograph* that Jay Ruby's exposition on death and photography analogizes to *Rachel Weeping.*

What Roland Barthes—and likely Jay Ruby as well—would term the *studium* of *Postmortem photograph of infant on lap of mother* is marked by its title; the picture belongs to that genre of "death photography" that places deceased infants on mothers' laps. Simply, that is what this photograph is. There are many photographs and paintings just like it; as a group, they tell us about a cultural practice, they show us something of general historical

Detail of Postmortem photograph of child on lap of mother.

interest.[17] It would appear—if it could—that the nameless mother weeps just like *Rachel,* and that from this parallel we could say something general, perhaps even universal, about mothers who feel and children who die and the pictures we need of them. But the *punctum,* in the *Postmortem photograph* and generally, leads us somewhere else.

The *punctum* is that thing in the photograph that punctures the *studium.* Whereas the *studium* is obvious, universal, banal even, the *punctum* is individual, a cut in the image-scene, sometimes painful. For me, what pierces this *Postmortem photograph*—that "accident which pricks me (but also bruises me, is poignant to me)"—is inside the space above the mother's chin.[18] There, where a face would be, is much more darkness than absence. Were it to be an ordinary *punctum* (no *punctum* is precisely ordinary, as every *punctum,* according to Barthes, is rigorously individual and individu-

alized), this darkness would be "what I add to the photograph and *what is nonetheless already* there."[19] But this bruising darkness is not *nonetheless* already there; it is rather *unmistakably* there. What made the absence that pricks me, whether or not I was meant to be pricked, appears with purpose. Perhaps the accident is that this purposeful absenting wounds at all, that the tearing is felt. Still, its wounds are not all obvious; the cut it makes is deeper than a gap between mouth and frame, something other than just a mother's head missing. This darkness (not absence) pierces this image and pierces as well the image-repertoire of race, death, and the maternal—within the context of Jay Ruby's text and within our visual culture—to which *Rachel Weeping* also belongs. This darkness (not absence) and where it takes our visions—to the full, fleshed-out faces of racialized maternal sentiment—is seeping.

There is much in *Postmortem photograph* that is either absent, unnamed, or misnamed. The layers of obscurity and occlusion are deeply penetrating. Jay Ruby recognizes that this image is a tintype but without qualification calls it, simply, a *photograph,* and proceeds to ignore it altogether in the text of his analysis. That the material of this picture's production, form, and significance is so fundamentally unseen is perhaps the first clue that the maternal within it needs an altogether other visuality to be understood. Historian Laura Wexler's study of domestic photography in *Tender Violence* is brilliantly instructive here. She reads photographs of African American "nursemaids and their charges," decoding what is ultimately the racialized impossibility of maternal signification in Madonna–child images in which the Madonna's phenotype fixes her as enslaved or formally enslaved.[20] Conceived as domestic visions for the pleasure and self-assurance of the slave master's family, photographs such as those taken by George Cook evidenced a maternal serenity *beyond* their frames, a serenity assured by the maternity denied to the laboring woman that appeared *within* their frames.[21]

There is, of course, a profound difference between Bellini-like images of the Madonna and child and the enormous body of pietà-like images to which *Rachel Weeping* and *Postmortem photograph* want to belong. Madonna–child shapes testify peacefully to life while pietà figures testify painfully, hopefully to life beyond death: both images need a maternal face gazing, maternal arms cradling; both address the family and participate in some collectivity, most often a nation. Where the shape of the revered maternal in these types is filled with darkness—not sorrow or serene sadness, but rather darkness—the skin of racial history sheds questions, speaks

George Cook, Baby Huestis Cook, 1871. Cook Collection, Valentine Richmond History Center.

denials, asks to be answered. Nameless nursemaids and scratched-away mothers in mourning: What ideas of family and future did they breed in the face of bondage and death? What essential things did they represent in their impossible relationships to maternal signification, in their impossible congruence with the shapes of Rachel weeping and Mary cradling?

Postmortem photograph is a misfit double to such visual maternal typologies as Rachel and Mary for a variety of historical, material reasons. Quite obviously, this *infant on lap of mother* is not a centered subject in any infamous work of art. As a tintype, even the material and mode of its composition is relatively quite "inferior." Considerably easier to make than ambriotypes or dauguerrotypes—the more coveted and skilled art forms of light writing—tintypes were often part of the artistic pastimes and cultural possessions of the less economically privileged classes during the late nineteenth century.[22] We cannot know who made this relatively unvalued picture of this now multiply devalued infant–mother pair: we can only read the layers and relationships of signification and defacement that obtain within the image itself and within the visual historical frames of those maternal types that it shadows and supports, but to which it necessarily does not belong.

A fact interesting—and haunting—for its technological and symbolic import: the background material of tintypes is always dark brown or black, whereas the background of photographs is traditionally white. That this black maternal body would disappear into the material of her intentional disfigurement was overdetermined as much by history, however, as it was by the tintype background that cropped her head. That her relationship to the dead body of what Jay Ruby assumes to be her infant would be obscured, many times over, was provided for in the political, affective motivations of *Rachel Weeping.* Charles Willson Peale bound Rachel's memory of baby Margaret and her sorrow at her death to his larger artistic and taxonomic projects that placed the white family—with its enlightened and cultured male heads—at the center of a burgeoning republic. By the time the *mother* in the *Postmortem photograph* posed with "her" deceased infant on her lap, much in the nation had changed, but an apparently black woman's body holding an obviously lighter-skinned, if not white, infant could not have indexed an untroubled mother–child bond or a universally understood maternal sorrow any more than it could have escaped referencing the "nursemaid with her charge" genre of photography that customarily featured such mixed pairings.

Indeed, it is *this* relationship—that of the enslaved woman's domestic, maternal labor to the flourishing, slave-owning white family—that *Postmortem photograph* most obviously references through its racial codes. In this sense, it matters not at all that Jay Ruby bought this tintype at a garage sale in the 1980s in the free state of Pennsylvania (the very same state where Charles Willson Peale painted *Rachel Weeping*), or that he dates its production to the postemancipation decade of the 1870s.[23] Then, as even now, in the North as in the South, firmly racialized notions of the revered, sorrowful maternal and the beloved, mourned child haunted every shape that (tried to) fit the form of the pietà.

What appear to be the phenotypic discrepancies between the *mother* and *infant* in *Postmortem photograph* suggest racial, gender, and sexual hauntings beyond, although intricately connected to, the white family's reproduction via African American women's labor. While the image-histories and maternal materialities of "nursemaids and their charges" haunt the signifying realm of this image, so too does the history of interracial rape.[24] What besides death might account for the paleness of the infant against the dark of its mother's dress, against the dark of her cut-away face, the blackness of her chin? What besides white guilt, white shame, white rage at the racial contamination represented in the contrast could have compelled someone to disappear this mother's face? I visited the archive, held her image in my hand and it was clear, unmistakable: time had not erased her, history had. It wasn't any sort of fading, but rather intentional *framing* that simultaneously put her in her maternal place and took her out of it, that fixed her at the constitutive outside, at the border, that sited her abjection.[25] And beyond that, she was peeled and scraped away some more.

The disappeared face in *Postmortem photograph* beckons us to search, to pose and to project our questions on the dark of that tintype, against the murk of history's violent material. I held the image, but touching it revealed nothing but more erasures, more layers of gaps. Someone or something meant to keep this mother out of the frame, she was *preserved as disappeared,* and then scratched away some more. Was she a nursemaid, a mistress, a mother to this child and/or to other children? And what of the infant? How did she or he die? Infant mortality was unfortunately all too common in this period: the very genre of postmortem photography was founded to soothe these losses, to somehow diminish their finality, indeed, to "secure the shadows" of not only infants and children, but other beloved family members who fell victim to illness, disease, and other fatal

misfortunes. What is remarkable about this particular death and its representation is the spectacular absenting it marks. The death shadows shaping it are its racial-historical—indeed, its racial-maternal—material.

Charles Willson Peale's *Rachel Weeping* renders a grieving mother *in a particular image,* producing a referent that adheres historically not only to our experience of this paint on this canvas, not only to this specific vision of a mother's feeling. Rather, the whiteness of the maternal, the whiteness of the dead-child-as-tragedy, and the whiteness on behalf of which sentimentality itself is (re)produced adhere to and within the project of U.S. visual nationalism. This project has never been, and could never be, without race or death. Individual maternal image-objects that obviously figure *both* race and death, therefore, are a particularly generative site within which to begin reading how the visual tropic trinity of race, death, and the maternal adheres in (the name of) national(ist) history and memory. *Rachel Weeping* and *Postmortem photograph of child on lap of mother* are two such individual objects, and—perhaps more significantly for our purposes—so is the haunting relationship, the persisting relationship, between the two.

The practice of making and imaging the dead, of breeding ghosts, has a long history in the United States, but many of its material products are all but absent from popular imagescapes. That the prevalence of portraiture and photography the likes of *Rachel Weeping* and *Postmortem photograph of child on lap of mother,* for example, is so scarce in critical and public discourse is testimony to "our general studied ignorance about death and the cultural activities surrounding it."[26] Whether the impetus for this ignorance is an aversion to the corpse or to mortality, or to the signifying relationship between the two, it is clear that we generally do not know or see ourselves recording death. Yet we have always done it. In the case of deceased loves ones, we have done it lovingly, with an eye toward preservation, resurrection, and restoration. In the case of the unloved, particularly those deceased members of "other" racial and ethnic groups, we have often done it brutally, but still with an eye toward preservation, resurrection, and restoration.

Indeed, the ephemeral effects of ghost images extend far beyond what is suggested by the historical inspirations and artistic material of their figuring. Countless mortuary and mourning paintings, postmortem photographs, and funeral photographs immortalize their subjects' spirits with light, color, and form—all visible, all signifying precisely what cannot be captured and must therefore haunt the fixing image-logics of identification,

what I earlier referred to in my discussion of *Camera Lucida* as the *photographic*. As the artistic and affective legacies of *Rachel Weeping* testify, spirits of dead infants and young children have long compelled the ghosting technologies of paint and film. Like images we take of our young ones living, our pictures of them dead manifest a claim to something never ours. Gazing, we freeze and mark—in order to record and resist—the ruin of inevitable loss come too soon. The sleep suggested, the peace hoped for, and the resurrection made material in these particular, more obvious animations of death has only very little to do with the specific corporeal referents—children's evacuated bodies—that index the untimely interruption of life. Historically, the grief work of funeral portraits and postmortem photographs of infants and young children has resisted disentangling from the ideological work of maternal and familial—and thus *racial*—national preservation and resurrection.

In *American Archives,* Shawn Michelle Smith advances an indispensable critical framework for understanding the relationship of private, familial imaging practices to the formation of a racial national imaginary. As she interrogates how to "make sense of the uncanny formal consonance and temporal congruence of popular and eugenicist family albums," she highlights the centrality of "baby's picture" to the ideological posing and projecting of white American identity.[27] Smith's readings of the racializing image cultures of both the family and eugenics make it impossible for us to understand pictures of infants—living or deceased—as politically innocuous. Drawing a parallel between the "fathers of the nation" recorded in the "Daguerrean Gallery" of nineteenth-century photographer Matthew Brady and the "children of the nation" preserved in family image-archives, Smith puts forth a formulation the truth of which has continued—even up to our current moment—to haunt U.S. national image cultures: "it is between the two terms of the family and the nation that Francis Galton [the 'father' of eugenics] located the site of racial reproduction. For Galton, the nation was simply a congregation of racialized families."[28]

The racializing work of posing infants and capturing their likenesses in the name of familial and national memories and identities occurred, and continues to occur, in countless visual mediums and discourses. Before the era of mechanical reproduction in which the accessible positive/negative photographic process was recruited to serve these racial imperatives, the more exclusive genre of painting did this work. When the essential, reproducible referent—a white child—was embodied by death itself, these im-

peratives took on a new urgency. In these cases, the labor of imaging was the labor not only of *preserving,* but also of *resurrecting,* the beloved object.

Writing about the singularity of the photograph among technologies of visual representation and reproduction, Barthes declared that "whatever it grants to vision and whatever its manner, a photograph is always invisible: it is not it that we see. In short, the referent adheres."[29] With this, he described the suturing in photographic seeing of the "real" image-object represented to the "imaged" image on film and paper. This realness sticks to photographic vision(s), seemingly turning material signifiers into the signifieds themselves, producing the image *as* the object to which it refers, rather than the object becoming an imaged re-vision. When the material of the image pictured is *maternal,* however, this real effect that Barthes articulated often does not depend on the photographic proper for its emergence. Rather, the photographic affects of maternal visions adhere through and beyond the countless visual technologies deployed in their figuring. Like the *material* signified of the photograph that eclipses the fact of its mediation and its difference from a real "object," the *maternal* signified of the pietà—the figure that bears, hosts, mourns, and poses for the resurrection of her progeny—has come to eclipse the fact of itself as a racialized (re)production within visual discourses of death and sentiment. Whatever the "nature" of maternal sentiment in moments of tragic loss, historical visual representations of such loss have fixed the relationship between how maternal figures feel—and how we feel about maternal figures—with and in a racializing logic that tells us how to see the differential value of lives and deaths. As an affective composition of race, death, and the maternal, the pietà has framed a relationship between these formations for centuries and remains host to their collision in countless dominant and critical political and cultural discourses.

Morrison's *Beloved,* for example, insists on re-membering the image of Margaret Garner's infanticide in a shape that no other previous visual or textual reconstruction would lend to the event: Sethe cradles her dead baby girl, referring to and rewriting Garner as a subject in a radically revised pietà. Indeed, "neither Stamp Paid nor Baby Suggs could make her put her crawling-already? girl down. Out of the shed, back in the house, she held on."[30] She held on, but no one reported it and no one saw it.[31] The newspaper accounts of the time, based on "eyewitness testimony," had Margaret Garner "holding in her hand a knife literally dripping with gore, over the heads of two little negro children, who were crouched to the floor," while "in one corner of the room . . . a nearly white child [was]

bleeding to death."[32] Dead before birth by slavery's hand, held now in her mother's arms, Beloved's pieced-apart body and humanity are brutally realized, like history, like race, like Mary Garner's babyhood and Margaret Garner's motherhood. Sethe severs her girl child from this world and holds her whole, kills and claims her in a devastating, impossible way. She cradles her, calls them beloved who were not beloved. Inhabiting the pietà's shadow, this revision makes our *visualities* of the maternal accountable to history's production of race and death: it demands that, like Beloved's older sister Denver who nurses immediately after the cutting, we take in the blood with the milk. *So Denver took her mother's milk right along with the blood of her sister.*[33]

In puzzling and poignant contrast, the most famous visual representation of the aftermath of Mary Garner's death does not re-member her mother holding her. Thomas Satterwhite Noble's 1867 painting—originally titled "Margaret Garner," but which came to be known through its *Harper's Weekly* lithographic reproduction in the same year as "The Modern Medea"— pictures, instead, Margaret Garner at the center of four older children, all of whom appear to be boys. Two of the boys are bleeding and lying motionless at their mother's feet while the other two, obviously terrified, appear to beg for her mercy. Four fugitive-slave hunters stand together, appalled by the vision.

This representation's departure from the one irrefutable historical fact of the event and its aftermath is remarkable: Garner killed one infant girl, but there is neither infant nor, apparently, girl anywhere in the frame. Noble's creative (re)visioning extended beyond this, however. With regard to the painting's gothic horror sensationalism and its monstrous depiction of Garner as an "ignoble savage," art historian Leslie Furth informedly speculates that

the many lurid newspaper accounts of the incident undoubtedly served as Noble's model. Such accounts typically featured "corpse discovery" scenes drawn from Gothic horror fiction and introduced by such formulaic narratives as, "On looking around, horrible was the sight that met the officer's eyes," followed by a recitation of vivid details of the murder scene from the point of view of eyewitnesses. Noble was probably also aware of the tradition of graphic renderings of heinous crimes that proliferated throughout the nineteenth century. These images included single broadsheets known as "penny

Mathew Brady's lithograph of Thomas Satterwhite Noble's 1867 painting. The lithograph was published in Harper's Weekly, May 18, 1867, with the caption "The Modern Medea—The Story of Margaret Garner." Photographs and Prints Division, Schomburg Center for Research in Black Culture, The New York Public Library, Astor, Lenox and Tilden Foundations.

dreadfuls" and those in illustrated weeklies devoted to criminal activity, such as New York's *National Police Gazette,* first published in 1845. Noble's preparatory illustration of the murdered Garner children recalls, for example, that of a contemporaneous print depicting the aftermath of a multiple homicide in Pennsylvania in 1866.[34]

Both Morrison's *Beloved* and Noble's *Margaret Garner* revision this scene through/as the formal and symbolic shadows of distinct racialized, death-themed maternal iconography. Morrison's rendering is a radical refraction of the pietà's form: it interrogates its political, cultural symbolism within a historically conscious framing of race, death, and the maternal. Noble's rendering, however, mirrors the political, cultural symbolism of the pietà even as it absents its form altogether: he ejects the black child/girl and the black, loving maternal from the frame and arranges his subjects in the

shape of the gothic corpse scene.[35] Looking at these profoundly compli-
cated representations, and their profound differences from one another in
the same frame of the pietà's (im)possible subjects, it is clear that no uni-
versal template of death and/or the maternal can bear Margaret Garner's
motherhood, but such templates nevertheless abound. Morrison's *Beloved*
etches disruptions in these templates, crosses lines and visualities, puts a
babe in her black mother's arms and re-members the *history* that bloodied
the sight and the failures of images and institutions that still do.

Although the preceding chapters have assumed the visual figuring of
maternal bodies and experiences as their explicit foci, the material stakes
of this book are much broader than this. By considering the role of ma-
ternal sentiment in national(ist) discourses of death and re-membering,
I have meant to make explicit the maternal visions—meaning how we
see maternal figures and how we see *their* seeing and feeling in visual
culture—that actually determine the value of life according to racialized
ideas of national belonging. Looking at the ways in which maternal sen-
timent is deployed and witnessed to elicit feelings about life, death, and
resurrection in a variety of visual contexts, we recognize that *feeling*—as
well as, perhaps, more obviously *being*—has become dependent on pro-
foundly limiting, profoundly powerful visions of "the mother."

What any one of the visual texts and events taken up in this book has
to do with any other may not be immediately obvious. But the material,
lived experiences of the relationship between the nation's past and pres-
ent, between official and subversive texts of remembering and forgetting,
and between, as James Baldwin notes, "who one loves or fails to love" can
perhaps only be understood by comparing and contrasting such appar-
ently different and disparate cultural productions as those discussed in
each of the preceding chapters.[36] Upon examination, the discursive struc-
tures working to shape the meaning of these events and texts within an
American national memory have much in common with regard to their
repudiating practices and effects, and in their influence on the racialized
constructions of the beloved and the disdained.

While the images that Jay Ruby includes in *Secure the Shadow* suggest
that only white photographers and white subjects have been appropriate
to death imaging, the self-determined visual memorialization practices
of African Americans that we learn about in James Van Der Zee's *Harlem
Book of the Dead* and Karla Holloway's *Passed On* declare something al-
together different. James Allen's *Without Sanctuary: Lynching Photography*

in America declares something different as well. Even so, there is at least one thing general and true that we can say about how the nation's shadow has been secured: nonwhites have not been absent from this process, they have been, rather, essential to it.

Of course, memorial photography and lynching photography are not (exactly) the same thing, and what maternal visualities have to do with either is not immediately obvious. Still, let's probe: what is the relationship between the maternally assisted practices of death rendering and resurrecting as evidenced in Ruby's *Secure the Shadow* and Allen's *Without Sanctuary*? It cannot be nothing. Here, as elsewhere, the separation between genres does work beyond that of differentiating apparently distinct visual cultural practices for the purpose of nuanced theoretical analyses. As a historian of art or photography, or as a visual anthropologist, one might legitimately argue—backed by the authority of disciplinary methodological conventions—that lynching pictures have nothing to do with pictures "securing the (beloved) shadow," that the first are remnants of a very historically specific practice of racialized dehumanization, and that the second are evidence of a transhistorical practice of preserving those we love. Still, our shadows are secured by both love and hate, and whatever the shapes of the darkness they figure—the shells of "us" or the bodies of "them"—we need them close.

If we linger at this intersection of visualized death and murder, if we interrogate not "just" what memorial photography entails and/or what lynching photography entails, but instead, for example, *the racialized relationship between apparently different practices of death imagery in the same, and even different, historical time periods in the United States,* our sites of inquiry expand and our answers complicate. The material of this relationship is decidedly elusive, ephemeral even, but again, it is not that it is not there. This material meets and congeals in what Diana Taylor might call—because there is no official *archive* that brings together, obviously and at once, all the pictures that lynch with all the pictures that covet—a racialized *repertoire* of death images in the United States.[37] Within this frame, we see how some of our most tender image-objects animate violence at the same time that violent pictures soothe. The maternal is everywhere in this relationship, even when our critical visions must coax her labor into appearance.

Acknowledgments

M Y WORK ON THIS PROJECT began many years—many lives, it seems—ago, and I have many individuals and communities to thank for the support they lent to it and to me. But first, those at the University of Minnesota Press who spent their faith, time, and ink to literally make the book: Richard Morrison, Kristian Tvedten, Adam Brunner, Daniel Ochsner, Anne Klingbeil, Laura Westlund, and David Thorstad.

While a graduate student in ethnic studies at the University of California San Diego, I studied the promises and challenges of comparative, interdisciplinary ethnic studies under the direction of an incredibly generous and accomplished faculty. George Lipsitz encouraged me to ask of everything I read and write, simply: "What's at stake?" Never adequately answered, that question is always my compass. I thank him and the rest of my committee (Lisa Lowe, Charles L. Briggs, Jane Rhodes, and Ellen Seiter) for guiding the research and questions that first inspired this book, as well as the other faculty members who supported the earliest hints at its ideas (Yen Le Espiritu, Jonathan Holloway, Ann duCille, and Michael Murashige). Those members of the beloved, mysteriously named "Ruby's Reading Group" at UCSD empowered me with their brilliance, rigor, and humor. I thank all of them: Victor Bascara, Gayatri Gopinath, Grace Kyungwon Hong, Chandan Reddy, Maurice Stevens, Victor Viesca, Daniel Widener, and Roderick Ferguson. Rod was my first and always close reader, my easy and constant friend. His belief in my work, at several crucial stages, made it possible.

Jennifer DeVere Brody has been magically present at every stage of this project, encouraging and challenging me. I thank her, deeply inadequately, for her close readings and warm, firm pushes forward. Lisa Marie Cacho shared with me every happy and hard life moment, every stuttering idea and not-right word that shaped this work, helped me revise and recover, and always reflected to me something coherent to be believed in. I can't thank her enough.

I am grateful to many colleagues at Ohio State University for keen insights and unwavering encouragement, but those to whom I owe special thanks are Philip Armstrong, Frederick Aldama, Tanya Erzen, Eugene Holland, David Horn, Kwaku Lorabi Korang, Margaret Lynd, Judith Mayne, Linda Mizejewski, Debra Moddelmog, Terry Moore, Barry Shank, Maurice Stevens, Daniel Reff, Ileana Rodriguez, Brian Rotman, Shu-Wen Tsai, Rebecca Wanzo, and Julia Watson. I also thank Rebecca Adelman, Damon Berry, Rita Trimble, Drew Lyness, and Brian Michael Murphy for sharing their brilliant graduate research with me.

Others who supported this project are far too many to name, but included among them are Elizabeth Abel, Natchee Blu Barnd, O. Hugo Benavidez, Sarah Blair, Jacqueline Bobo, Eileen Borris, Daphne Brooks, Beverlee Bruce, Luz Calvo, Timothy K. Choy, Ebony Coletu, David Coyoca, Ofelia Ortiz Cuevas, Carlos Ulises Decena, Geoff Eley, Lydia English, Catrióna Rueda Esquibel, Mary Margaret Fonow, May Fu, Maribel Garcia, Zamira Ha, Judith Halberstam, Phillip Atiba Goff, Avery Gordon, Robb Kendrick, Jill Lane, Jesse Mills, Regina Morantz-Sanchez, Zachary Morgan, Ralina Joseph, Laura Oaks, Leigh Raiford, Barbara Rodriguez, Richard T. Rodríguez, Lynn Sacco, Chela Sandoval, Shawn Michelle Smith, Rickie Solinger, Siobhan Somerville, Min Sook Heo, Suzette Spencer, Jacqueline Stewart, Marita Sturken, Megan Sweeney, Arlene Torres, Elizabeth Tufts-Brown, Janet Walker, and Ara Wilson. Many, many thanks.

My brothers and sisters (Emilio Jr., Lillian, Andy, Chris, and DeAnna) have shared their families with me, as well as the hard and joyful path that landed me here. I am deeply grateful for their love and support. Our late father, Emilio Tapia Sr., gave all of us—very early—words to name injustice and ways to act against it. I remember him as I work to find my own.

Soliyah Stevens-Ogaz gives me art, questions, and unshakable faith in the solidity of chosen family. I thank her for her closeness. I thank my daughter, Raeden Gibran Tapia-Stevens, for the laughter she brings me, for her own fierce sense of justice, for her thunder and her calm. Martin, Ylana, and Zinaida Miller sustain me with their humor, penetrating questions, libraries, and unconditional love. Joshua L. Miller listens intently to my words and silences, spoken and written: he supports, pushes at, and learns their structures with me. I thank him for accompanying me, encouraging me, and being an example of integrity in love and work that I cite daily.

I dedicate this book to my mother, Emma Eve Tapia, in memory of her absolute singularity, in appreciation of her love and vision.

Notes

Introduction

1. Matt Prigge, "Upward Christian Soldier," *Philadelphia Weekly,* May 3, 2006.

2. Michael Daly, *The Book of Mychal: The Surprising Life and Heroic Death of Father Mychal Judge* (New York: St. Martin's Press, 2008); Michael Ford, *Father Mychal Judge: An Authentic American Hero* (Mahwah, N.J.: Paulist Press, 2002); Glen Holsten, *Saint of 9/11: The True Story of Father Mychal Judge,* DVD (91 min.) video recording, Arts Alliance America 2006; Kelly Ann Lynch, *He Said Yes: The Story of Father Mychal Judge,* illustrated by M. Scott Oatman (Mahwah, N.J.: Paulist Press, 2007); "Saint Mychal Judge: To Encourage Greater Faith, Hope and Love through 'The Saint of 9/11,'" http://saintmychaljudge.blogspot.com/ (December 15, 2009).

3. The five rescuers depicted in Stapleton's widely circulated photograph are firefighter Christian Waugh, former NYPD Lt. William Cosgrove, Goldman Sachs's employee John Maguire, Office of Emergency Management employee Kevin Allen, and firefighter Zachary Vause. See Neil Graves, "What Really Happened after Father Mike Died," *New York Post,* September 9, 2002, 10.

4. Historically, there have been a wide variety of less well-known configurations of the pietà, many of which include male bodies as one of the cradling and/or surrounding figures. For example, whereas Michelangelo's most famous *Pietà* (marble sculpture, Rome 1498–99) features just the Virgin Mary cradling the dead Christ, his sixteenth-century sculpture that features Joseph of Arimathea as the centered cradler of Christ—with Mary Magdalene and the Virgin Mary as flanking supports—has also been described as a pietà, although many argue that it is more properly understood as a Deposition or Lamentation, postcrucifixion scenes that include several mourners. See Antonio Paolucci and Aurelio Amendoa, *Michelangelo: The Pietàs-Photographs by Aurelio Amendola* (Milan: Skira, 1998), and Frederick Hartt, *Michelangelo's Three Pietàs* (New York: Harry N. Abrams, 1975). The most widely accepted definition of a pietà, however, stipulates the relationship between the Virgin Mary and Christ as the centered subject.

5. For many years, Mychal Judge had been affiliated with DignityUSA, a coalition of out Catholics. See Michael Daly, *The Book of Mychal: The Surprising Life and Heroic Death of Father Mychal Judge* (New York: St. Martin's Press, 2008).

6. Bob Adams, "The Pope and Mychal Judge," *The Advocate,* December 21, 2001, 16.

7. Dennis Lynch, "A September 11th Hijacking," *Catholic Online,* June 26, 2002, http://www.catholic.org/featured/headline.php?ID=18 (November 18, 2010).

8. John M. Kelley, "A Gay Saint in Fact," http://saintmychaljudge.blogspot .com/ (December 15, 2009).

9. The act marked the first time the federal government had extended to same-sex couples benefits equal to those of legal spouses, parents, and children of public safety officers. According to the National Fallen Fighter's Association, "The Mychal Judge Police and Fire Chaplains Public Safety Officers' Benefits Act of 2002, retroactive to September 11, 2001, amended the PSOB Act of 1976 in the following ways: "It added chaplains to the definition of 'public safety officers'; defined chaplain as any individual serving as an officially recognized or designated member of a legally organized volunteer fire department or legally organized fire or police department who was responding to a fire, rescue, or police emergency; stipulated that if the public safety officer had no surviving spouse or eligible children, the beneficiary would be the individual designated as the beneficiary on the officer's most recently executed life insurance policy. Prior to this change, parents were the next level of beneficiary if there were no spouse or eligible children" (http://www.firehero.org/resources/benefits/psobclaimprocess.html, [December 15, 2009]).

10. For an incisive analysis of the centrality of whiteness in the ideological frame of homonormative patriotism, see Jasbir K. Puar, *Terrorist Assemblages: Homonationalism in Queer Times* (Durham, N.C.: Duke University Press, 2007).

11. Andrew Sullivan, "Why We Should Support This War," originally published in *PlanetOut* (September 21, 2001), http://www.indegayforum.org/news/show/26927.html (December 15, 2009). For an incisive reading of notions of citizenship and gay identity that center the white, gay, male, see Roderick Ferguson, "Race-ing Homonormativity: Citizenship, Sociology, and Gay Identity," in *Black Queer Studies: A Critical Anthology,* ed. E. Patrick Johnson and Mae G. Henderson (Durham, N.C.: Duke University Press, 2005), 52–67.

12. For a critique of the homogenizing and universalizing dangers of gay nationalism, see Lisa Duggan, "Making It Perfectly Queer," in *Sex Wars: Sexual Dissent and Political Culture,* ed. Lisa Duggan and Nan Hunter (New York: Routledge, 2006), 149–63.

13. Stapleton's photograph was one of many images of 9/11 discussed in David Friend's *Watching the World Change: The Stories behind the Images of 9/11* (New York: Farrar, Straus and Giroux, 2006), 22. The photograph was also featured on November 5, 2001, in an episode of *Oprah!* titled "Photos That Define Us." On the show, Winfrey interviewed Bob Rogers, Father Mychal's nephew, about the photograph. About the firefighters who carried Judge, Rogers said, "I see those five

men basically like angels, carrying him away, taking him to his next job, and this is a picture that—which tells me that he's ready to help everybody else."

14. See Jay Winter, "War Memorials and the Mourning Process," in *Sites of Memory, Sites of Mourning: The Great War in European Cultural History* (Cambridge: Cambridge University Press, 1995), 78–118. In an online article titled "The Pietà Revisited?" Father Johann G. Roten, Director of the International Marian Institute, observes: "The Pietà may have been one of the most representative Marian motifs of the twentieth century, not in the least due to two world wars. In fact we find in Western Europe countless representations of the *Pietà* on marketplaces and in cemeteries. They serve as war memorials commemorating the fallen soldiers of a village, region, or nation . . . The dead body of Christ is replaced by that of a soldier, and in place of Mary we find a feminine figure symbolizing *Germania* (Germany) or *Marianne* (France), meaning the respective fatherland or nation." The main subject of Roten's article is whether artist Mark Balma's 2004 work, titled *Pietà*, actually "qualifies as a Pietà." Balma's painting depicts Jacqueline Kennedy cradling President John F. Kennedy in their limousine, at Parkland Hospital in Dallas, Texas, after his assassination. Ultimately, Roten concludes that "the comparison between Balma's Pietà and the traditional Pietà remains purely external, a matter of posture and position." Roten's article includes an image of Balma's painting (http://campus.udayton.edu/mary/pieta.html [March 1, 2010]). According to the November 15, 2006, Minnesota Radio story "Minnesotan's JFK Painting Bound for Vatican," Balma's painting was offered to, and refused by, several museums, including the Minneapolis Institute of Arts and the Smithsonian, but was then displayed at the Cathedral of St. Paul in St. Paul, Minnesota, as part of a weeklong symposium devoted to examining Kennedy's assassination. The radio program also reported that Balma planned to present the painting to the pope, who would then include it in the Vatican's museum collection (http://minnesota.publicradio.org/display/web/2006/11/15/jfkpieta/[March 1, 2010]). In a personal communication on February 25, 2010, Mark Balma's assistant informed me that the painting had found a home in a private collection.

15. The photograph was taken by amateur photographer Charles Porter. For a brief but critically incisive discussion of photojournalistic pietàs, including a treatment of the photograph of Baylee Almon, see John Taylor, "Disaster Tragedy," in *Body Horror: Photojournalism, Catastrophe and War* (New York: New York University Press, 1998), 43–68.

16. The public's fascination with Baylee Almon's mother, Aren Almon—who was a twenty-two-year-old single mother at the time of Baylee's death—was extreme for many years. The press followed and celebrated the birth of Almon's second child, as well as her marriage. Her recovery from the tragedy of the terror, and the circumstances of her "nontraditional" status as single mother—through the birth of another child and her instantiation within a traditional family via

marriage—were spectacularized media events. See Edward T. Linenthal, "'A Single Chord of Horror': The Memorial Vocabulary of American Culture," in *The Unfinished Bombing: Oklahoma City in American Memory* (New York: Oxford University Press, 2001), 109–74.

17. Women have been ascribed a multitude of material and ideological care-giving roles in contexts of war, such that a wide range of feminized labor assumes the valence of maternity. In her historical account *Our Mothers' War: American Women at the Front and at Home in World War II* (New York: Free Press, 2004), Emily Yellin casts a variety of women's wartime roles as maternal. Roles that ranged from factory work to child rearing to musical stage entertainment to pinup "appearances" for the troops all served a caregiving, maternal function. Yellin's work demonstrates that the maternalized feminine has been historically harnessed for/as national, patriotic inspiration, as motivation and justification for carrying out the just cause of war.

18. The Orthodox Catholic Church discussed its declaration of Father Mychal Judge's sainthood within the context of an indictment of Muslim extremists, "Saints of the Orthodox-Catholic Church of America," http://www.orthodox catholicchurch.org/saints.html (September 1, 2009).

19. Daryl Lang, "Graphic Rescue Photo Becomes a Symbol of New Orleans," *Editor and Publisher* (September 15, 2001).

20. Ibid.

21. See Robert D. Bullard, "Differential Vulnerabilities: Environmental and Economic Inequality and Government Response to Unnatural Disasters," *Social Research* 75.3 (2008): 753–84.

22. I have chosen not to reproduce Chambers's photograph of Hollingsworth here because, while I wish to juxtapose the nature of its intent and digital circulation as a pietà to that of Stapleton's photograph of Judge, my purpose here is not to rectify any "absence" of images of African American corpses in representations of Katrina nor to provide an example of photographic evidence of the institutional racial neglect that precipitated and defined the disaster. As Henry Giroux establishes (in "Reading Katrina: Race, Class and the Biopolitics of Disposability," *College Literature* 33.3 [2006]), no such absence exists. Although the image of Hollingsworth's dying body worked as testimony to racial neglect for many who saw and wrote about it, my point is not to offer it here, again, as testimony. Rather, I wish to discuss the differently politicized ascriptions of maternal properties to these very different snapshots of national crises, and I believe it is possible to do so without reproducing the photograph of Hollingsworth's "rescue." The photograph may be viewed in Lang, "Graphic Rescue Photo Becomes a Symbol of New Orleans."

23. See the September 14, 2005, blog post "American Shame: The Edgar

Hollingsworth Story," by RobertInWisconsin on The Daily Kos, http://www .dailykos.com/story/2005/9/14/12516/3649 (December 1, 2009).

24. For an extensive discussion of the online use and manipulation of images of Mychal Judge as a saint, see Claudia Schippert, "Saint Mychal: A Virtual Saint," *Journal of Media and Religion* 6.2 (2007): 109–32. Schippert applies Katherine Hayle's notion of the "flickering signifier" to her reading of the various acts of online memorialization at work through the "sign of Mychal."

25. Sullivan, "Why We Should Support This War."

26. Historically, politicized maternal concern, grief, and rage at the loss of and threat to the livelihoods of children and other sentimentalized national subjects has played a significant role in indicting institutionalized discrimination, terror, and death in countless national and international contexts. The body of scholarship in this regard is large, much of it treating Latin American contexts, and would require inordinate space to document here. A few key texts include Rosa Linda Fregoso, ed., *Lourdes Portillo: The Devil Never Sleeps and Other Films* (Austin: University of Texas Press, 2001); Nikki Craske, *Women and Politics in Latin America* (New Brunswick, N.J.: Rutgers University Press, 1999); Mary S. Pardo, "Madres del Este de Los Angeles, Santa Isabel (MELA-SI)," in *Mexican American Women Activists: Identity and Resistance in Two Los Angeles Communities* (Philadelphia: Temple University Press, 1998), 136–41; Alexis Jetter, Annelise Orleck, and Diana Taylor, eds., *The Politics of Motherhood: Activist Voices from Left to Right* (Hanover, N.J.: University Press of New England, 1997); Diana Taylor, "Trapped in Bad Scripts: The Mothers of the Plaza de Mayo," in *Disappearing Acts: Spectacles of Gender and Nationalism in Argentina's "Dirty War"* (Durham, N.C.: Duke University Press, 1997), 183–222; Marguerite Guzman Bouvard, *Revolutionizing Motherhood: The Mothers of the Plaza de Mayo* (Wilmington, Del.: Scholarly Resources, 1994); Marysa Navarro, "The Personal Is Political: Las Madres de Plaza de Mayo," in *Power and Popular Protest: Latin American Social Movements,* ed. Susan Eckstein (Berkeley: University of California Press, 1989); Patricia Chuchryk, "Subversive Mothers: The Women's Opposition to the Military Regime in Chile," in *Women, the State, and Development,* ed. Sue Ellen Charlton, Jana Everett, and Kathleen Staudt (Albany: State University of New York Press, 1989); Xiolan Bao, "Politicizing Motherhood: Chinese Garment Workers' Campaign for Daycare Centers in New York City, 1977–1982," in *Asian/Pacific Islander American Women: A Historical Anthology,* ed. Shirley Hune and Gail M. Nomura (New York: New York University Press, 2003), 286–300; Melissa Wright, "Pardoxes, Protests, and the Mujeres de Negro of Northern Mexico, in *Terrorizing Women: Feminicide in the Americas,* ed. Rosa Linda Regoso and Cynthia Bejarano (Durham, N.C.: Duke University Press, 2010), 277–92.

27. Giroux, "Reading Katrina."

28. See Christopher Metress, ed., *The Lynching of Emmett Till: A Documentary Narrative* (Charlottesville: University of Virginia Press, 2002); Michael Randolph Oby, "Black Press Coverage of the Emmett Till Lynching as a Catalyst to the Civil Rights Movement," *Communication Theses* (2007), Paper 20; Shaila Dewan, "How Photos Became Icon of Civil Rights Movement," *New York Times*, August 28, 2005, 12.

29. See Amy Louise Wood, *Lynching and Spectacle: Witnessing Racial Violence in America, 1890–1940* (Chapel Hill: University of North Carolina Press, 2009); Dora Apel and Shawn Michelle Smith, *Lynching Photographs* (Berkeley: University of California Press, 2008); Dora Apel, *Imagery of Lynching: Black Men, White Women, and the Mob* (New Brunswick, N.J.: Rutgers University Press, 2004); James Allen, *Without Sanctuary: Lynching Photography in America* (Santa Fe, N.M.: Twin Palms Publishers, 2000); Leigh Raiford, "The Consumption of Lynching Images," in *Only Skin Deep*, ed. Coco Fusco and Brian Wallis (New York: Harry N. Abrams, 2003), 267–73; Jacqueline Goldsby, *A Spectacular Secret: Lynching in American Life and Literature* (Chicago: University of Chicago Press, 2006).

30. See George Lipsitz, *The Possessive Investment in Whiteness: How White People Profit from Identity Politics* (Philadelphia: Temple University Press, 1998).

31. For a discussion of "postracial" and "color-blind' manifestations of racialized power, see Ian Haney Lopez, "Colorblind White Dominance," in *White by Law: The Legal Construction of Race* (New York: New York University Press, 2006), 143–61.

32. Giroux, "Reading Katrina," 174.

33. Treating these issues with regard to moving images, Elizabeth Alexander considers African American spectatorship of George Holliday's eighty-one-second videotape of Los Angeles police violently beating resident Rodney King and the murder trial of O. J. Simpson in 1993 within this continuous history of spectacularizing "black bodies in pain for public consumption" in "'Can You Be BLACK and Look at This?': Reading the Rodney King Video(s)," *Public Culture* 7 (1994): 78.

34. Ariella Azoulay, *The Civil Contract of Photography* (New York: Zone Books, 2008), 201. For additional discussions of the politics and ethics of circulating photographs of atrocity, pain, and torture, see Ariella Azoulay, *Death's Showcase: The Power of Image in Contemporary Democracy* (Cambridge: MIT Press, 2001); Mark Reinhardt, Holly Edwards, and Erina Duganne, eds., *Beautiful Suffering: Photography and the Traffic in Pain* (Chicago: University of Chicago Press, 2007); Taylor, *Body Horror*; Barbie Zelizer, *Remembering to Forget: Holocaust Memory through the Camera's Eye* (Chicago: University of Chicago Press, 1998); Andrea Liss, *Trespassing through Shadows: Memory, Photography, and the Holocaust* (Minneapolis: University of Minnesota Press, 1998); Susan Sontag, *Regarding the Pain of Others*

(New York: Farrar, Straus and Giroux, 2003); Susan A. Crane, "Choosing Not to Look: Representation, Repatriation, and Holocaust Atrocity Photography," *History and Theory* 47 (October 2008): 309–30.

35. See Saidiya Hartman, "Redressing the Pained Body: Toward a Theory of Practice," in *Scenes of Subjection: Terror, Slavery and Self-Making in Nineteenth-Century America* (New York: Oxford University Press, 2007), 49–78. For a lucid reading of the racial and gendered construction of Mamie Till Bradley's sympathetic, maternal authority to imbue images of her son's body with political import, see Ruth Feldstein, "'I Wanted the Whole World to See': Constructions of Motherhood in the Death of Emmett Till," in *Motherhood in Black and White: Race and Sex in American Liberalism, 1930–1965* (Ithaca, N.Y.: Cornell University Press, 2000), 86–110. See also Koritha Mitchell, "Mamie Bradley's Unbearable Burden: Sexual and Aesthetic Politics in Bebe Moore Campbell's *Your Blues Ain't like Mine*," *Callaloo* 13.4 (2008): 1048–67; and Fred Moten, "Visible Music," in *In the Break: The Aesthetics of the Black Radical Tradition* (Minneapolis: University of Minnesota Press, 2003), 171–231, for his discussion of the "phonic substance" of the published photographs of Emmett Till's tortured body, a "substance" made possible by his mother's decision to have it performed.

36. The son of the former mayor of Denver (Henry V. Johnson, mayor from 1899 to 1901), Tom Loftin Johnson was forty-one years old in 1941. He graduated from Yale's School of Fine Arts in 1923 and lived in Bedford Hills, New York, at the time of the Directions in American Painting Exhibition." His most public works to this point were murals he installed at West Point and Governor's Island. See Arthur Miller, "Native Artists Dig into Earth Again," *Los Angeles Times,* November 2, 1941, C7; "Brave Show," *Bulletin Index,* October 31, 1941, 15.

37. Millard Sheets as quoted in Miller, "Native Artists Dig into Earth Again."

38. Edward Alden Jewell, "Tom Johnson Wins $1,000 Art Prize," *New York Times,* October 24, 1941, 25; John Selby, "Florida Artist Wins Prize," *Los Angeles Herald Express,* October 24, 1941; Jeanette Jena, "New York Artists Win Five Carnegie Show Awards," *Pittsburgh Post-Gazette,* October 24, 1941, 21; Penelope Redd, "Carnegie Judges Award Seven Art Prizes," *Sun-Telegraph,* October 24, 1941; "Art Show Winner," *Los Angeles Evening Herald Express,* October 24, 1941; W. Peter MacDonald, "Carnegie Art Award Winner Built Bedford Home by Hand," *White Plains Reporter Dispatch,* October 25, 1941; John Selby, "Painting of Negro Tragedy Wins Art Exhibition Prize," *Philadelphia Inquirer,* October 25, 1941; Carlyle Burrows, "'Directions' Shown in Pittsburgh," *New York Herald Tribune,* October 26, 1941, 8; Grace V. Kelly, "Finds Best Paintings at Pittsburgh Exhibition Art Left out of Prize Awards," *Cleveland Plain Dealer,* October 26, 1941, 13B; Edward Alden Jewell, "In the Realm of Art: Pittsburgh Opens Its Big Annual," *New York Times,* October 26, 1941, 9; "Western-Born Artists Win in Eastern Competition," *Los Angeles Times,* October 26, 1941, 8; "That Tiresome Fashion" (editorial), *New*

York Times, October 28, 1941; "Strictly American Scene Wins Prize," *Atlanta Daily World,* October 29, 1941, 1; "Brave Show," 15; "Painting on Lynch Evil Wins 1st Prize at Carnegie Exhibit," *Chicago Defender,* November 1, 1941, 7; "Lynch Picture Brings Artist $1000 Prize," *Baltimore Afro American,* November 1, 1941, 14; Miller, "Native Artists Dig into Earth Again," C7; "Which Way American Art?" *Newsweek,* November 3, 1941, 63; "Art: Chicago v. Pittsburgh," *Time,* November 3, 1941; "Award $1,000 Prize to Lynch Painting," *Pittsburgh Courier,* November 8, 1941, 7; Howard Devree, "A Reviewer's Notebook: Brief Comment on Some of the Recently Opened Shows—A Baroque Survey," *New York Times,* February 1, 1942, X10.

39. Jewell, "In the Realm of Art"; Kelly, "Finds Best Paintings at Pittsburgh Exhibition Art Left out of Prize Awards."

40. Redd, "Carnegie Judges Award Seven Art Prizes."

41. Ibid. Although Redd reads the dynamically grieving figure against the tree as "the father," the article about the painting published in the *Bulletin Index* ("Brave Show")—as well as what appears to be the figure's dress—suggests that the figure is the victim's wife.

42. See Apel, *Imagery of Lynching;* Goldsby, *A Spectacular Secret;* Wood, *Lynching and Spectacle.*

43. See Dora Apel, "The Antilynching Exhibitions of 1935: Strategies and Constraint," in *Imagery of Lynching,* 83–132.

44. Letter from Tom Loftin Johnson to John O' Connor, acting director of the Department of Fine Arts at the Carnegie Institute, September 26, 1941 (courtesy of Carnegie Museum of Art archives).

45. Ibid.

46. Apel, *Imagery of Lynching.*

47. See Stacy I. Morgan, *Rethinking Social Realism: African American Art and Literature* (Athens: University of Georgia Press, 2004).

48. http://www.poyi.org/63/08/ae02.php (December 1, 2009).

49. For discussions of death as a racialized social experience, see Orlando Patterson, *Slavery and Social Death* (Cambridge, Mass.: Harvard University Press, 1982); Michael T. Taussig, *Shamanism, Colonialism and the Wild Man: A Study in Terror and Healing* (Chicago: University of Chicago Press, 1991); Joseph Roach, *Cities of the Dead: Circum-Atlantic Performance* (New York: Columbia University Press, 1996); Hartman, *Scenes of Subjection;* Avery Gordon, *Ghostly Matters: Haunting and the Sociological Imagination* (Minneapolis: University of Minnesota Press, 1997); and Sharon Patricia Holland, *Raising the Dead: Readings of Death and (Black) Subjectivity* (Durham, N.C.: Duke University Press, 2000).

50. For critically astute and methodologically innovative, cross-media treatments of national memory making, see Marita Sturken, *Tangled Memories: The Vietnam War, the AIDS Epidemic, and the Politics of Remembering* (Berkeley: Uni-

versity of California Press, 1997) and *Tourists of History: Memory, Kitsch, and Consumerism from Oklahoma City to Ground Zero* (Durham, N.C.: Duke University Press, 2007).

51. I refer here to Bazin's "ontology of the photographic image," which derives from his relation of visual arts to "the practice of embalming the dead." While Bazin's "mummy complex" generalizes broadly from the plastic arts to anxieties of mortality, my claim is for a nationally specific and historicized theory of the production and circulation of images of death in U.S. visual culture. See André Bazin, "The Ontology of the Photographic Image," trans. Hugh Gray, *Film Quarterly* 13.4 (1960): 4–9.

52. On these topics, see the texts referenced in notes 29 and 34.

53. Taussig, *Shamanism, Colonialism and the Wild Man,* 4. See also Gordon, *Ghostly Matters;* Holland, *Raising the Dead;* Patterson, *Slavery and Social Death;* and Roach, *Cities of the Dead.*

54. Taussig, *Shamanism, Colonialism and the Wild Man,* 4.

55. Ibid. Joanna E. Ziegler provides a history of the emergence of the pietà in the visual artistic realm in *Sculpture of Compassion: The Pietà and the Begines in the Southern Low Countries c. 1300–c. 1600* (Brussels/Rome: Institut Historique Belge de Rome, 1992).

56. As Adam Lively observes, "the modern idea of race as a scientific or pseudo-scientific means of classifying the human population by physical type was invented in the 18th century" (Adam Lively, *Masks: Blackness, Race, and the Imagination* [New York: Oxford University Press, 2000, 1998], 13). See also David Roediger, *How Race Survived U.S. History* (New York: Verso, 2008); Robert Bernasconi, *Race* (Malden, Mass.: Blackwell Publishers, 2001); and Reginald Horsman, *Race and Manifest Destiny: The Origins of American Racial Anglo-Saxonism* (Cambridge, Mass.: Harvard University Press, 1981).

57. In "Stabat Mater," Julia Kristeva reads a sexualized joining of the *Mater Dolorosa*—the grieving Virgin—with the body of Christ at the scene of death, which is also the scene in which resurrection is assured (Julia Kristeva, "Stabat Mater," in *The Kristeva Reader,* ed. Toril Moi, trans. Leon S. Roudiez [New York: Columbia University Press, 1986], 160–86).

58. Discussions of Mary are surprisingly scarce in the Bible, given the increasing prevalence and significance of her image in Christianity since the blooming of the Cistercian's Marion cult in the twelfth century. Thereafter, the brief mentions of Mary in the Bible were fleshed out into narratives, images, and eventually dogmas in both the Eastern and the Western churches. See Marina Warner, *Alone of All Her Sex: The Myth and the Cult of the Virgin Mary* (New York: Knopf, 1976). See also Michael P. Carroll, "Mary and the Mother Archetype," in *The Cult of the Virgin Mary: Psychological Origins* (Princeton, N.J.: Princeton University Press, 1992).

59. Articulating the sexualized, reproductive desire projected onto the pietà, Julia Kristeva reminds us that the space within which the *Mater Dolorosa* joins with the body of the dead Christ is indeed precisely the space of resurrection, the space of salvation's conception, the site wherein maternal desire is disciplined in the name of a higher order. "The ordering of the maternal libido reached its apotheosis when centred in the theme of death. The *Mater Dolorosa* knows no masculine body save that of her dead son, and her only pathos (which contrasts with the somewhat vacant, gentle serenity of the nursing Madonnas) is her shedding tears over a corpse ... And yet, Marian pain is in no way connected with tragic outburst: joy and even a kind of triumph follow upon tears, as if the conviction that death does not exist were an irrational but unshakeable maternal certainty, on which the principle of resurrection had to rest" ("Stabat Mater," 175).

Expounding on the historical, political import of the Virgin's resurrecting image, Kristeva also ponders the timing of the Vatican's elevation of the Assumption to dogma only after World War II. This narrative, wherein Mary surpasses death proper and rises "body and soul towards the other world" was celebrated with feasts as early as the seventh century in the Eastern church and the twelfth century in the Western church, but the Roman Catholic Church required some more powerful inspiration to embrace it as official Word. Kristeva asks of the Vatican's embrace of the Assumption in 1950: "What death anguish was it intended to soothe after the conclusion of the deadliest of wars?" The Holy Mother's rising and resurrecting force—imaged in the Assumption that carries her own body and soul "towards the other world" or the pietà that holds the Savior's promise to return to this one—finds what is perhaps indeed its most essential place inside modern spaces of death. Images of death joined to the revered maternal foretell, assure, promise rebirth to those visions that fix on them in moments of crisis and terror (ibid).

60. See Warner, *Alone of All Her Sex.*

61. See Julia Kristeva, *Powers of Horror: An Essay on Abjection,* trans. Leon S. Roudiez (New York: Columbia University Press, 1982). See also Mary Caputi, "The Abject Maternal: Kristeva's Theoretical Consistency," *Women and Language* 16.2 (Fall 1993): 32–56.

62. Psychoanalysis, with its emphasis on understanding primary processes of subject formation, has given these historically consistent, affective investments in the maternal, death, and (re)birth a central place in its theorizations. Carl Jung accounts for them in his treatment and elaboration of archetypes, those essential elements of the collective unconscious around which myths, symbols, and rituals—religious and otherwise—take shape. See Carl Jung, *Four Archetypes: Mother, Rebirth, Spirit, Trickster* (Princeton, N.J.: Princeton University Press, 1970). See also Carroll, *The Cult of the Virgin Mary,* 32–35. Previous to Jung, Sig-

mund Freud links death and the maternal through universalized "drives," "principles," "complexes," and "stages," most notably in his essay, "Mourning and Melancholia," in *The Freud Reader*, ed. Peter Gay (New York: Norton, 1995), 584–89, and *Beyond the Pleasure Principle* (New York: Norton, 1990). Jacques Lacan emphasizes the process of a subject's "birth" into the symbolic as coterminous with the "mirror phase" break from maternal (presymbolic) space in *Écrits: A Selection*, trans. Bruce Fink (New York: Norton, 2004). D. W. Winnicott and Melanie Klein give the maternal a central role in the object relations that usher one into subjectivity, healthfully or otherwise, depending on whether the breast is "good" or "bad" (Melanie Klein, *The Psychoanalysis of Children*, trans. Alix Strachey [New York: Delcourte Press, rev. ed. 1975], and D. W. Winnicott, *The Child, the Family, and the Outside World* [New York: Penguin, 1964]). Kristeva locates the maternal at/as the border between the being of a subject and that subject's obliteration. Necessary for, *and* necessarily "radically excluded" from, the coherent and bounded subject, the maternal/abject is—at once—life and death (Kristeva, *Powers of Horror*).

63. Lauren Berlant, "The Theory of Infantile Citizenship," in *The Queen of American Goes to Washington City: Essays on Sex and Citizenship* (Durham, N.C.: Duke University Press, 1997), 25–54.

64. Benedict Anderson, *Imagined Communities: Reflections on the Origin and Spread of Nationalism* (New York: Verso, 1991, 1983), 9. See also Étienne Balibar and Immanuel Wallerstein, *Race, Nation, Class: Ambiguous Identities* (New York: Verso, 1991).

65. Where she appears in visual proximity to death, the mother assumes her clearest and truest form as the abject, for—following Julia Kristeva—the maternal/abject is that which makes the self possible, but also threatens it perpetually. The maternal/abject body is both essentially reproductive and annihilating. We are therefore compelled—over and over and over again—to *make* and to *see* her do right by death. *American Pietàs* reads this compulsion, this image-drive that consolidates, comforts, and the "subject on trial," here meaning the subject-in-formation within a cultural symbolic of racialized nationalism. Kristeva theorizes the subject-on-trial/in process in *Revolution in Poetic Language*, trans. Leon S. Roudiez (New York: Columbia University Press, 1984).

66. E. Ann Kaplan, *Motherhood and Representation: The Mother in Popular Culture and Melodrama* (New York: Routledge, 1992), 7.

67. For a concise history of the racialized production of human liberty through institutionalized treatments of maternal bodies, see Dorothy Roberts, *Killing the Black Body: Race, Reproduction and the Meaning of Liberty* (New York: Vintage, 1999).

68. Ziegler, *Sculpture of Compassion*.

69. See Karla Holloway's *Passed On: African American Mourning Stories* (Durham, N.C.: Duke University Press, 2003) for a treatment of the racialized experience and treatment of death and memorialization in the United States.

70. Holland, *Raising the Dead,* 15.

71. In *Slavery and Social Death: A Comparative Study* (Cambridge, Mass.: Harvard University Press, 1985), Orlando Patterson discusses the historical circumstances by which blacks have been denied the social heritage of their ancestors, and by which they have become what he calls "genealogical isolates," denied by racism an anchoring in both the past and the present (312).

72. Gordon, *Ghostly Matters,* 17.

73. Ibid.

74. Ibid.

75. Laura Wexler, *Tender Violence: Domestic Images in an Age of U.S. Imperialism* (Chapel Hill: University of North Carolina Press, 2000).

76. See Saidiya Hartman's discussion of the racialized violence of identification in *Scenes of Subjection,* 118–20.

77. See Patterson, *Slavery and Social Death.*

78. Hazel Carby, *Reconstructing Womanhood: The Emergence of the Afro-American Woman Novelist* (New York: Oxford University Press, 1987); Ann duCille, "The Occult of True Black Womanhood," in *Female Subjects in Black and White: Race, Psychoanalysis, Feminism,* ed. Elizabeth Abel, Barbara Christian, and Helene Moglen (Berkeley: University of California Press, 1997); and Hortense Spillers, "Mama's Baby, Papa's Maybe: An American Grammar Book," *Diacritics* 17.2 (1987). In *Reconstructing Womanhood,* Carby engages the racialization of womanhood and motherhood in her analysis of the late-twentieth-century gender codes according to which women were declared to be, or not to be, women. These "womanly" codes of purity, piety, submissiveness, and domesticity invariably denied womanhood to enslaved black women who, by virtue of their status as sexual and reproductive property, could "abide" by none of them. As the means by which womanhood came (not) to be, the cult was the discursive and material backdrop against which humanity was absolutely denied to black females. Yet, as Carby's close reading of "The Emergence of the Afro-American Woman Novelist" illumines, black women writers effectively "reconstructed" dominant notions of motherhood as a universal experience through literary narrative. Antebellum artists such as Nancy Prince, Harriet Wilson, and Harriet Jacobs used their narratives to analyze, negotiate, and resist the racial criteria that fixed them always outside the possibility of (gendered) subjectivity. In doing so, they made historical and social what were taken to be timeless and natural: the experiences and identities of "women" and "mothers." See also Patricia Hill Collins, "Shifting the Center: Race, Class and Feminist Theorizing about Motherhood," in *Mothering: Ideology, Experience and*

Agency, ed. Evelyn Nakano Glenn, Grace Chang, and Linda Rennie Forcey (New York: Routledge, 1994), 45–65.

79. Carby, *Reconstructing Womanhood,* 61.

80. See Roberts, *Killing the Black Body.*

81. Victor Burgin, *In/Different Spaces: Place and Memory in Visual Culture* (Berkeley: University of California Press, 1996), 21–22.

82. See Nicholas Mirzoeff, "The Subject of Visual Culture," in *The Visual Culture Reader,* ed. Nicholas Mirzoeff (New York: Routledge, 2002), 3–23; W. J. T. Mitchell, "Showing Seeing: A Critique of Visual Culture," *Journal of Visual Culture* 1.2 (2002): 165–81; Mieke Bal, "Visual Essentialism and the Object of Visual Culture," *Journal of Visual Culture* 2.1 (2003): 5–32.

1. Maternal Visions, Racial Seeing

1. Some notable exceptions are Marianne Hirsch, *Family Frames: Photography, Narrative and Postmemory* (Cambridge, Mass.: Harvard University Press, 1997); Jane Gallop, *Living with His Camera* (Durham, N.C.: Duke University Press, 2003); Diana Knight, *Barthes and Utopia: Space, Travel Writing* (London: Oxford University Press, 1997); Carol Mavor, *Reading Boyishly: Roland Barthes, J. M. Barrie, Jacques Henri Lartigue, Marcel Proust, and D. W. Winnicott* (Durham, N.C.: Duke University Press, 2008). These texts include analyses of the centrality of, if not Barthes's own mother, then "the" mother to *Camera Lucida*'s meditations on the photograph.

2. Roland Barthes, *Camera Lucida: Reflections on Photography,* trans. Richard Howard (New York: Hill and Wang, 1981), 40.

3. See Kristeva, *Powers of Horror,* for her discussion of the maternal as object.

4. Jane Gallop (*Living with His Camera*) argues that the maternal "nature" of the photograph lies in the fact that the mother is the quintessential photographic subject, that "she" is thus a photograph's perfect object. This is quite different from the relationship between the *logics* of the maternal and the photographic that I hope to illumine.

5. Barthes, *Camera Lucida,* 6.

6. This culturally constructed notion of the ideal mother as distinct in her proximity to nature, as tending toward selflessness, and as a primary host for the child's (and the family's) developmental processes is evident across a range of dominant and would-be subversive epistemologies, from psychoanalysis to sociology, from nationalism to feminism. See Shari L. Thurer, *The Myths of Motherhood: How Culture Reinvents the Good Mother* (New York: Penguin, 1995).

7. Barthes does not use the theoretical term "abject" in his text, although it is clear from the original French edition of *Camera Lucida* (*La Chambre Claire*)—

which includes the footnotes and bibliography that are absent from the English translation—that he was indeed in conversation with Julia Kristeva's work. Indeed, Kristeva was a student and friend of his, and by all accounts he respected and learned immensely from her ideas. Even though Barthes likely did not have the benefit of fully engaging Kristeva's concept of the abject—her *Powers of Horror* was published in 1982—I argue that *Camera Lucida* nevertheless foreshadowed this concept in its articulation of the photograph as a kind of skin, as a border/frame that bounds *and* threatens subjectivity.

8. Barthes, *Camera Lucida*, 92.

9. Ibid., 74. I interpret this as not only a rejection of the universalized gendering attributed to the family structure by psychoanalysis, but also as an allusion to and personal rejection of the universalized family as established in visual cultural—specifically, photographic—arenas. In his essay "The Great Family of Man," Barthes critically treats Edward Steichen's 1955 photography exhibition Family of Man at New York's Museum of Modern Art, wherein close to three hundred photographers from sixty-eight countries collectively composed a picture with 508 photographs of "the human experience." The exhibition highlighted would-be universally representative "human" moments of birth, love, war, and death. See Roland Barthes, "The Great Family of Man," in *Mythologies,* trans. Annette Lavers (New York: Macmillan, 1972), 100–116. For a book-length analysis of the exhibition and its worldwide influence, see Eric Sandeen's *Picturing an Exhibition: The Family of Man and 1950s America* (Albuquerque: University of New Mexico Press, 1995). Barthes was also clearly in intertextual conversation with Richard Avedon's 1976 portrait collection *The Family,* as *Camera Lucida* reproduces as its penultimate image one of its photographs, namely, Avedon's portrait of African American civil rights leader A. Philip Randolph. See Richard Avedon, "The Family," in the October 1, 1976, issue of *Rolling Stone.*

10. Roland Barthes, *Roland Barthes,* trans. Richard Howard (New York: Hill and Wang, 1994).

11. Barthes, *Camera Lucida,* 3.

12. Ibid., 6

13. Ibid., 9; emphasis added.

14. Raymond Williams, *Marxism and Literature* (Oxford: Oxford University Press, 1977), 132.

15. Barthes, *Camera Lucida,* 9.

16. Ibid., 7.

17. Ibid., 18. In her essay "Touching Photographs," Margaret Olin argues, as do I, that *Camera Lucida* is most usefully understood as a first-person creative exposition, as a text written in the voice of a character, the photographic Spectator. See Margaret Olin, "Touching Photographs: Roland Barthes's 'Mistaken' Identification," *Representations* 80 (2002): 99–118.

18. For key historical and theoretical texts on race and photography, see Shawn Michelle Smith, *Photography on the Color Line: W. E. B. DuBois, Race, and Visual Culture* (Durham, N.C.: Duke University Press, 2004), and *American Archives: Gender, Race and Class in Visual Culture* (Princeton, N.J.: Princeton University Press, 1999); Coco Fusco and Brian Wallis, eds., *Only Skin Deep: Changing Visions of the American Self* (New York: International Center of Photography/Harry N. Abrams, 2003); Wexler, *Tender Violence;* Leigh Raiford, *Imprisoned in a Luminous Glare: Photography and the African American Freedom Struggle* (Chapel Hill: University of North Carolina Press, 2011).

19. Barthes, *Camera Lucida,* 14.

20. Frantz Fanon, *Black Skin, White Masks,* trans. Charles Lam Markman (Boston: Grove Press, 1967), 116.

21. Ibid, 112.

22. Ibid.

23. Barthes, *Camera Lucida,* 92.

24. Olin, "Touching Photographs," 114.

25. Ibid.

26. Ibid.

27. Barthes, *Camera Lucida,* 26. Subsequent references are given in the text.

28. See Louis-Jean Calvet, *Roland Barthes: A Biography,* trans. Sarah Wykes (Bloomington: Indiana University Press, 1995).

29. I want to thank Paul Roth, executive director of the Avedon Foundation, for pointing out to me that, in some instances, Avedon referred to his portrait of Casby as "William Casby, Former Slave."

30. Paul Roth suggested to me that *Camera Lucida* treats Casby's portrait like a punctum in the text, that because it emerges again—after its original appearance—it "penetrates (à la punctum) the everyday."

31. See Shawn Michelle Smith, "Race and Reproduction in *Camera Lucida,*" in *Photography Degree Zero: Reflections on Roland Barthes's Camera Lucida,* ed. Geoffrey Batchen (Cambridge, Mass.: MIT Press, 2009), 243–58.

32. See David Horn, *The Criminal Body: Lombroso and the Anatomy of Difference* (New York: Routledge, 2003); Jonathan Finn, *Capturing the Criminal Image: From Mug Shot to Surveillance Society* (Minneapolis: University of Minnesota Press, 2009); Anne Maxwell, *Picture Imperfect: Photography and Eugenics, 1870–1940* (Portland, Ore.: Sussex Academic Press, 2008).

33. Barthes, *Camera Lucida,* 9.

34. Ibid., 18.

35. Barthes, *Mythologies.*

36. Barthes, *Camera Lucida,* 73.

37. Barthes scholars are understandably quite taken with the idea of—for no one has seen it, of course—the Winter Garden photograph. In *Barthes and Utopia,*

Diana Knight offers one of the most nuanced readings in print of *Camera Lucida* and the role of this particular image-idea, particularly in her chapter titled "Maternal Space." Of her many fascinating points, Margaret Olin also treats the image in very theoretically subtle and critical ways, declaring ultimately that it matters less whether or not the Winter Photograph existed than it does that Barthes performed his own photographic dis/identifications through a narrative about a/his maternal image (Knight, *Barthes and Utopia*; Olin, "Touching Photographs").

38. Barthes died in 1980. Shortly thereafter, and in the same year, *Camera Lucida* was first published in French as *La Chambre Claire*.

39. An example of *Camera Lucida*'s autobiographical reception and treatment: Hervé Guibert's assertion that "it's the second half of the book [in which Barthes writes of his mother] which is the most limpid, authentic, and necessary, and hence the most beautiful" ("Roland Barthes and Photography: The Sincerity of the Subject," in *Critical Essays on Roland Barthes*, ed. Diana Knight [New York: G. K. Hall and Co., 2000], 115–17).

40. Calvet, *Roland Barthes*.

41. Barthes, *Camera Lucida*, 73.

42. Jacques Derrida asserts that the Winter Garden photograph is, indeed, the *punctum* of the text ("The Deaths of Roland Barthes," in *The Work of Mourning*, ed. Pascale-Anne Brault and Michael Naas [Chicago: University of Chicago Press, 2001], 31–68).

43. Barthes, *Camera Lucida*, 73.

44. Ibid., 72.

45. Ibid., 69.

46. Gordon, *Ghostly Matters*.

2. Commemorating Whiteness

1. Fan Web site, author unknown, "Diana—Into the Light," http://www.royalnetwork.com/hearts/light.html (accessed September 15, 1998; site now discontinued).

2. Fan Web site, author unknown, "Diana, Legend of Love," http://www.geocites.com/Wellesley/6417/ (accessed September 15, 1998; site now discontinued).

3. "Mass Grief," *Economist* 344.8034 (September 13 1997): 6; *The Media Report to Women* described the death of Diana as "the most popular single subject on U.S. Newsmagazine in 1997" (*Media Report to Women* 26.1 [1998]: 10).

4. Fred Bronson, "U.S. Lights 3.4 Million 'Candles,'" *Billboard*, October 1997, 110. See also Susan J. Hubert, "Two Women, Two Songs: The Subversive Iconography of 'Candle in the Wind,'" *NWSA Journal: National Women's Studies Association Journal* 11.2 (1999): 124–37.

5. There are, quite literally, far too many such commemorative acts in the

global popular sphere to document. For example, the ten-year anniversary of Diana's death in August 2007 saw the publication/broadcast of, among many other commemorative texts, a thanksgiving memorial service at the Guard's Chapel, London; a "Princess Diana Memorial Concert" at Wembley Stadium organized by her sons; *Diana, An Amazing Life: The People Cover Stories, 1981–1997* (New York: People Books, 2007); a *Time* special issue, "Ten Years On: Why Diana Mattered" (September 10, 2007); Rosalind Coward, *Diana: The Portrait, Anniversary Edition* (Riverside, N.J.: Andrews McMeel Publishing, 2007); a raft of documentaries, including *Diana: Last Days of a Princess,* DVD, Genius Products, 2007; and at least fifteen new books published, by the count of L' Agence France-Presse.

6. Earl Spencer as quoted in *People Weekly: The Diana Years,* Commemorative Edition (New York: People Books, 1997), 159.

7. James Baldwin, *The Evidence of Things Not Seen* (New York: Holt Paperbacks, 1995 [1987]), 11.

8. Among the many books and anthologies that treat the question of Diana's national (British and American) and global significance are Jeffrey Richards, Scott Wilson, and Linda Woodhead, eds., *Diana: The Making of a Media Saint* (New York: I. B. Tauris, 1999); Mandy Merck, ed., *After Diana: Irreverent Elegies* (New York: Verso, 1998); Julie Burchill, *Diana* (London: Orion Publishing, 1998); Beatrix Campbell, *Diana, Princess of Wales: How Sexual Politics Shook the Monarchy* (London: Women's Press, 1999); Sally Bedell Smith, *Diana in Search of Herself: Portrait of a Troubled Princess* (New York: Times Books, 1999); Jude Davies, *Diana, a Cultural History: Gender, Race, Nation, and the People's Princess* (New York: Palgrave, 2001); Rosalind Brunt, ed., "'Diana' Special Issue," *Journal of Gender Studies* 8.3 (1999); Colleen Denney, *Representing Diana, Princess of Wales: Cultural Memory and Fairy Tales Revisited* (Madison, N.J.: Fairleigh Dickinson University Press, 2005); Sarah Bradford, *Diana* (New York: Viking, 2006); Tina Brown, *The Diana Chronicles* (New York: Doubleday, 2007).

9. *Life* 20.11 (November 1997).

10. *People Weekly: The Diana Years,* 132.

11. The subset of "Diana studies" that most directly relate to my argument are those that have sought to document and interpret collective emotional reactions to Diana's death. See Diana Taylor, "False Identifications: Minority Populations Mourn Diana," in *The Archive and the Repertoire: Performing Cultural Memory in the Americas* (Durham, N.C.: Duke University Press, 2003), 133–60; Bryan Grigsby, "Diana's Death and Public Perception," *News Photographer* 52.11 (1997): 16–26; Tony Walter, *The Mourning for Diana* (New York: Berg, 1999); Annette Kuhn, "Flowers and Tears: The Death of Diana, Princess of Wales: Preface," *Screen* 39.1 (1998): 67–68; Douglas James Davies, "Popular Reaction to the Death of Princess Diana," *Expository Times* 109.6 (1998): 173–76; John William Drane and Chris Sugden, *Death of a Princess: Making Sense of a Nation's Grief* (London:

Silver Fish, 1998); Majella Franzmann, "Diana in Death: A New or Greater Goddess?" *Australian Folklore: A Yearly Journal of Folklore Studies* 13 (1998): 112–23; Janice Hocker Rushing, "Putting Away Childish Things: Looking at Diana's Funeral and Media Criticism," *Women's Studies in Communication* 21.2 (1998): 150; Martin Montgomery, "Speaking Sincerely: Public Reactions to the Death of Diana," *Language and Literature: Journal of the Poetics and Linguistics Association* 8.1 (1999): 5–33; J. M. Wober, "A Feeding Frenzy, or Feeling Friendsy? Events after the Death of Diana, Princess of Wales," *Journal of Popular Culture* 34.1 (2000): 127–34; David R. Pillow and Mary E. McNaughton Cassill, "Media Exposure, Perceived Similarity, and Counterfactual Thinking: Why Did the Public Grieve When Princess Diana Died?" *Journal of Applied Social Psychology* 31.10 (2001): 2072–94; Hugh O'Donnell, Robert W. Spires, and Rhoda Gilbert, "A Tale of Two Funerals?" *Television Quarterly* 31.4 (2001): 72–76; James Thomas, *Diana's Mourning: A People's History* (Cardiff: University of Wales Press, 2002); William J. Brown, Michael D. Basil, and Mihai C. Bocarnea, "Social Influence of an International Celebrity: Responses to the Death of Princess Diana," *Journal of Communication* 53.4 (2003): 587–605; Michael A. Bull, Sheila Clark, and Katherine Duszynski, "Lessons from a Community's Response to the Death of Diana, Princess of Wales," *Omega: Journal of Death and Dying* 46.1 (2003): 35–49; Stephanie Marriott, "The BBC, ITN and the Funeral of Princess Diana," *Media History* 13.1 (2007): 93–110; Rob Turnock, *Interpreting Diana: Television Audiences and the Death of a Princess* (London: British Film Institute, 2008); James Thomas, "From People Power to Mass Hysteria: Media and Popular Reactions to the Death of Princess Diana," *International Journal of Cultural Studies* 11.3 (2008): 362–76; Roel Puijk, "Intense Media Coverage," *Communications: The European Journal of Communication Research* 34.1 (2009): 1–20.

12. In *Life's America* (Philadelphia: Temple University Press, 1994), Wendy Kozol discusses the ideological work *Life* magazine performed after World War II to teach domesticity and the "American" family as white and middle-class, and to erase the heterogeneity of the U.S. American experience. She points out that *Life* legitimated its role with the notion of photographic realism—the idea that the technology of the camera delivers pieces through images of an unmediated reality or truth. The significance of visual culture as both a *site* and *stake* of identity formation is illumined by Kozol's observation that these images were put together from, and in turn used to further construct, dominant discourses of patriotism, masculinity, and femininity in postwar America.

13. For studies of public responses to the death in transnational media contexts, see Uju Uchendu-Ozoka, *Diana: An African Perspective* (Lagos: Gong Publishers, 1998); Paolo Mancini and Chiara Moroni, *La Principessa Nel Paese Dei Mass Media: Lady Diana e Le Emozioni Della Modernità* (Rome: Editori Riuniti, 1998); "Framing en La Prensa Española: La Información sobre la Muerte y Funeral de Diana de

Gales," *Comunicación y Sociedad* 12.1 (1999): 137–61; Daniel Dayan, "Rituels Populistes: Public et Télévision aux Funérailles de Lady Diana," *Bulletin d' Histoire Politique* 14.1 (2005): 89–107; Pedro Agustín Díaz Arenas and Jeremy D. Fox, *Valores y héroes de la globalidad: Diana, Clinton y Pinochet* (Bogotá, Colombia: Editorial El Búho, 2000).

14. Mother Teresa died of cardiac arrest in her convent in Calcutta on September 5, 1997, approximately one week after Diana Spencer was killed in the auto accident in Paris. See Eric Pace, "Mother Teresa, Hope of the Despairing, Dies at 87," *New York Times*, September 6, 1997, 1.

15. On the confluence of events, see Christine Pina, "Lady Di et Mère Teresa: Deux Saintes Catholiques?" *Religiologiques* 19 (1999): 79–95; Derek Stanovsky, "Princess Diana, Mother Teresa, and the Value of Women's Work," *NWSA Journal* 11.2 (1999): 146.

16. In 1962, Mother Teresa received the *Padmashree* ("Magnificent Lotus") Award from the Indian government in honor of her work among the poor and sick of India. She also received the first Pope John XXIII Peace Prize in 1971, the Jawaharlal Nehru Award for International Understanding in 1972, and, in 1979, she was awarded the Nobel Peace Prize. She used all of the money accompanying these awards to fund the centers of the Missionaries of Charity, which she founded in 1948 ("Mother Teresa Memorial, Biography," http://www.ccrnet .com/mother_teresa/biography.html [accessed November 14, 1998; site now discontinued]).

17. "Farewell to a Princess, and to an Angel," *Life* (November 1997), 14.

18. Ibid.

19. A number of studies have drawn parallels rather than contrasts among collective "mourning events." See C. Blank-Reid, "What Can We Learn from Famous Traumas? . . . Princess Grace of Monaco . . . Diana, Princess of Wales . . . Rev. Dr. Martin Luther King, Jr.," *Nursing* 31.4 (2001): 32cc1–32cc4; Michael Brennan, "Condolence Books: Language and Meaning in the Mourning for Hillsborough and Diana," *Death Studies* 32.4 (2008): 326–51.

20. See Victor Burgin's discussion of the "third effect" in "Art, Common Sense and Photography," in *Visual Culture: The Reader,* ed. Jessica Evans and Stuart Hall (London: Rivers Oram, 1999), 41–50.

21. Analyses of the sanctification of Diana in death have tended to consider the death and public mourning as an isolated event. See, for example, Luke Bretherton, "Icon, Goddess, Folk Hero, or what," *Regeneration Quarterly* 3.4 (1997): 7–8; Gillian Bennett and Anne Rowbottom, "'Born a Lady, Died a Saint': The Deification of Diana in the Press and Popular Opinion in Britain," *Fabula: Zeitschrift für Erzählforschung/Journal of Folktale Studies/Revue d' Études sur le Conte Populaire* 39.3–4 (1998): 197–208; Marion Bowman, "The People's Princess: Vernacular Religion and Politics in the Mourning for Diana," *Acta Ethnographica Hungarica: An*

International Journal of Ethnography 46.1–2 (2001): 35–49; and Richards, Wilson, and Woodhead, *Diana.*

22. "Farewell to a Princess, and to an Angel," 18.

23. Ibid., 19.

24. A complementary argument might be made for the public media narrations of the deaths of young, white girls. See, for example, Jo Ann Conrad, "Docile Bodies of (Im)Material Girls: The Fairy-Tale Construction of Jon Benet Ramsey and Princess Diana," *Marvels and Tales: Journal of Fairy-Tale Studies* 13.2 (1999): 125–69.

25. "Farewell to a Princess, and to an Angel," 18.

26. Ibid., 20.

27. Ibid.

28. Ibid.

29. On the "floral tribute" to Diana, see Susanne Greenhaulgh, "Our Lady of Flowers: The Ambiguous Politics of Diana's Floral Revolution," in *Mourning Diana: Nation, Culture, and the Performance of Grief,* ed. Adrian Kear and Deborah Lynn Steinberg (London: Routledge, 1999), 40–59.

30. See Raka Shome, "White Femininity and the Discourse of the Nation: Re/membering Princess Diana," *Feminist Media Studies* 1.3 (2001): 323–42.

31. Judith Stacey, *In the Name of the Family: Rethinking Family Values in the Postmodern Age* (Boston: Beacon Press, 1996), 47–48.

32. Ibid., 6.

33. Ibid.

34. Daniel Patrick Moynihan, for the Office of Policy Planning and Research, U.S. Department of Labor, *The Negro Family: The Case for National Action* (Santa Barbara: Greenwood Press, 1981 [1965]).

35. Sexualities studies scholars have read popular responses to Diana's death in relation to her well-publicized work on AIDS relief and changing social structures of heteronormativity. See Iain Morland and Annabelle Willox, *Queer Theory* (New York: Palgrave Macmillan, 2005); Elizabeth Stuart, "A Queer Death: The Funeral of Diana, Princess of Wales," *Theology and Sexuality: The Journal of the Institute for the Study of Christianity and Sexuality* 13 (2000): 77–91; Gill Valentine and Ruth Butler, "The Alternative Fairy Story: Diana and the Sexual Dissidents," *Journal of Gender Studies* 8.3 (November 1999): 295–303; Kai Wright, "Remembering Diana: Princess' Brave Actions Helped in Fight against AIDS Phobia," *Washington Blade,* September 5, 1997.

36. Catherine Hall, *White, Male, and Middle Class: Explorations in Feminism and History* (New York: Routledge, 1992).

37. Ibid., 75–93.

38. Ibid., 86.

39. Ibid., 89.

40. Shirley Samuels, ed., *The Culture of Sentiment: Race, Gender, and Sentimentality in 19th Century America* (New York: Oxford University Press, 1992), 3.

41. Laura Wexler, "Tender Violence: Literary Eavesdropping, Domestic Fiction, and Educational Reform," in ibid., 15.

42. Ibid.

43. Ibid.

44. In *Reconstructing Womanhood,* Hazel Carby illumines the racially exclusionary nature of the "cult of true womanhood," the dominant ideological codes through which womanhood was defined and performed. Her analyses of the work of nineteenth-century black women novelists reveal how these women struggled to assert their humanity, and to defend their lives as women and mothers, within an oppressive structure that defined "woman" as everything an enslaved female could not be: pure, pious, submissive, and domestic. Carby's work convincingly demonstrates the imperative for feminist analyses of patriarchy that are attendant to its racialized and racializing nature: by virtue of their race (free status), white women have historically been the sole occupiers of "true" womanhood and it is within this racially privileged space that the Culture of Sentiment, as an empowering *patriarchal* practice, was born. For further discussion of how the category of race troubles the notion that nineteenth-century women and men simply occupied separate spheres—private and public, empowered and disempowered—see "No More Separate Spheres," special issue of *American Literature* 70.3 (1998).

45. Wexler, "Tender Violence."

46. *People Weekly: The Diana Years,* 6–8.

47. Ibid, 9.

48. Ibid.

49. In this respect, Rob Stones's formulation of "abstract intimacies" among mass consumers of visual media of contemporary journalism for figures such as Princess Diana and Bill Clinton is illuminating. See Rob Stones, "Abstract Intimacies: The Princess and the President," *Sexualities* 2.2 (1999): 255–59.

50. *People Weekly: The Diana Years,* 15.

51. Ibid., 132–43.

52. Ibid., 139.

53. In "Diana and the Religion of the Heart" (119–39), Linda Woodhead discusses the spiritual commitment and popular religious appeal of Diana as a humanitarian. Woodhead seems to argue that the universal reverence for Diana was and is appropriate to both the many wonderful acts of kindness she committed and her freely loving and honest spirit. Although I agree that Diana was responsible for important change in the lives of many suffering individuals, and for drawing attention to important global issues of war, poverty, and illness, I believe it's

necessary to understand the liberal individualist doctrine to which Diana's "Religion of the Heart" and its followers subscribe as one that has historically covered over inequalities based on race and class. Indeed, what likely appeals to so many about Diana's apparently limitless love and generosity toward those in need is the ocular "proof" that the globally circulated images of her as a healing angel provide that the world's ills—even (especially, perhaps) those based on structural inequalities—are subsiding.

54. Hartman, *Scenes of Subjection*, 20.

55. Ibid., 19.

56. Ibid., 20.

57. Ibid.

58. Tina Brown, *The Diana Chronicles* (New York: Doubleday, 1997), 12.

59. Ibid.

60. Lauren Berlant, "The Female Woman: Fanny Fern and the Form of Sentiment," in Samuels, *The Culture of Sentiment*, 281.

61. Raymond Williams, *Marxism and Literature* (Oxford: Oxford University Press, 1977), 132.

62. Ibid.

63. Ibid.

64. Ibid.

65. Wexler, "Tender Violence," 19.

66. Williams, *Marxism and Literature*, 132.

67. Studies of digital media conversations and memorials in the wake of Diana's death provide evidence of such diversities. See Lori D. Stone and James W. Pennebaker, "Trauma in Real Time: Talking and Avoiding Online Conversations about the Death of Princess Diana," *Basic and Applied Social Psychology* 24.3 (2002): 173–83; Marguerite Helmers, "Media, Discourse, and the Public Sphere: Electronic Memorials to Diana, Princess of Wales," *College English* 63.4 (2001): 437–56; Diana Taylor, "Downloading Grief: Minority Populations Mourn Diana," in Kear and Steinberg, *Mourning Diana*, 187–210.

68. Herbert Marcuse, *One-Dimensional Man: Studies in the Ideology of Advanced Industrial Society* (Boston: Beacon Press, 1964), 11.

69. Ibid., 12.

70. *People Weekly: The Diana Years*, 158.

71. Barthes refers to the photograph that stands alone as a "continuous message," a "message without a code" (Roland Barthes, *Image, Music, Text*, trans. Stephen Heath [New York: Hill and Wang, 1977], 17).

72. Earl Spencer, as quoted in *People Weekly: The Diana Years*, 159.

73. Barthes, *Image, Music, Text*, 61–63; emphasis added.

74. Baldwin, *The Evidence of Things Not Seen*, 80.

3. *Beloved* Therapies

1. Toni Morrison, *Beloved* (New York: Plume, 1987), 274.

2. Bernard Weinraub, "'Beloved' Tests Racial Themes at Box Office," *New York Times,* October 14, 1998, E1 and E8, and Bernard Weintraub, "Despite Hope, 'Beloved' Generates Little Heat among Moviegoers," *New York Times,* November 9, 1998, E4; Sharon Waxman, "At the Box Office, 'Beloved' Is a Tough Sell," *Washington Post,* November 11, 1998, D1; "Autumn Flops," *Economist,* November 21, 1988, 86.

3. For other critical, scholarly treatments of Demme's *Beloved,* see Natalie Zemon Davis, *Slaves on Screen: Film and Historical Vision* (Cambridge, Mass.: Harvard University Press, 2000), and Allison Berg, "Epilogue: Representing Motherhood at Century's End," in *Mothering the Race: Women's Narratives on Reproduction* (Champaign: University of Illinois Press, 2002), 133–44.

4. In *Cinematernity,* Lucy Fischer points out that feminist film theory has focused a lot of attention on melodrama and horror as sites within which to analyze maternal imagery and ideologies of motherhood. Her examination of maternal representations and filmic technologies in other established genres demonstrates the ideologically coproductive nature of apparently distinct film categories, and encourages us to think about the intertextuality of visual performances of motherhood. Beyond these contributions, however, Fischer offers a critique of genre practices that is useful to the present examination of racial configurations of the maternal in film. She argues that the maternal figure is a central one in the whole of cinematic culture, and thus engages its various representations in various genres to illumine how visual narratives imply a specific gender and sexual politics. I wish to suggest that an accounting of the racialization of reproduction, maternity, and maternal bodies that occurs in history and in visual culture problematizes Fischer's reading of these politics within "cinematernity," as well as destabilizes the boundaries between "commonsense" notions of genres like horror and melodrama. See Lucy Fischer, *Cinematernity: Film, Mother, Genre* (Princeton, N.J.: Princeton University Press, 1996). See also Kaplan, *Motherhood and Representation;* Ruth Feldstein, *Motherhood in Black and White: Race and Sex in American Liberalism,* 1930–1965 (Ithaca, N.Y.: Cornell University Press, 2000); Barbara Creed, "Horror and the Monstrous-Feminine: An Imaginary Abjection," in *Feminist Film Theory: A Reader,* ed. Sue Thornham (New York: New York University Press, 1999), 251–66.

5. For a treatment of the extracinematic fascination and reception of film stars, see Richard Dyer, *Heavenly Bodies: Film Stars and Society* (New York: Macmillan, 1986).

6. Linda Williams, "Melodrama Revised," in *Refiguring American Film Genres:*

History and Theory, ed. Nick Browne (Berkeley: University of California Press, 1998), 50.

7. See Richard Alleva, "Mistranslated," *Commonweal* 125.20 (November 20, 1998): 18; John Simon, "Beloved," *National Review,* November 23, 1998, 59; and Richard A. Blake, "Free at Last," *America,* November 7, 1998, 24.

8. Morrison, *Beloved,* 3.

9. In his review of *Beloved* titled "Mistranslated," Richard Alleva despairs at Demme's failure to adequately convey the complexity of racialized historical trauma as it is lived by individuals, daily: "Toni Morrison deployed and controlled the ghostly elements of her story with her powerful and flexible prose style. Her language says boo!, then her language calms us down. We see ghosts only when her words allow us to and, even then, only within the context of normal human activity. But horror on screen is both more immediately shocking and more combustible than literary spookiness. When director Jack Clayton made *The Innocents,* his adaptation of *The Turn of the Screw,* he measured his shocks out in small doses so we wouldn't miss the struggle going on within his heroine. But Demme slathers on his effects. The very first scene of the poltergeist's attack, with a dog slammed so hard against a wall that its eye pops out, is straight from Exorcist Territory, and so are the early appearances of Beloved, skin acrawl with insects, speaking at first in a basso profundo, later in babyish prattle. The lighting effects recall science fiction thrillers like *The Fly* or *Stargate,* and they come on so strong and so soon that they put us in the wrong frame of mind for the subtle human relationships that follow" (Alleva, "Mistranslated," 18–23).

10. Weinraub, "'Beloved' Tests Racial Themes at Box Office," E1 and E8.

11. Karen Halttunen, "Early American Murder Narratives: The Birth of Horror," in *The Power of Culture,* ed. Richard Wightman Fox and T. J. Jackson Lears (Chicago: University of Chicago Press, 1993), 67–102.

12. See Roberts, *Killing the Black Body,* for a historicized discussion of racialized institutional constructions of motherhood and reproduction in the United States.

13. Creed, "Horror and the Monstrous-Feminine."

14. Morrison, *Beloved,* 274.

15. Creed, "Horror and the Monstrous-Feminine," 252.

16. "Production Featurette" clip on *Beloved* DVD, Touchstone Pictures.

17. Morrison, *Beloved,* 193.

18. Vivian Sobchak, "Phenomenology and the Film Experience," in *Viewing Positions: Ways of Seeing Film,* ed. Linda Williams (New Brunswick, N.J.: Rutgers University Press, 1995), 46–48.

19. Christine Gledhill, "Rethinking Genre," in *Reinventing Film Studies,* ed. Christine Gledhill and Linda Williams (London: Oxford University Press, 2000), 221–43.

20. Oprah Winfrey, *Journey to Beloved* (New York: Hyperion, 1998), 18.

21. Oprah Winfrey, epigraph to *Journey to Beloved*.

22. Morrison's character Sethe, and the novel *Beloved* itself, is based in part on the actual experiences of Margaret Garner, a fugitive slave from Kentucky who killed her infant when she and her family were discovered by slave masters exercising their right to hunt and return runaways under the Fugitive Slave Law. For a historical account of Garner's story, see Steven Weisenburger, *Modern Medea: A Family Story of Slavery and Child-Murder from the Old South* (New York: Hill and Wang, 1998).

23. Weinraub, "'Beloved' Tests Racial Themes at Box Office." This reference to Beloved as Winfrey's personal *Schindler's List* indicates yet again Winfrey's public role as a national "savior." There is no "Schindler" character in the film *Beloved;* rather, Winfrey herself (as an entity outside of the film) is "Schindler," the one who makes sacrifices and labors for years toward the emancipation of an entire population, at great personal risk and financial expense. Given the themes of Morrison's *Beloved,* we might imagine that this population would/could somehow be the descendants of enslaved African Americans. Indeed, Winfrey includes them in her "freeing" project of telling/knowing the historical truth and then "letting it go," but she also includes "everyone" who is suffering not only from a lack of historical knowledge and reckoning, but also from the feeling of not having been forgiven for these aversions.

24. "Production Featurette" clip on *Beloved* DVD.

25. Lawrence Toppman, "A Faithful 'Beloved,'" *Charlotte Observer,* October 16, 1998, 7E.

26. For analyses of Winfrey's popular therapeutic appeal, see Eva Illouz, *Oprah Winfrey and the Glamour of Misery: An Essay on Popular Culture* (New York: Columbia University Press, 2003), and Trystan T. Cotton and Kimberly Springer, *Stories of Oprah: The Oprahfication of American Culture* (Jackson: University Press of Mississippi, 2010).

27. In the "Production Featurette" included on Touchstone's DVD release of *Beloved,* Winfrey asserts that "Jonathan Demme was destined to direct this *[Beloved]*. As I was destined to be a part of it. As Toni Morrison was destined to write it."

28. Winfrey, *Journey to Beloved*, 18.

29. T. J. Jackson Lears, *No Place of Grace: Antimodernism and the Transformation of American Culture, 1880–1920* (Chicago: University of Chicago Press, 1981), 44–46. Subsequent references are given in the text.

30. Jon Cruz, *Culture on the Margins* (Princeton, N.J.: Princeton University Press, 1999); Nathan Huggins, *Harlem Renaissance* (New York: Oxford University Press, 1971).

31. Winfrey, *Journey to Beloved*, 23.

32. Ibid., 24.

33. Ibid.

34. In her chapter on Winfrey in *Profiles of Female Genius: Thirteen Creative Women Who Changed the World* (New York: Prometheus Books, 1994), Gene Landrum remarks that Winfrey "deserves everything she earns because she did it the old-fashioned way: she earned it!" This remark is consistent with Landrum's general characterization of Winfrey as an individual who has triumphed, without the aid of any "favors," despite many *personal* hardships. Winfrey's early childhood experiences of poverty and sexual abuse are held out as the unique and almost exclusive obstacles that she had to overcome in her rise to mainstream success (390).

35. Ibid.

36. Ibid., 391.

37. Ibid., 381.

38. See Janice Peck, "Literacy, Seriousness and the Oprah Winfrey Book Club," in *Tabloid Tales: Global Debates over Media Standards,* ed. C. Sparks and J. Tulloch (London: Rowman and Littlefield, 2000), 229–50. For another lucid treatment of the affective appeal of Winfrey and the politics of sentimentality, see Rebecca Wanzo, "The Reading Cure: Oprah Winfrey, Toni Morrison, and Sentimental Identification," in *The Suffering Will Not Be Televised: African American Women and Sentimental Political Storytelling* (New York: State University of New York Press, 2009), 79–112.

39. Janice Peck notes that Winfrey has remarked that "everything in your world is created by what you think," and goes on to say that "Winfrey's commitment to 'positive' thoughts and topics and her continual assertation that all social ills are the consequence of 'negative' ... thoughts are an ascription that holds equally for every conceivable problem from depression to racism" ("Literacy, Seriousness and the Oprah Winfrey Book Club," 243).

40. Landrum, *Profiles of Female Genius,* 375.

41. Ibid., 378.

42. Sau-ling Wong, "Caregivers of Color in the Age of Multiculturalism," in *Mothering: Ideology, Experience, Agency,* ed. Grace Chang and Linda Rennie Forcey (New York: Routledge, 1994), 69.

43. Morrison, *Beloved,* 275.

44. Ibid., 89.

45. Ibid., 23.

46. Spillers, "Mama's Baby, Papa's Maybe," 76.

47. "Production Feauturette" clip on *Beloved* DVD.

48. Jacqueline Bobo, *Black Women as Cultural Readers* (New York: Columbia University Press, 1995), and Christine Gledhill, "Pleasurable Negotiations," in *Female Spectators,* ed. D. Priram (London: Verso, 1988).

4. Prodigal (Non)Citizens

1. Kristin Luker, *Dubious Conceptions: The Politics of Teenage Pregnancy* (Cambridge, Mass.: Harvard University Press, 1996), 71–76.

2. Senator Edward Kennedy introduced the "National School-Age Mother and Child Health Act" in 1975, which allocated federal resources to educating teenagers about birth control and providing them with access to contraceptives; however, this act did not pass (ibid., 71).

3. This resulted in the passage of Title X, an amendment to the Social Security Act of 1935 that stipulated federal support for birth control. Prior to Title X, contraceptive education and services were outlawed, except those provided on a private basis. Because the decision to provide such services was left to the discretion of physicians, the ability of women to control their own fertility was severely limited to the middle and upper classes, members of which could afford private doctor's fees (ibid., 72).

4. Ibid., 72–73.

5. See David M. Reimers, *Unwelcome Strangers: American Identity and the Turn against Immigration* (New York: Columbia University Press, 1998).

6. See Ann Laura Stoler, *Haunted by Empire: Geographies of Intimacy in North American History* (Durham, N.C.: Duke University Press, 2006), and Alys Eve Weinbaum, *Wayward Reproductions: Genealogies of Race and Nation in Transatlantic Modern Thought* (Durham, N.C.: Duke University Press, 2004). On racialized imagery within consumer citizenship, see Mona Domosh, *American Commodities in an Age of Empire* (New York: Routledge, 2006); Marilyn Maness Mehaffy, "Advertising Race/Raceing Advertising: The Feminine Consumer (-Nation), 1876–1900," *Signs* 23.1 (1997): 131–74; and Ellen Gruber Garvey, *The Adman in the Parlor: Magazines and the Gendering of Consumer Culture* (New York: Oxford University Press, 1996.

7. See Dorothy Roberts, "The Value of Black Mothers' Work," *Connecticut La Review* 26 (1994): 871–78; Rickie Solinger, *Pregnancy and Power: A Short History of Reproductive Politics in America* (New York: New York University Press, 2005); Rickie Solinger, *Beggars and Choosers: How the Politics of Choice Shapes Adoption, Abortion, and Welfare in the United States* (New York: Hill and Wang, 2002); Rickie Solinger, *Wake Up Little Susie: Single Pregnancy and Race Before Roe v. Wade* (New York: Routledge, 2000 [1992]); Jael Silliman, Marlene Gerber Fried, Loretta Ross, and Elena Gutiérrez, *Undivided Rights: Women of Color Organize for Reproductive Justice* (Cambridge, Mass.: South End Press, 2004); Jennifer Nelson, *Women of Color and the Reproductive Rights Movement* (New York: New York University Press, 2003); Annette Lawson and Deborah L. Rhode, *The Politics of Pregnancy: Adolescent Sexuality and Public Policy* (New Haven: Yale University Press, 1993); and Kristin Luker, *Abortion and the Politics of Motherhood*

(Berkeley: University of California Press, 1984). Discussing how the politics of consumer citizenship inflects the politics of state-sanctioned reproduction and "legitimate" motherhood (which can only occur within a heteronormative context), Dorothy Roberts observes that "an individual's entitlement to welfare benefits now depends on her relationship to the market . . . As unpaid caregivers with no connection to a male breadwinner, single mothers are considered undeserving clients of the welfare system" (Roberts, "The Value of Black Mothers' Work," 872). Roberts is here treating the popular and institutional treatment of the "welfare queen" as someone who has forfeited her right to services and support from the state, but I argue that her observations also apply to the pregnant teen, who, because of her youth and presumably unwed status, also lacks an appropriate relationship to the market.

8. See Helena Austin and Lorelei Carpenter, "Troubled, Troublesome, Troubling Mothers: The Dilemma of Difference in Women's Personal Motherhood Narratives," *Narrative Inquiry* 18.2 (2008): 378–92.

9. On queer motherhood, see Fiona Nelson, "The Discursive Journeys of Lesbian and Heterosexual Women into Motherhood," *Journal of GLBT Family Studies* 3.2 (2007): 223–65; and Julie M. Thompson, *Mommy Queerest: Contemporary Rhetorics of Lesbian Maternal Identity* (Amherst: University of Massachusetts Press, 2002).

10. Cindy Patton, *Fatal Advice: How Safe-Sex Education Went Wrong* (Durham, N.C.: Duke University Press, 1996), 7.

11. For studies that conceptualize earlier racializing trends in California public-health policies, see Natalia Molina, *Fit to Be Citizens?: Public Health and Race in Los Angeles, 1879–1939* (Berkeley: University of California Press, 2006), and Nayan Shah, *Contagious Divides: Epidemics and Race in San Francisco's Chinatown* (Berkeley: University of California Press, 2001).

12. Patton, *Fatal Advice,* 23. See also Kristin Luker, "Sex, Social Hygiene, and the State: The Double-Edged Sword of Social Reform," *Theory and Society* 27.5 (1998): 601–34.

13. In "Black Ladies, Welfare Queens, and State Minstrels: Ideological War by Narrative Means," Wahneema Lubiano provides an astute analysis of the ideological work of images of African American women in public discourse, arguing that this work is achieved, in great part, via the calling upon of already-existing racialized narratives that images of African American women trigger. She argues that these racialized narratives are then deployed to assist in the decoding of whatever image and issue is at hand, influencing the reading of their significance such that they conform to the racialized (de)valuing of African American women represented, historically, by popular figurings of the "black lady" and the "welfare queen." With regard to the images used in many teen pregnancy preven-

tion campaigns, including those in California during the late 1990s, the racialized narratives deployed to render and read the imagery and significance of pregnant teens were narratives that established Mexican immigrants and other, perhaps nondescript, nonwhites who evidenced interracial sexual relations as threats to the entitlements and purities attending whiteness-as-Americanness (in *Race-ing Justice, En-Gendering Power,* ed. Toni Morrison [New York: Pantheon Books, 1992], 323–63). See Sonja M. Brown Givens and Jennifer L. Monahan, "Priming Mammies, Jezebels, and Other Controlling Images: An Examination of the Influence of Mediated Stereotypes on Perceptions of an African American Woman," *Media Psychology* 7.1 (2005): 87–106.

14. Lisa Sun-Hee Park, "Perpetuation of Poverty through 'Public Charge,'" *Denver University Law Review* 78.4 (2002): 1.

15. See Steven Bender, *Greasers and Gringos: Latinos, Law, and the American Immigration* (New York: New York University Press, 2003), and Reimers, *Unwelcome Strangers.*

16. See Peter Brimelow, *Alienation: Common Sense about America's Immigration Disaster* (New York: HarperPerennial, 1996).

17. Lynn Fujiwara, *Mothers without Citizenship: Asian Immigrant Families and the Consequences of Welfare Reform* (Minneapolis: University of Minnesota Press, 2008), 7.

18. For an incisive discussion of the political, economic, and cultural contexts of Proposition 187, see Lisa Marie Cacho, "'The People of California Are Suffering': The Ideology of White Injury in Discourses of Immigration," *Cultural Values* 4.4 (2000): 389–418.

19. Also part of this context was Proposition 227, the "English for the children" referendum, which was designed to eliminate bilingual education in public classrooms that, in California during the 1990s, were "dominated" by Latino students. See Otto Santa Ana, *Brown Tide Rising: Metaphors of Latinos in Contemporary American Public Discourse* (Austin: University of Texas Press, 2002), 197–249. On mass-media constructions of Latinas/os, see Marco Portales, *Crowding Out Latinos: Mexican Americans in the Public Consciousness* (Philadelphia: Temple University Press, 2000).

20. See Patricia Zavella, "Transnational Mexican Sexuality," *Journal of American Ethnic History* 24.3 (2005): 77–80; José E. Limón, "Tex-Sex-Mex: American Identities, Lone Stars, and the Politics of Racialized Sexuality," *American Literary History* 9.3 (1997): 598–616. For a discussion of visual iconography linking mid-twentieth-century U.S. domestic and international policy debates over poverty and adoption, see Laura Briggs, "Mother, Child, Race, Nation: The Visual Iconography of Rescue and the Politics of Transnational and Transracial Adoption," *Gender and History* 15.2 (August 2003): 179–200. On sexualized and racialized

dynamics within visual and literary representation of surrogate mothers, see Ruth McElroy, "Surrogate Motherhood and Its Representation," *European Journal of Cultural Studies* 5.3 (2002): 325–42.

21. As Lisa Sun-Hee Park explains, "public charge" is a term used by the Immigration and Naturalization Service and the State Department to refer to immigrants who have or will become dependent on public benefits. It is a designation that has historically been used "as grounds for inadmissibility and deportation" ("Perpetuation of Poverty through Public Charge," 1).

22. Ibid., 15.

23. Ibid.

24. Author's telephone interview with representatives of Runyon, Saltzman, and Einhorn (media agency representatives for the PRP's ads), March 15, 2002.

25. A Bay Area community clinic director who participated in Lisa Sun-Hee Park's study of the port-of-entry investigations stated that "if [it was] determined that [the women of Asian and Latino origin interviewed by the DHS and the INS had] had children within a certain period, then they would [be asked], who paid for it? What kind of insurance did you have? Who was your health care provider? And if someone ended up showing their Medi-Cal card, then they were totally in the next realm of interview" (Park, "Perpetuation of Poverty through 'Public Charge,'" 15).

26. See Roberts, *Killing the Black Body.*

27. Notable exceptions in this regard are Solinger's *Wake Up Little Susie* and Luker's *Dubious Conceptions.*

28. Rickie Solinger, "Race and 'Value': Black and White Illegitimate Babies, 1945–1965," in *Mothering: Ideology, Experience, Agency,* ed. Evelyn Nakano Glenn, Grace Chang, and Linda Rennie Forcey (New York: Routledge, 1993), 287–310.

29. Ibid., 288.

30. Ibid., 289.

31. These notions would achieve even greater institutional legitimacy in 1965 with the publication of Daniel Patrick Moynihan's *The Negro Family: The Case for National Action* (Washington, D.C.: U.S. Department of Labor, 1965).

32. Arlene Dávila, *Latinos Inc.: The Making and Marketing of a People* (Berkeley: University of California Press, 2001), 11.

33. Ibid., 10.

34. On the narrative techniques of racialized public-health campaigns, in this case a South African photo-comic, see C. Mathews, K. Everett, and J. Stein, "The Role of Identification and Narrative in Health Promotion Material: The Case of Race in Roxy," *AIDS Bulletin* 6.4 (1997): 19–20.

35. California Department of Health Services, 1999.

36. Cacho, "The People of California Are Suffering," 393.

37. On televisual imagery, see Meredith Li-Vollmer, "Race Representation in

Child-Targeted Television Commercials," *Mass Communication and Society* 5.2 (2002): 207–22. See also T. G. M. Ex Carine, Jan M. A. M. Janssens, and Hubert P. L. M. Korzilius, "Young Females' Images of Motherhood in Relation to Television Viewing," *Journal of Communication* 52.4 (2002): 955–71.

38. Donald Lowe, *The Body in Late Capitalist USA* (Durham, N.C.: Duke University Press, 1995), 134.

39. The PRP media campaign included "in-language" television, radio, and print ads whose conception and production was contracted out to "community" agencies familiar with the non-English speaking populations being targeted.

40. In *Fatal Advice: How Safe-Sex Education Went Wrong*, Cindy Patton discusses the important differences between public-health education initiatives aimed at "at-risk" communities versus those aimed at the population at large (23–25).

41. Perhaps logically, the "all-world look" of the models in the abstinence ads consisted of dark brown hair, brown eyes, and medium skin. Perhaps logically (also), every person that I asked to identify the models racially/ethnically marked them "Latina/o." Although a systematic study might determine more definitively how people who saw the ads racially identified the figures they depicted, that these figures were not meant to be widely perceived as "Caucasian" is apparent.

42. Dávila, *Latinos Inc.*, 11.

43. Ibid., 11.

44. Author's telephone interview with representatives of Runyon, Saltzman, and Einhorn, March 15, 2002.

5. Breeding Patriotism

1. Susan Faludi, *Terror Dream: Fear and Fantasy in Post-9/11 America* (New York: Metropolitan Books, 2007), 93.

2. See Adi Drori-Avraham, "September 11th and the Mourning After: Media Narrating Grief," *Continuum: Journal of Media and Cultural Studies* 20.3 (2006): 289–97.

3. Julian Bond, "Reflections on 9/11: Why Race, Class, Gender, and Religion Matter," *Philosophia Africana* 5.2 (2002): 1–11.

4. Senator John McCain is quoted on September 11 as saying, "These attacks clearly constitute an act of war" (Alison Mitchell and Katharine Q. Seelye, "Horror Knows No Party as Lawmakers Huddle," *New York Times*, September 12, 2001, A20). The following day, articles headlined President Bush's similar declaration. See Robert D. McFadden, "A Grim Forecast," *New York Times*, September 13, 2001, A1; Katharine Q. Seelye and Elisabeth Bumiller, "Bush Labels Aeriel Terrorists Attacks 'Acts of War,'" *New York Times*, September 13, 2001, A16; and Elaine Sciolino, "Long Battle Seen," *New York Times*, September 16, 2001, A1, 5.

5. Leah Eckberg Feldman, "The Widows of War," *Good Housekeeping* 236.5 (2003): 50, 52, 54, 56.

6. See Meghana Nayak, "Orientalism and 'Saving' US State Identity after 9/11," *International Feminist Journal of Politics* 8.1 (2006): 42–61; Julie Drew, "Identity Crisis: Gender, Public Discourse, and 9/11," *Women and Language* 27.2 (2004): 71–7; and Inderpal Grewal, "Transnational America: Race, Gender and Citizenship after 9/11," *Social Identities* 9 (2003): 535–61.

7. A comprehensive list of journalistic coverage of the "9/11 Widows" would require inordinate space here. For key iterations, see the articles cited throughout this chapter.

8. In this regard, contemporary constructions of widowhood and national death are intriguingly in dialogue with those of the U.S. slaveholding past, economic definitions of personhood, and gendered scripts of "mastery," as Kristen E. Wood argues in *Masterful Women: Slaveholding Widows from the American Revolution through the Civil War* (Chapel Hill: University of North Carolina Press, 2004). On legal and popular frameworks of U.S. widowhood, see also John Fabian Witt, *The Accidental Republic: Amputee Workingmen, Destitute Widows, and the Remaking of American Law, 1868–1922* (Cambridge, Mass.: Harvard University Press, 2000), and Lisa Wilson, *Life after Death: Widows in Pennsylvania, 1750–1850* (Philadelphia: Temple University Press, 1992).

9. Lynn Spigel, "Entertainment Wars: Television Culture after 9/11," *American Quarterly* 56.2 (June 2004): 246–47.

10. Ibid., 247.

11. Research suggests the emotional and psychic effects of witnessing the events of September 11, 2001, in person and via television have distinctive features and traits. See, for example, David B. Henry, Patrick H. Tolan, and Deborah Gorman-Smith, "Have There Been Lasting Effects Associated with the September 11, 2001, Terrorist Attacks among Inner-City Parents and Children?" *Professional Psychology: Research and Practice* 35.5 (2004): 542–47; W. E. Schlenger, J. M. Caddell, L. Ebert, K. B. Jordan, K. M. Rourke, D. Wilson, et al., "Psychological Reactions to Terrorist Attacks: Findings from the National Study of Americans' Reactions to September 11," *JAMA* 288 (2002): 581–88; R. C. Silver, E. A. Holman, D. N. McIntosh, M. Poulin, and V. Gil-Rivas, "Nationwide Longitudinal Study of Psychological Responses to September 11," *JAMA* 288 (2002): 1235–44; and S. Galea, J. Ahern, H. Resnick, D. Kilpatrick, M. Bucuvalas, J. Gold, et al., "Psychological Sequelae of the September 11th Attacks in Manhattan, New York City," *New England Journal of Medicine* 346 (2002): 982–87.

12. Indeed, many of the images of 9/11 widows appeared in the popular visual landscape within the specific frames of continued threat and terror. For example, the 2003 ABC News *Primetime* episode that featured the widows began with a story of Homeland Security measures' failure to detect and stop a suitcase at the

port of Los Angeles that was full of depleted uranium and planted by ABC News two years after 9/11 to test "How safe is the country today?"

13. Wexler, *Tender Violence*, 21.

14. For another discussion of how the *People Weekly* cover story displays and reinforces the nationalist reproductive role of the widows, see Deborah Cohler, "Keeping the Home Front Burning: Renegotiating Gender and Sexuality in U.S. Mass Media after September 11," *Feminist Media Studies* 6.3 (2006): 245–61.

15. Feminist scholarship on heteronormative and pronatalist discourse is extensive. Some key texts include a variety of historical, national, and transnational contexts. See Faye D. Ginsburg and Rayna Rapp, eds., *Conceiving the New World Order: The Global Politics of Reproduction* (Berkeley: University of California Press, 1995); Michelle Goldberg, *The Means of Reproduction: Sex, Power, and the Future of the World* (New York: Penguin Press, 2009); Linda Gordon, *Woman's Body, Woman's Right: A Social History of Birth Control in America* (New York: Grossman Publishers, 1976); Solinger, *Pregnancy and Power* and *Wake Up Little Susie;* Betsy Hartmann, *Reproductive Rights and Wrongs* (Boston: South End Press, 1995); Laura L. Lovett, *Conceiving the Future: Pronatalism, Reproduction, and the Family in the United States: 1890–1938* (Chapel Hill: University of North Carolina Press, 2007); Diana T. Meyers, "The Rush to Motherhood: Pronatalist Discourse and Women's Autonomy," *Signs* 26.3 (spring 2001): 735–73; Gayle Rubin, "Thinking Sex: Notes for a Radical Theory of the Politics of Sexuality," in *Pleasure and Danger: Exploring Female Sexuality,* ed. Carole S. Vance (Boston: Routledge, 1984); Ann Laura Stoler, "Sexual Affronts and Racial Frontiers: European Identities and the Cultural Politics of Exclusion in Colonial Southeast Asia," in *Tensions of Empire: Colonial Cultures in a Bourgeois World,* ed. Frederick Cooper and Ann Laura Stoler (Berkeley: University of California Press, 1997), 198–237; Laura Briggs, *Reproducing Empire: Race, Sex, Science and U.S. Imperialism in Puerto Rico* (Berkeley: University of California Press, 2003); Ellen K. Feder, *Family Bonds: Genealogies of Race and Gender* (Oxford: Oxford University Press, 2007); Ann Ferguson, "On Conceiving Motherhood and Sexuality: A Feminist-Materialist Approach," in *The Socialist Feminist Project: A Contemporary Reader in Theory and Politics,* ed. Nancy Holmstrom (New York: Monthly Review Press, 2002), 128–36; Lynne Haney and Lisa Pollard, eds., *Families of a New World: Gender, Politics, and State Development in a Global Context* (New York: Routledge, 2003); Amy Kaplan, "Manifest Domesticity," in *The Futures of American Studies,* ed. Donald E. Pease and Robyn Wiegman (Durham, N.C.: Duke University Press, 2002); Carol Pateman, *The Sexual Contract* (Stanford, Calif.: Stanford University Press, 1988); Shane Phelan, *Sexual Strangers: Gays, Lesbians, and Dilemmas of Citizenship* (Philadelphia: Temple University Press, 2001); Judith Stacy, *In the Name of the Family: Rethinking Family Values in the Postmodern Age* (Boston: Beacon Press, 1996); and Roberts, *Killing the Black Body.*

16. Galina Espinoza et al., "Small Blessings," *People Weekly* 57.7 (2002): 48–74.

17. Ibid., 55.

18. Ibid., 52.

19. For a phenomenological study of the variegated experiences of 9/11 and Iraq/Afghanistan war widows, see Mary Ellen Doherty and Elizabeth Scannell-Desch, "The Lived Experience of Widowhood during Pregnancy," *Journal of Midwifery and Women's Health* 53.2 (2008): 103–9.

20. Espinoza et al., "Small Blessings," 63.

21. "Gifts of Love," *Primetime,* first broadcast August 29, 2002, by ABC. See also "9/11 Babies: Five Years Later," *Primetime,* first broadcast September 7, 2006, by ABC.

22. In her memoir, Kristen Breitweiser—the most publicly visible of the "Jersey Girls"—narrates the struggle entailed in realizing the 9/11 Commission and her disillusionment with regard to her belief in the U.S. government's commitment to protecting its citizens. As members of the Family Steering Committee, the Jersey Girls lobbied for and consistently monitored and criticized the effectiveness of the 9/11 Commission's investigations. They have continued to lament the fact that the commission's recommendations have not been implemented, and they maintain that the safety of U.S. citizens is sacrificed to economic interests. See Kristen Breitweiser, *Wake-up Call: The Political Education of a 9/11 Widow* (New York: Grand Central Publishing, 2006).

23. For a vitriolic attack on the Jersey Girls' "exploitation" of their "victim" status for the benefit of "liberal" political agendas, see Ann Coulter's *Godless: The Church of Liberalism* (New York: Crown Forum, 2006), 100–112. In addition to authoring the attack, Coulter also delivered it on a number of television talk shows. Serving as a counterrepresentation to this is the awarding of a "Women of the Year" award to the Jersey Girls by *Ms. Magazine.* See Jessica Seigel, "Women of the Year: Jersey Girls," *Ms. Magazine* 14.4 (winter 2004): 32–33. In addition, Kristen Breitweiser was awarded the Ron Ridenhour Award honoring "truth telling" ("Ron Ridenhour Awards Go to 'Jersey Girls,' Seymour Hersh, Adrian Nicole LeBlanc," *Times-Picayune,* April 24, 2005, 7).

24. Andrew Jacobs, "A Town's Public Memory, Its Residents' Private Grief," *New York Times,* March 9, 2002, A1, A8.

25. Ray Nowosielski, *9/11: Press for Truth,* Disinformation Studios, 2006.

26. David Friend, "Watching the World Change: The Stories behind the Images of 9/11," *Vanity Fair,* August 21, 2006.

27. See Joan Walsh, "The Mother of All Battles: Cindy Sheehan almost Single-Handedly Launched an American Antiwar Movement. In the Process, She's Exposed a President's Feet of Clay," *Progressive Populist* 11.16 (2005): 1, 8.

28. See Laura Knudson, "Cindy Sheehan and the Rhetoric of Motherhood: A Textual Analysis," *Peace and Change* 34.2 (2009): 164–83, and Janis L. Edwards

and Amanda Leigh Brozana, "Gendering Anti-War Rhetoric: Cindy Sheehan's Symbolic Motherhood," *Journal of the Northwest Communication Association* 37 (2008): 78–102.

29. Kristen Lombardi, "Mother of All Protestors," *Village Voice,* October 18, 2005; "Bush Backers Amass to Counter 'Peace Mom,'" *USA Today,* September 22, 2005; "'Peace Mom' Returns to Texas to Continue Anti-war Protest," *USA Today,* September 24, 2005; and Karen Houppert, "Cindy Sheehan: Mother of a Movement?" *Nation* 282.23 (2006): 11–16.

30. See, for example, Byron York, "Cindy's Movement," *National Review* 57.16 (2005): 20–22.

31. Cindy Sheehan, "Good Riddance, Attention Whore," The Daily Kos, May 28, 2007, http://www.dailykos.com/storyonly/2007/5/28/12530/1525.

Conclusion

1. Morrison, *Beloved,* 210.

2. Ibid., 275.

3. For a historical account of the events on which Morrison's novel is based, see Weisenburger, *Modern Media.*

4. See Mark Reinhardt, "Who Speaks for Margaret Garner? Slavery, Silence, and the Politics of Ventriloquism," *Critical Inquiry* 29.1 (2002): 81–119.

5. Holland, *Raising the Dead,* and Gordon, *Ghostly Matters.*

6. Jay Ruby, *Secure the Shadow: Death and Photography in America* (Boston: MIT Press, 1995).

7. Ibid., 32, 89.

8. These mortuary or "deathbed" portraits had existed in a limited way since the Renaissance, but had become quite common in less wealthy families by the seventeenth century. See Phoebe Lloyd, "A Death in the Family," *Philadelphia Museum of Art Bulletin* 78.335 (1982): 2–13.

9. Ibid., 3. See also Edward Schwarzschild, "Death Defining/Defying Spectacles: Charles Willson Peale as Early American Freak Showman," in *Freakery: Cultural Spectacles of the Extraordinary Body,* ed. Rosemarie Garland Thomson (New York: New York University Press, 1996), 82–96.

10. See Schwarzschild, "Death Defining."

11. Alan Trachtenberg, *Reading American Photographs: Images as History, Mathew Brady to Walker Evans* (New York: Hill and Wang, 1989), 6.

12. Ibid.

13. David Ward, *Charles Willson Peale: Art and Selfhood in the Early Republic* (Berkeley: University of California Press, 2004), 81.

14. Lloyd, "A Death in the Family," 5.

15. Ibid., 5, 7.

16. In 1812, Peale wrote *An Essay to Promote Domestic Happiness,* the positions of which likely influenced many of his portrait compositions, especially those in which family members touch and are posed in an informal manner. As David C. Ward and Sydney Hart observe, "the book's centerpiece is an attack on intemperance and a condemnation on the evils of drinking. It concludes with a program for reform in which Peale argued that it was the wife's responsibility to reform her husband and preserve the household" (David C. Ward and Sydney Hart, "Subversion and Illusion in the Life and Art of Raphaelle Peale," *American Art* 8.3/4 [1994]: 98–99).

17. Barthes, *Camera Lucida,* 26–28.

18. Ibid., 27.

19. Ibid., 155.

20. See the chapter titled "Seeing Sentiment: Photography, Race, and the Innocent Eye" in Wexler, *Tender Violence,* 52–93.

21. See also Jacqueline Jones, *Labor of Love, Labor of Sorrow: Black Women, Work and the Family from Slavery to the Present* (New York: Basic Books, 1985); Deborah Gray White, *Ain't I a Woman?: Female Slaves in the Plantation South* (New York: Norton, 1985); Jennifer Morgan, *Laboring Women: Reproduction and Gender in New World Slavery* (Philadelphia: University of Pennsylvania Press, 2004).

22. See Robert Hirsch, *Seizing the Light: A History of Photography* (New York: McGraw-Hill, 1999).

23. Jay Ruby, e-mail to author, August 28, 2008.

24. See Hannah Rosen, *Terror in the Heart of Freedom: Citizenship, Sexual Violence, and the Meaning of Race in the Postemancipation South* (Chapel Hill: University of North Carolina Press, 2008).

25. I thank Robb Kendrick, photographer and author of *Revealing Character: Texas Tintypes* (Houston: Bright Sky Press, 2005), for applying his expertise to help me understand the likely manner in which the maternal figure in *Postmortem photograph* was defaced.

26. Ruby, *Secure the Shadow,* 52.

27. Smith, *American Archives,* 115.

28. Ibid., 116. See Roberts, *Killing the Black Body,* for a treatment of late-twentieth-century eugenicist discourses in legal, medical, and popular discourses.

29. Barthes, *Camera Lucida,* 6.

30. Morrison, *Beloved,* 151–52.

31. No accounts of the incident "put" the baby Mary in Margaret Garner's arms. That representations of the event are thus "faithful" to the real, in this regard faithful to history, points to the radical failures of imagination that would "see," as Morrison's *Beloved* does, Garner as the pietà's maternal figure. See Reinhardt, "Who Speaks for Margaret Garner?" for a discussion of the conflicting accounts of the scene of Margaret's infanticide.

32. See Samuel May's treatment of primary documentation of the infanticide in "Margaret Garner and Seven Others," in *Toni Morrison's Beloved: A Casebook*, ed. William Andrews and Nellie McKay (New York: Oxford University Press, 1999), 25.

33. Toni Morrison, *Beloved*, 152.

34. Leslie Furth, "'The Modern Medea' and Race Matters," *American Art* 12.2 (1998): 41.

35. Leslie Furth notes that some speculate that Noble chose not to depict the dead infant because the vision would be too macabre (ibid.).

36. Baldwin, *The Evidence of Things Not Seen*, 11.

37. Taylor, *The Archive and the Repertoire.*

Index

ABC, 109, 115–17, 118, 120, 125, 186n12

abject, the, 30–31, 37, 39, 74, 131, 133, 144, 165n65, 167n7

abstinence ads, 100–108, 185n41

Acquaviva, Courtney, 114

Acquaviva, Paul, 114

Adolescent and Family Life Act, 91

Adolescent Health, Services, and Pregnancy Prevention and Care Act, 91

African Americans, 6–8, 33, 36–38, 77, 131–32, 141, 166n71; African American women, 22, 97; the maternal and, 143–44; memorialization practices of, 150–51; Winfrey and, 86

Aid to Families with Dependent Children (AFDC), 91

Alexander, Elizabeth, 160n33

Al-Fayed, Dodi, 43, 58

Alfred P. Murrah Federal Building, 5

Alien, 74

Allen, James: *Without Sanctuary: Lynching Photography in America*, 150–51

Allen, Kevin, 155n2

Alleva, Richard, 178n9

Almon, Aren, 157n16

Almon, Baylee, 5, 157n15, 157n16

American Museum in Philadelphia, 137

Angola, 58–60

anti-immigration discourse, 98, 105, 107

anti-immigration legislation, 94, 108

antimodernists, 82–83

Asians, 106

Assumption, the, 164n59

Avedon, Richard: "William Casby, Born a Slave," 35, 37–38

Azoulay, Ariella, 9

Baldwin, James, 150; *The Evidence of Things Not Seen*, 43, 44, 66

Balma, Mark: *Pietà*, 157n14

Barthes, Henriette, 39, 40, 41

Barthes, Roland, 64–65, 139–41, 147, 170n38; *Camera Lucida*, 23, 24, 29–42, 146, 167n7, 168n17, 169n30, 169n37, 170n38, 170n42; "continuous message," 64; "The Great Family of Man," 168n9; *Mythologies*, 39; "obtuse meaning," 64–65

Bazin, André, 13–14, 163n51

Beloved, 23, 25; abjection in, 131; adaptation of, 67–90, 178n9; DVD version of, 84–85; genre and, 68, 69–75; ghosts in, 85, 131–32; history and, 80, 84, 87–88, 89, 131–32; horror and, 68, 69–75, 78–79, 84, 89; infanticide in, 88; the maternal and, 75, 78–79, 87, 88–89, 131–32, 133; melodrama and, 68, 69, 78–79, 89

Berlant, Lauren, 18, 61

Bertillon, Alphonse, 38

Bessler, Isabel, 126–27

bilingual education, 183n19
"biopolitics of disposability," 8
birth, 164n62
birth control, 102, 181n2
Bobo, Jacqueline, 89
Boudinet, Daniel: "Polaroid of an
 Empty Room," 40
Brady, Matthew, 149; "Daguerrean
 Gallery," 146
Brazza, Savorgnan de, 35
Breitweiser, Kristen, 122–23, 124, 125,
 188n22
Broadmoor neighboorhood, New
 Orleans, Louisiana, 6
Brooklyn Botanic Garden, 109, 116
Bureau of Labor Statistics, 50
Burgin, Victor: *Place and Memory in
 Visual Culture*, 23
Bush, George W., 3, 122, 127–28, 185n4

Cacho, Lisa, 99–100
Calcutta, India, 48–49
California, 19, 23, 25–26, 94–96, 98, 100,
 102, 105, 106, 108, 182n13, 183n19
California Bureau of State Audits, 95
California Department of Health
 Services (DHS), 93–95, 96, 102
Calvet, Louis-Jean: "The First Death,"
 40
"Camp Casey," 128
Carby, Hazel, 22, 166n78, 175n44
Carnegie Institute, 9–12
Carnegie International, 10–11
Carrie, 74
Casazza, Patty, 122–23, 124, 125
Casby, William, 37–38, 169n30
Cathedral of St. Paul, 157n14
Catholic Church, 158n18, 164n59
Catholic Online, 3
Chambers, Bruce: "American *Pietà*,"
 6–7, 9, 12–13, 158n22

Charles, Prince of Wales, 58
Charlotte Observer, 80
Cheney, Dick, 128
Chicago Defender, 7
children, death of, 71, 74, 76–77, 88, 133,
 147, 159n26, 179n22, 190n31
chora, 41
Christian iconography, 141, 143, 164n59.
 See also pietàs; *specific works and
 figures*
citizenship, 92, 94, 105–8, 132, 181–82n7;
 American, 18–19; consumption
 and, 92, 98, 105–8, 181n7; difference
 and, 106; family and, 97–98; public
 health and, 91–108; race and, 21–22,
 96, 100, 106, 108; racialized, 21; sexu-
 ality and, 100; whiteness and, 92, 100
"Civil Contract of Photography," 9
Civil War, 138
class, 51–54, 61–62, 110, 172n12
Clifford, Charles: "Alhambra," 40
Collins, Patricia Hill, 22
consumer citizenship, 92, 98, 105–8,
 181n7
consumption, 92, 96, 97–98, 100, 102,
 107–8, 181n7
Cook, George, 141; *Baby Huestis Cook*,
 142
Copley, John Singleton, 134
Cosgrove, William, 155n2
Creed, Barbara, 78; "Horror and the
 Monstrous-Feminine," 67, 74
Cruz, Jon, 83
"culture of sentiment," 51–55
"Curves" poster, 100, 101, 102, 105

Daily Kos, The, 128
Dávila, Arlene, 97–98, 106
death, 7, 8, 65–66, 113, 133–34, 143; in
 Beloved, 131–33; of Diana, 43–66,
 173n14, 173n21, 174n35; double, 33;

history and, 144–45; the maternal and, 13–23, 31, 38–42, 141, 143–45, 147, 149–50, 164n62, 165n65; of Mother Teresa, 45–49, 50, 173n14, 173n16; national, 24, 186n8; photography and, 32–42, 139, 145–47, 150–51; race and, 14–21, 21–23, 31, 38–42, 144–45, 147–48, 149–50, 151; sentiment and, 147; social, 6, 7, 14, 20, 21, 34, 41–42, 69, 77, 88; space of, 15; in U.S. history, 13–14
"death photography," 139–40
Deedes, Bill, 61
Demme, Jonathan, 68–69, 70, 73, 78, 79, 81, 85, 89, 178n9
Derrida, Jacques, 170n42
Diana, Princess of Wales, 23–24, 43–66, 133; American memorialization of, 44–45, 51–55, 170n5; in Angola, 58–61; commodification of, 61, 65; death of, 43–66, 173n14, 173n21, 174n35; as embodiment of ideology, 49–51, 52, 60–64; funeral of, 43, 46–48, 50, 55–57; ghosting of, 61, 62–64, 66; "magic touch" of, 58, 60, 61–62; physicality of, 49; popularity of, 175n53; sanctification of, 173n21
"Diana studies," 44–45, 171n11
DignityUSA, 155n5
domesticity, 51–55, 172n12
domestic partners, 3
duCille, Anne, 22

Elise, Kimberly, 85
Ellison, Ralph, 20
England, 52
ethnicity, the maternal and, 110. See also race; specific ethnic groups
Europe, 5, 52
evangelicals, 52

Faludi, Susan: "Perfect Virgins of Grief," 110
family, 44, 49–51, 146, 168n9; African American, 97; citizenship and, 97–98; ideology of, 49–51, 52, 96, 97; postmodern condition of, 49, 51; race and, 97, 146; rhetoric of, 49–51, 92
Family of Man Exhibition, 168n9
Family Steering Committee, 188n22
family values, rhetoric of, 49–51
Fanon, Frantz: Black Skin, White Masks, 33, 38
"Fatherhood Is Forever" ads, 105
feeling, 30, 32, 40, 62–63, 147, 150, 159n26. See also sentimentalism
FEMA (Federal Emergency Management Agency), 6
femininity, 44, 45, 48, 51–52, 57–58, 63, 74–75. See also maternal, the
feminism, 57–58, 68, 75, 92, 177n4
feminist film theory, 68, 177n4
Fields, Chris, 5
film theory, 68, 77–78, 177n4
Fischer, Lucy, 177n4
Freud, Sigmund, 29, 164n62
Friend, David: Watching the World Change: The Stories behind the Images of 9/11, 126–27, 156n13
Fugitive Slave Law, 179n22
Fujiwara, Lynn, 94
Furth, Leslie, 148–49

Gallop, Jane, 167n4
Galton, Francis, 38, 146
Garner, Margaret, 131–34, 147–50, 179n22, 190n31
Garner, Mary, 148, 190n31
gay community, 3, 4
ghosts, 20–21, 41, 47, 77, 85, 114, 115, 131–32, 145–46

Giroux, Henry, 7, 8, 158n22
Gledhill, Christine, 78, 89
Glover, Danny, 68, 85
Good Housekeeping, 110
Gordon, Avery, 20–21, 41, 132
grief, 134, 138–39, 144–45, 146, 159n26
Ground Zero, 1, 2

Hall, Catherine: *White, Male, and Middle Class*, 52
Halttunen, Karen: "Early American Murder Narratives: The Birth of Horror," 73–74
Harper's Weekly, 148, 149
Hartman, Saidiya, 21; *Scenes of Subjection*, 60–61
haunting, 41, 85, 131–32. *See also* ghosts
heteronormativity, 94, 98
heterosexuality, 51, 94, 98, 110
history, 145, 150, 166n71; in *Beloved*, 69, 73–75, 80, 84, 87–89, 131–32; death and, 144–45; photography and, 139–40, 151; race and, 24–25, 133, 141, 143, 145; violence and, 144–45
Holland, Sharon, 21, 132; *Raising the Dead*, 20
Holliday, George, 160n33
Hollingsworth, Edgar, 6–7, 8, 9, 12–13, 158n22
Holloway, Karla: *Passed On*, 150
Hollywood, 23, 25, 67–90
Homeland Security, 186n12
homosexual icon: Mychal Judge as, 3
horror, 68, 69–75, 78–79, 84, 89, 177n4
Huggins, Nathan, 83
Hurricane Katrina, 6, 7, 8, 12, 158n22

iconography, Christian, 15–16, 18–19, 141, 143, 164n59. *See also specific works and figures*
identification, violence of, 60–61

identity, national, 24–25, 54, 97–98, 113, 132–33, 146. *See also* citizenship
ideology, 49–51; Diana as embodiment of, 49–51, 52, 60–64; of family, 49–51, 52, 96, 97; of *Life* magazine, 172n12; of race, 98–99; of reproduction, 125
"Idiot Children in an Institution," 35
Illegal Immigration Reform and Immigrant Responsibility Act, 93
illegitimacy, 96, 97–98
immigrants, 93, 94–95; Asian, 93, 95; Latin American, 93, 95; Mexican, 95; undocumented, 94. *See also* immigration
immigration, 19, 92, 93–96, 105, 184n21; perils of, 94–95; race and, 95–96, 98–99, 100, 108, 182n13; teen pregnancy and, 182n13. *See also* immigrants
Immigration Act of 1965, 19, 91, 93
Immigration and Naturalization Service (INS), 94–95, 96, 184n21
Immigration Reform and Immigrant Responsibility Act of 1996, 19
India, 48–49
infanticide, 71, 74, 76–77, 88, 133, 147, 179n22, 190n31
Iraq War, 125, 127–28
Islam, 125

Jacobs, Ari, 116
Jacobs, Jenna, 116
Jersey Girls, 122–23, 124, 125, 188n22
Jesus Christ, 1–3, 5, 15, 16, 17, 18, 155n3, 163n57, 164n59. *See also* pietàs
Jet (magazine), 7
John, Elton: "A Candle in the Wind '97," 43
Johnson, Tom Loftin, 161n36; *American Pietà*, 9–12

journalism, 5–7, 12–13, 25. *See also* media; *specific publications*
Judge, Mychal, 1–6, 9, 12–13, 21, 155n5, 156n9, 156n13, 158n18, 158n22
Jung, Carl, 164n62

Kaplan, E. Ann: *Motherhood and Representation,* 19
Kennedy, Edward, 181n2
Kennedy, John F., 157n14
Kentucky, 131
Kertesz, Andre: "The Violinist's Tune," 37
King, Rodney, 160n33
Kip Taylor Memorial Fund, 115
Klein, Melanie, 164n62
Klein, William, 36, 37
Kleinberg, Mindy, 122–23, 124, 125
Knight, Diana, 169n37
Kozol, Wendy, 172n12
Kristeva, Julia, 41, 164n59, 164n62, 165n65; *Powers of Horror,* 74, 167n7; "Stabat Mater," 163n57
Kucinich, Dennis, 124

Lacan, Jacques, 164n62
Lamb, Christina, 61
Landrum, Gene, 180n34
language, 105, 106–7, 108
Latinas, 25–26, 94, 105, 106, 185n41
Latinos, 25–26, 94, 105–7, 183n19
Lears, T.J. Jackson, 81–82, 83; *No Place of Grace,* 81–82
Le Brun, Charles: *Traité des Passions,* 139
Life (magazine), 25, 44; "Collector's Edition," 44–48, 50; ideology of, 172n12
Lively, Adam, 163n56
Lloyd, Phoebe, 134, 139
Lombroso, Cesare, 38
"Long Room," 137

Los Angeles, California, 95
Los Angeles International Airport, 95
Los Angeles Police Department, 160n33
Louisiana, 6
Lowe, Donald, 102
Lubiano, Wahneema, 182n13
Lynch, Dennis, 3
lynchings, 8, 9–10, 11–12, 150–51

Madonna–child, 141, 143. *See also* Virgin Mary
Maguire, John, 155n2
Marcuse, Herbert, 63–64
Mater Dolorosa, 134, 139, 163n57, 164n59. *See also* Virgin Mary
maternal, the, 4–5, 134, 138–39, 147, 167n6; absent, 38–42; in *Beloved,* 68, 74–75, 78–79, 87–89, 131, 133; class and, 110; death and, 13–23, 31, 38–42, 141, 143–45, 147, 149–50, 164n62, 165n65; discourse and, 4, 22, 26–27, 148, 150; ethnicity and, 110; horror and, 177n4; the maternal body, 29–30, 31; maternal space, 4; maternal types, 143; melodrama and, 128–29, 177n4; monstrous, 123–24; patriotism and, 113; photography and, 29–33, 38–42, 167n4; race and, 14–21, 21–27, 30–31, 38–42, 75, 78–80, 110, 144–47, 149–50; repudiation of, 75; sexuality and, 110; slavery and, 143–44; in visual discourses, 22, 26–27, 148, 150 (*see also* motherhood: imagery of); whiteness and, 145. *See also* motherhood
McCain, John, 185n4
McFarland, Rick, 6
media, 43–66, 109–10, 157n16, 186n12. *See also specific media outlets*
Medi-Cal programs, 94–95, 96, 98

melodrama, 68, 69, 73, 75–79, 89, 128–29, 177n4

memorialization, 114, 134, 150–51

memory, 24–25, 87–88, 109–29, 150. *See also* memorialization

Mexican-American War, 138

Mexico, 95, 138

Miami Herald (newspaper), 6

Michelangelo (di Lodovico Buonarroti Simoni): *Pietà,* 6, 16, 17, 19, 155n3

middle-class identity, 51–54, 61–62

Milam, Jackie, 119

Milam, Little Ron, 119

Milam, Ron, 119

Minnesota Radio: "Minnesotan's JFK Painting Bound for Vatican," 157n14

Mississippi, 7

modernity, 82–83

Monroe, Marilyn, 43

monstrosity, 74–78, 88. *See also* horror

"monstrous-feminine, the," 74–75

Morrison, Toni: *Beloved,* 23, 25, 67–90, 131–32, 147–50, 178n9, 179n22, 179n23, 190n31. *See also Beloved*

motherhood, 45, 52, 94, 115, 138, 150, 167n4, 167n6, 177n4; in *Beloved,* 131–32; criminalized, 93; imagery of, 22, 26–27, 29–33, 38–42, 126–27, 143, 144–45, 148, 150, 167n4; pregnancy, 23, 25–26, 91–108, 126–27, 181n2; race and, 96, 97, 108; rhetoric of, 92; single, 92, 96, 97, 157n16. *See also* maternal, the

Moynihan Report, 51

multiculturalism, 86–87

Museum of Modern Art, 168n9

Mychal Judge Police and Fire Chaplains Public Safety Officers Benefit Act, 3, 156n9

national belonging, 97–98, 100, 108, 150

national death, 24, 113, 186n8

National Guard, 5–7

national identity, 54, 146; formation of, 97–98, 132–33; national body, 113; race and, 24–25; U.S., 24–25. *See also* citizenship

nationalism, 2–5, 18, 19, 109–29, 132–33

national memory, 109–29, 150

National School-Age Mother and Child Health Act, 181n2

Native Americans, 53–54

Nelson, Gigi, 114–15

Nelson, Lyndsi, 114

Nelson, Peter, 114

New Orleans, Louisiana, 6

Newton, Thandie, 69–70, 72, 85

New York Times, 67, 122–23, 124

Niepce, Nicephore: "The Dinner Table," 40

"9/11 Babies," 112–20, 125

"9/11 Babies: Five Years Later," 125

9/11 Commission, 122, 188n22

9/11: Press for Truth, 123–25

9/11 widows, 109–29, 186n12, 188n22

Noble, Thomas Satterwhite: "Margaret Garner" ("The Modern Medea"), 148–49

Nowosielski, Ray, 123, 124

"obtuse meaning," 64–65

Oklahoma City, Oklahoma: bombing in, 5, 157n16

Olin, Margaret, 169n37; "Barthes' Mistaken Identification," 33–34, 35; "Touching Photographs," 168n17

Oprah *(The Oprah Winfrey Show),* 84, 109, 111; "Oprah's Book Club," 84; "Photos That Define Us," 156n13

Orange County Register, 5–6

"Pager" poster, 102, 104, 105

Park, Lisa Sun-Hee, 93, 184n21, 184n25

Partnership for Responsible Parenting (PRP), 23, 25–26, 93–98, 100, 101, 103, 104, 105–6, 107

patriarchy, 50, 125

patriotism. *See* nationalism

Patterson, Orlando, 21, 166n71

Patton, Cindy, 92

Peale, Charles Willson, 134, 137–38; *The Artist in His Museum,* 137; *An Essay to Promote Domestic Happiness,* 190n16; *News from the Front,* 138; *Pearl of Grief,* 138; *Rachel Weeping,* 134, 135, 137–46

Peck, Janice, 84, 180n39

People magazine, 25, 44; "Commemorative Edition: *The Diana Years,*" 44–45, 55–62, 64, 65; *People Weekly,* 109, 112, 114, 115–16, 119

Personal Responsibility and Work Opportunity Reform Act, 93

photography, 23, 24, 141, 143, 168n9; Barthes and, 29–42; bodies and, 32–34; the body and, 32; death and, 32–38, 38–42, 139, 145–46, 150–51; history and, 139–40, 151; the maternal and, 29–32, 38–42, 167n4; memorial, 150–51; photographic theory, 31–32; photojournalism, 5–7, 12–13; race and, 33, 38–42, 146–47, 150–51, 158n22; representation and, 147; reproduction and, 147; structure of, 32; violence and, 151; whiteness and, 150–51

"Pictures of the Year International" competition, 13

pietàs, 1–7, 15, 133, 134, 139–41, 144, 147, 149–50, 155n3, 157n14, 164n59, 190n31. *See also specific works*

Poltergeist, 69

Porter, Charles, 157n15

Port of Entry Fraud Detection Programs, 94, 95–96, 98, 105

postmodernism, 49, 51, 55, 83

Postmortem photograph of child on lap of mother, 134, 136, 139, 140–45

pregnancy: imagery of, 126–27; rhetoric of, 91–92; teen, 23, 25–26, 91–108, 181n2

preservation, 145, 146, 147

Primetime, 109, 115–16, 117, 118, 120, 125, 186n12

Proposition 187 (California), 19, 94, 98, 100, 105

Proposition 227 (California), 183n19

"protest pietàs," 7

protests, 127–28

Psycho, 74

psychoanalysis, 164n62, 168n9

public health, 91–108

public-health education initiatives, 92–93, 96, 100–105. *See also specific initiatives*

public services, race and, 93–94

punctum, 34–37, 140–41, 170n42

race, 7–8, 44, 51, 53–55, 61–63, 91–92, 95, 97, 107–8, 172n12, 186n8; in abstinence ads, 185n41; adoption and, 96–97; in *Beloved,* 69, 73, 75, 77–79, 81, 83–84, 89, 132–33; bodies and, 96; citizenship and, 21–22, 96, 100, 106, 108; classifications of, 38, 163n56; death and, 14–23, 31, 38–42, 144–45, 147–51; family and, 146; fertility and, 96, 108; gender and, 22, 75, 175n44; history and, 24–25, 133, 141, 143, 145; ideology of, 98–99; imagery and, 94–95; immigration and, 95–96, 98–100, 108, 182n13; the maternal and, 14–27, 30–31, 38–42, 75, 78–80, 110, 144–47, 149–50; memory and, 24–25; motherhood and, 96, 97, 108; national identity and,

24–25; photography and, 33, 38–42, 146–47, 150–51, 158n22; public health and, 92; public services and, 93–94; reproduction of, 146; sexuality and, 75, 93, 96, 97–98, 105, 108; social death and, 6, 7, 21, 69, 88; technology and, 33; teen pregnancy and, 182n13; violence and, 21. *See also* racism

Rachel. *See* Peale, Charles Willson: *Rachel Weeping*

"Rachel's Lament," 138

racism, 7–8, 10–12, 38, 83–84, 87–88

Ramos, Alfred, 6

Randolph, A. Philip, 35–36

Rankin, John, 60

Raphaelle (Raffaello Sanzio da Urbino), 138

religion, nationalism and, 2–3

Rembrandt (Rembrandt Harmenszoon van Rijn), 138

reproduction, 92, 94–97, 108, 112–20, 125, 131, 132–33, 146–47

resurrection, 145, 146, 147, 151, 163n57, 164n59

Richards, Beah, 85

Rios, Luis, 6

Roberts, Dorothy, 181n7

Rogers, Bob, 156n13

Roten, Johan G., 157n14

Roth, Paul, 169n30

Ruby, Jay, 139, 141, 143, 144; *Secure the Shadow: Death and Photography in America*, 133–34, 150–51

safe sex, 102

Samuels, Shirley, 53

San Antonio Express-News, 6

Sander, August: "Notary," 35

San Francisco, California, 95

San Francisco International Airport, 95

"Save Our State" campaign, 94

Sawyer, Diane, 109, 116, 117, 120

sentiment. *See* feeling

sentimentalism, 53, 62–63

September 11, 2001, terrorist attacks, 1, 2, 5, 12–13, 109–29, 185n4, 186n11; "9/11 Babies," 112–20, 125; "9/11 Babies: Five Years Later," 125; 9/11 Commission, 122, 188n22; *9/11: Press for Truth*, 123–25; "9/11 Victims' Families Relentless Fight for Truth," 123–24; widows of, 26, 109–29, 186n12, 188n22

"Ser Adolescente" ads, 107

"Ser Padre" ads, 105, 107

sexuality, 92, 94, 95–96, 100, 102, 105; Barthes and, 36; citizenship and, 100; commercialization of, 100, 102; horror and, 75; language and, 107; the maternal and, 110; race and, 75, 93, 96, 97–98, 105; safe sex, 102; whiteness and, 97–98

Sheehan, Casey, 127

Sheehan, Cindy Lee Miller, 127–28

Sheets, Millard, 10–11

Simpson, O. J., 160n33

slavery, 22, 33, 37, 38, 147–48, 179n22, 186n8; in *Beloved*, 77, 84, 87, 131–32; the maternal and, 143–44

Smith, Shawn Michelle: *American Archives*, 146

Sobchak, Vivian, 77–78

social death, 6, 7, 14, 20–21, 34, 41–42, 69, 77, 88

Social Security Act of 1935, Title X, 181n3

Solinger, Rickie: "Race and 'Value': Black and White Illegitimate Babies, 1945–1965," 97

sorrow, maternal, 134, 138–39, 144–45, 159n26

Spanish, 105, 106–7
spectator-theorist, 35–36
Spencer, Diana. *See* Diana, Princess of Wales
Spencer, Earl, 43, 45, 65
Spigel, Lynn: "Television Culture after 9/11," 111
Spillers, Hortense, 22
Stacey, Judith, 49–51
Stapleton, Shannon: "American *Pietà*," 1–5, 9, 12–13, 21, 155n2, 156n13, 158n22
Steichen, Edward, 168n9
Stones, Rob, 175n49
St. Paul, Minnesota, 157n14
"structure of feeling," 62–63
studium, 34–36, 37, 40, 41, 140
subjectivity, 33, 77, 83, 132–33, 164n62, 165n65
Sullivan, Andrew, 4
Sunday Times, 61

Taupin, Bernie, 43
Taylor, Dean, 115
Taylor, Diana, 151
Taylor, Kip, 115
Taylor, Luke, 115
Taylor, Nancy, 115
teen pregnancy, 23, 25–26, 91–108, 181n2, 182n13
Teresa, Mother, 45–49, 50, 173n14, 173n16
terrorism, 4, 121, 125, 185n4. *See also* Oklahoma City, Oklahoma; September 11, 2001, terrorist attacks
therapeutic mode, 81–82, 83, 85
Till, Emmett, 7–8, 9
Till Bradley, Mamie, 7, 8
tintypes, 143, 144
Titian, 138
Toppman, Lawrence, 80
Trachtenberg, Alan, 137

"Unanswered Questions of September 11 Widows, The," 120–21

Van Auken, Lorie, 122–23, 124, 125
Van Der Zee, James, 34, 36, 37; *Harlem Book of the Dead*, 150
Vatican, 164n59
Vause, Zachary, 155n2
Village Voice, 120–21, 122
violence: in *Beloved*, 73, 131–32; history and, 144–45; of identification, 60–61; photography and, 151; racial, 7–8, 9–10, 11–12, 21
Virgin Mary, 1, 15–16, 17, 18, 133, 134, 143, 155n3, 163n57, 163n58, 164n59. *See also* pietàs
visuality, 9, 30; hypervisibility, 66; material structures of, 41–42; the maternal and, 22, 26–27, 114; race and, 94–95; visual discourses, 19, 22, 26–27; visual production, 23–24

Walter Reed Army Medical Center, 115
war, 92, 158n17
war on terror, 4, 121, 185n4
Washington, George, 134
Washington Post, 67
Waugh, Christian, 155n2
welfare, 92, 94, 105, 181n7, 184n21. *See also specific programs*
West, Benjamin, 134
Wexler, Laura, 21, 53–54, 112; *Tender Violence*, 109, 141
"Wheels" poster, 102, 103, 105
whiteness, 3, 21–22, 146, 172n12; benevolent, 54–55; citizenship and, 92, 100; the maternal and, 145; the media and, 43–66; photography and, 150–51; sexuality and, 97–98; white masculinism, 3; white

minoritization, 93–94; white self-making, 21

"Why We Should Support This War," 4

widowhood, 186n8. *See also* 9/11 widows

Williams, Linda, 78; "Melodrama Revised," 69

Williams, Raymond, 32, 62, 63

Wilson, Pete, 93, 94

Winfrey, Oprah, 25, 85, 109, 133, 156n13, 180n34, 180n39; African American community and, 86; as "America's psychiatrist," 68, 81, 84, 87; *Beloved* and, 67–90, 179n23; as "Every-woman," 85–86; forgiveness and, 81; *Journey to Beloved,* 81; media body of, 86

Winnicott, D. W., 164n62

Winter Garden photograph, 34, 39, 41, 169n37, 170n42

womanhood, 45, 175n44. *See also* femininity; motherhood; women

women, 52, 57–58, 63, 92, 125, 138; African American, 22, 89, 97, 166n78, 175n44, 182n13; in *Beloved,* 89; immigrant, 91–108; reproduction of, 95–96; sexuality of, 95–96; war and, 158n17; white, 96–97. *See also* womanhood

Wong, Sau-ling: "Caregivers of Color in the Age of Multiculturalism," 86–87

Woodhead, Linda, 175n53

World Trade Center, 1–2, 116, 125, 126–27

World War II, 9, 97, 164n59

Yellin, Emily, 158n17

RUBY C. TAPIA is associate professor of comparative studies and women's studies at The Ohio State University.